CLAYS AND GLAZES IN STUDIO CERAMICS

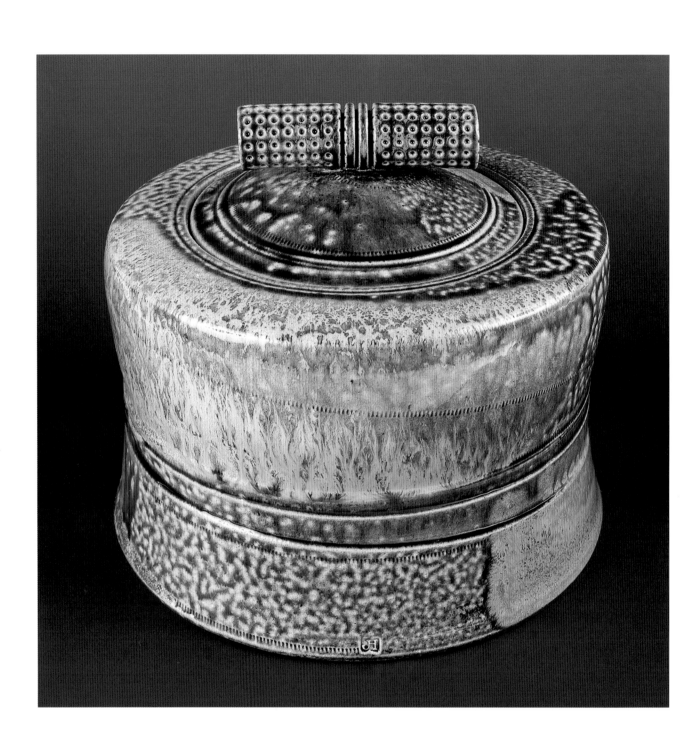

Clays and Glazes in Studio Ceramics

David Scott

The Crowood Press

First published in 1998 by
The Crowood Press Ltd
Ramsbury, Marlborough
Wiltshire SN8 2HR

British Library Cataloguing-in-Publication Data
A catalogue record for this book is available from
the British Library.

ISBN 1 86126 138 1

Photograph previous page: lidded salt glaze jar by
Jane Hamlyn.

Acknowledgements
I would like to acknowledge all the people who have
helped me in writing and producing this book: the
potters and ceramists who generously contributed
information and images of their work; Cathy Niblett
at the Potteries Museum, Stoke-on-Trent, for her
enthusiasm, knowledge and co-operation in provid-
ing the historical references; Alex McErlain and
Emmanuel Cooper for their thoughtful and helpful
advice; Harry Fraser of Potclays Ltd; Dick Brown for
the photographs, and all my other colleagues at
Loughborough University in the School of Art and
Design for their support and tolerance during the
writing of this book.

Typefaces used: text and headings, ITC Giovanni;
chapter headings, ITC Tiepolo.

Typeset and designed by
D & N Publishing
Membury Business Park, Lambourn Woodlands
Hungerford, Berkshire.

Printed and bound in China.

Contents

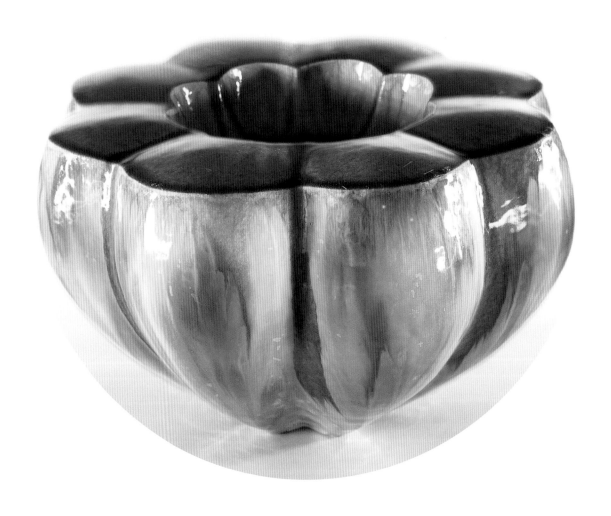

Introduction

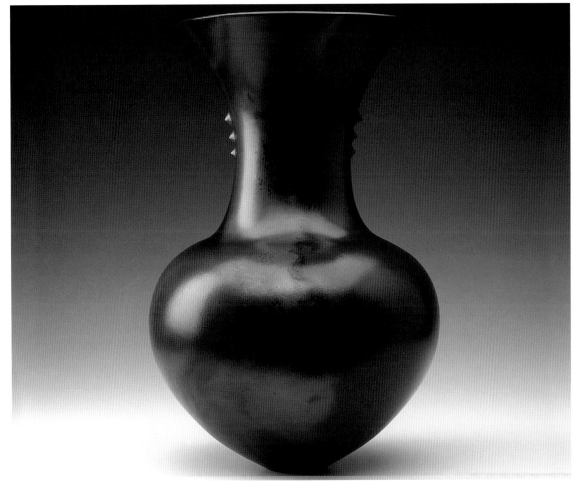

Magdalene Odundo – coiled vessel with burnished terra sigilata, reduction fired. Photograph by Abbas Nazari.

There have been many books written on this subject for the serious student and practitioner, and the essential problem that they all have had to overcome is how to make a science accessible to someone whose primary interest is creative, rather than technical. The art of ceramics is one of our most ancient ones. The science of ceramics is much more recent, and of course beautiful ceramics have been, and are still being made with very little understanding of how the materials and processes combine to produce the richness and variety that make ceramic such an important creative medium.

It is, however, almost impossible to avoid some investigation and learning about the ceramic materials if we are to exercise choice in what we make, and how we make it, although it is important to remember that increased technical understanding does not automatically mean 'better' work. The maker has to balance control of the medium against creativity and sympathy for it in order to use his knowledge in an appropriate way.

The pot by Magdalene Odundo is a wonderful example of how a simple technique, in this case coil-building a vessel, covering it with a

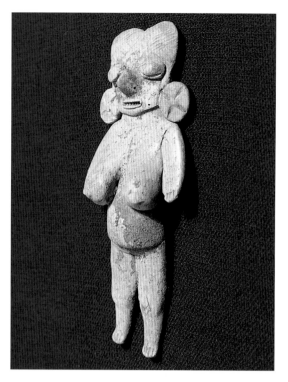

Ancient South American female figure, 300BC. The Potteries Museum, Stoke-on-Trent (right).

Greek Wine Jug, 600BC. The Potteries Museum, Stoke-on-Trent (far right).

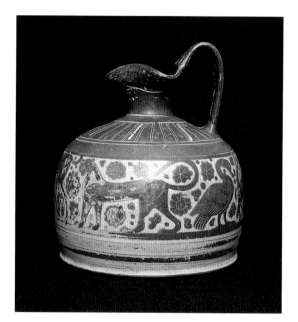

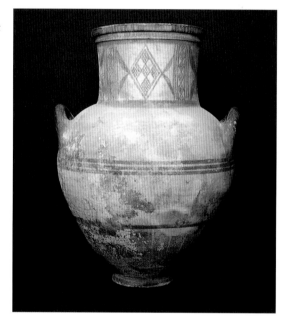

Large vase, Cypriot fourth-century BC. The Potteries Museum, Stoke-on-Trent.

burnished slip and firing at low temperature, when used sympathetically and appropriately can display the essential beauty of the material. 'Primitive' techniques and processes like this have been used in many different cultures to create beautiful objects long before more sophisticated understanding of clay was developed.

The first pottery objects were probably small sculptures and figurines produced early in the development of humankind, and it is likely that clay was one of the first materials we learned to manipulate. The first small vessels were probably formed in the hand, with rounded bases

and dried in hot sun, and later, baked in open fires. There is general agreement that the Nile and Euphrates valleys (Mesopotamia) in the ancient Near East saw some of the earliest wares developed from around 10,000BC, although there were also some roughly parallel beginnings in China. However, it was not until 5,000BC onwards that the first glazed pottery began to appear. It is difficult to say for certain how glazes were discovered, but 'contamination' of the clay with soluble alkali such as soda, which would then migrate to the surface of the ware during drying and form a glaze at the clay surface when fired, combined with attempts to colour the ware with copper in the form of powdered malachite and Azurite, is a possible explanation. This process is one that is well known amongst those who have worked with clay, especially when reclaiming red clays. Soluble salts get into the clay, partly via the hands (sweat) of the potter, but mainly through the water used to break the clay back down to a slurry prior to drying and preparation. The salts rise to the surface and leave ugly and irregular areas of yellow, known by the unattractive but apt description of 'scumming'. This phenomenon was in fact refined by the Egyptians into a body now known as 'Egyptian Paste' and used to make ornaments and beads.

Pottery also began to develop around the Mediterranean Sea in the first and second millennia BC, in Cyprus and Crete, leading eventually to the Greek and Roman civilizations that dominate Western visual culture to this day. At

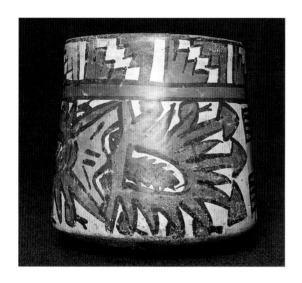

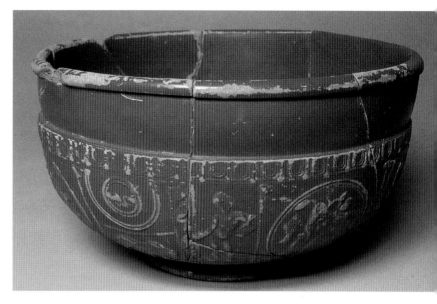

about the same time, pottery was on a parallel course of development in China, where throwing on the wheel was also being learned, although technological development, particularly in kiln construction and consequently higher temperature glazes, was more rapid. This arguably kept the whole of the Far East at the forefront of technical advancement until the Industrial Revolution in Europe.

Pottery-making also evolved in all major civilizations in the pre-Christian era, notably in South America. Less is known about early African civilizations, but it is probably true to say that the main technical development of ceramics was in the Far East, Near East and Mediterranean. In Britain, after the departure of the Romans, who had brought with them relatively sophisticated forms and techniques, in particular their Samian ware which was virtually mass-produced throughout their empire, pottery reverted to technically crude and simple utilitarian wares. Pottery was generally perceived by the society of its time to be of little cultural value, and it is interesting to compare the technical control of high-fired Chinese ceramics by the seventeenth century (*see* right) with the English slipware piece from the same period (*see* overleaf), which may appear crude in comparison. It is, of course, invidious to make comparisons of this nature; the point is made simply to underline the chronological variations in the evolution of world ceramics, and the need to be careful not to confuse technical achievement with aesthetic achievement.

It has been argued by some that the highest peaks of achievement were reached in the Song and Ming periods, while others make that claim for the Attic wares of ancient Greece, and certainly pottery made in these cultures shows a high degree of understanding of ceramic materials and processes as well as a high level of aesthetic value. However, I believe that it is true to say that the next major technical advances came along in the Industrial Revolution in Europe in the eighteenth century. Many of the advances came in Germany and England,

*N*azca cup vessel seventh century AD. The Potteries Museum, Stoke-on-Trent (above left).

*R*oman Samian ware, second century AD. The Potteries Museum, Stoke-on-Trent (above).

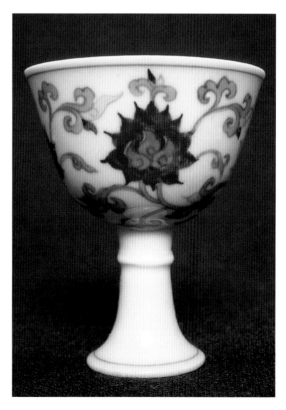

*M*ing Dynasty stem cup. The Potteries Museum, Stoke-on-Trent.

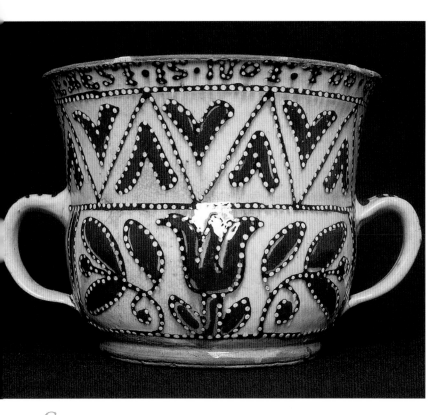

from a perhaps mistaken, but probably inevitable, desire to imitate the fine porcelains imported from China. John Astbury in England and Johann Bottger in Germany are often credited with the crucial breakthroughs in developing porcelain-type clays, through the addition of finer, whiter clays from Devon and the Meissen area respectively. By 1800, the addition of calcined animal bone to clay bodies was being perfected, most notably at the Spode factory in Stoke-on-Trent, which gave a truly white, translucent and exceptionally strong fired strength. Its drawback was that its clay content was relatively low and it was therefore more suitable for casting than hand-making techniques, but this made it ideal for the new age of mass-production techniques. Bone china is probably the most important ceramic innovation to come from England, and this material is still synonymous with the highest quality pottery possible. Technical progress continues in the manufacturing processes used in industry, and indeed even in studio ceramics, where traditional methods and materials are

Seventeenth-century Staffordshire slipware posset pot. The Potteries Museum, Stoke-on-Trent (above).

Early eighteenth-century Spode bone china teapot. The Potteries Museum, Stoke-on-Trent (below).

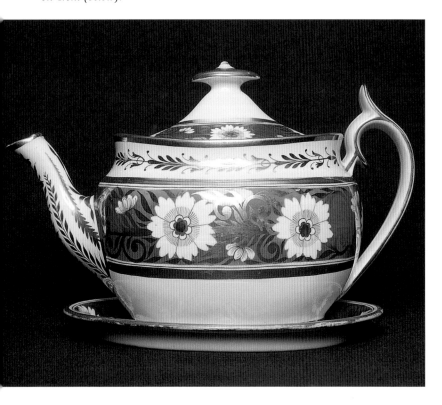

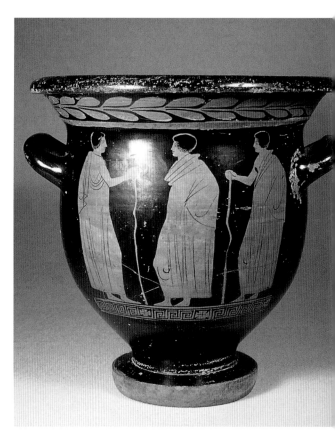

Black Attic krater, sixth-century BC. The Potteries Museum, Stoke-on-Trent.

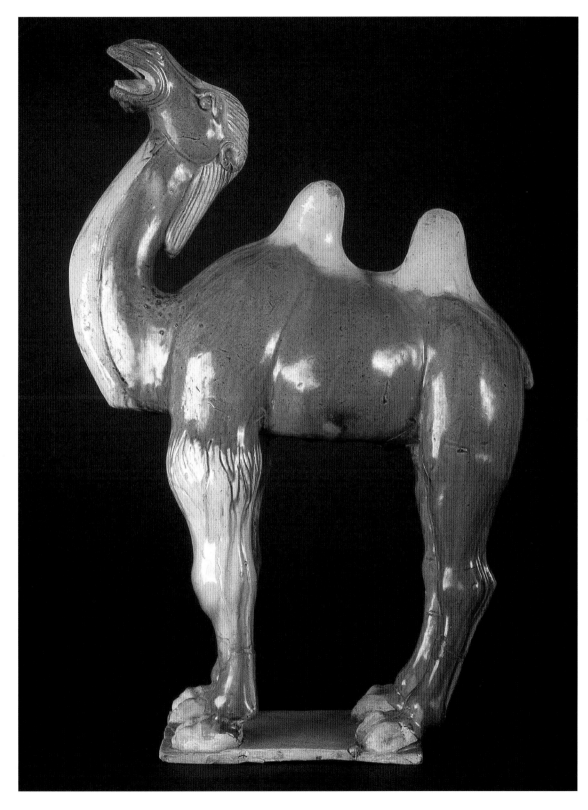

Camel, lead glazed. T'ang Dynasty (600–900AD). The Potteries Museum, Stoke-on-Trent.

considered to have intrinsic value, newer materials such as ceramic fibre and techniques like paper clay have an influence on what we make. The changes are perhaps more subtle than those that were brought about as the Industrial Revolution spread around the world, but the involvement of so many individuals in the medium means that the art and craft of ceramics continue to be an important and developing means of cultural expression.

Health and Safety

I will highlight particular hazards as the book progresses, but it is important to note that almost all ceramic materials contain some risk hazard, largely due to the inhalation of non-degradable dust particles which cause irritation to the respiratory system. Also many of the materials used are toxic, that is poisonous if absorbed into the blood stream.

To some readers the above may seem a rather off-putting statement, so it should be counter-balanced by saying that common sense and good workshop practice will minimize most risks and that no-one should fear working with ceramic materials any more than many other common substances.

The main hazard that potters face is the basic material itself, clay. It has a high proportion of silica content, as do many glaze ingredients, so that the dust which is created in any pottery workshop or studio is inevitably high in silica. Risk comes from repeated careless exposure, usually ten to twenty years, although obviously individuals vary in their ability to withstand exposure, and the damage to the lungs is irreversible. The symptoms are similar to pneumoconiosis: chronic shortness of breath (due to scarring of the lung tissue), chest pain and loss of energy. This has been a common enough illness in the past to have its own name, Silicosis. Dust creation should always be minimized in the workshop. This can be achieved by keeping the use of dry materials to a minimum, and then only with the proper extraction and ventilation systems, the wearing of an appropriate dust mask, regular cleaning of overalls, and cleaning up with water, never with a sweeping brush which serves only to disturbs the finest particles and make them airborne again.

Many other ceramic materials also pose similar dust hazards to silica, but some are also toxic. Lead has always been an important component of glazes, and its poisonous nature is well known. In its raw oxide form it was used in glazes until relatively recently, and many glaze books still contain recipes which include raw lead oxide, which is toxic and can be ingested through the lungs from breathing (lead poisoning was a major killer in the pottery industry until well into this century).

However, the use of raw lead compounds in ceramic glazes is now almost a thing of the past. It is now supplied only in 'safe' forms (*see* page 74), and even these are subject to ever increasing restrictions and safety standards. Many other ceramic compounds are potentially equally dangerous, however, and all hazardous materials sold to the potter should now have health and safety recommendations clearly stated on the packaging by the suppliers. Despite this, the individual must still take care to act responsibly in the use, storage and disposal of all such materials.

Generally, all pottery substances should be treated cautiously as both dust and toxic hazards, but with the good housekeeping methods outlined above, and adherence to suppliers' guidelines, there should be acceptable minimal health risks to the individual.

Dust mask.

Part 1
Clay

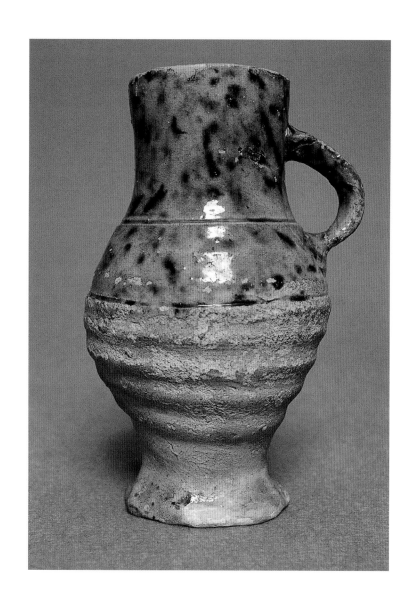

Formation & Types of Clay

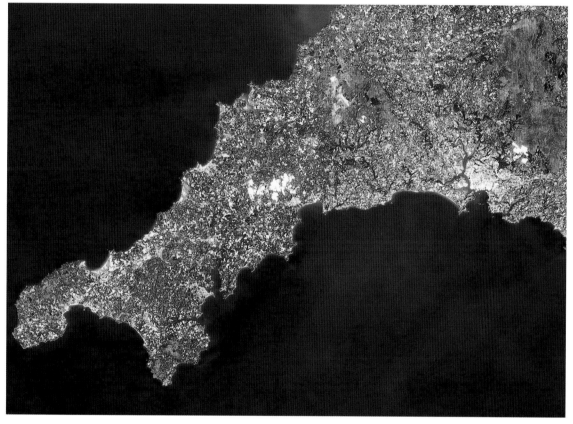

Cornwall and west Devon seen from space; the white china clay mines at St Austell and on the edge of Dartmoor are clearly visible in the centre and on the right. (Courtesy of M-Sat.)

Clay, and the mineral oxides in its make-up, are among the commonest on the planet. The formation of clay is simply a stage in the decomposition of volcanic (igneous) rock which was molten in the formation of the earth's crust, a process which of course is still going on. The rock from which clay is commonly formed is granite, and it is convenient for us that many of the essential ceramic materials are derived from granite, and that it is such a common component of the earth's crust.

Primarily, clay forms in and around large granite outcrops, a good example of which is Dartmoor in south-west England. The formation of clay is a continuous process, but one that began deep in geological time, billions of years ago. The process of decomposition of the semi-molten granite was begun by the hot acid gases emerging from the earth's interior, creating sub-compounds of feldspar, quartz and mica, and is continued by water and weathering to the present day. It is important to stress the geological time-span involved here, and the elemental nature of the process, where rain, ice, glacial action and plant growth have slowly but surely brought about fundamental changes in the make up of the earth's surface, and have all played their part in the metamorphosis of the rock into clay.

The formation of clay from the feldspathic rock is largely achieved by weathering. A typical composition of a feldspar is potassium oxide (K_2O), alumina oxide (Al_2O_3), and silica dioxide (SiO_2), correctly expressed by the formula: $K_2O.Al_2O_3.6SiO_2$ The final stages of the weathering process wash away the soluble potassium, and the clay thus formed has the following formula:

$$Al_2O_3.2SiO_2.2H_2O$$

This is the commonly used and simplified formula for 'pure' clay, sometimes known as china clay or kaolinite.

It is important to note here that this formula, and others throughout the book, are usually 'typical' or 'ideal' formulae, that is, they ignore variations and minor impurities. It might also be useful to make the point that ceramics, in the sense that those who are interested in it creatively would understand, is an inexact science, full of traditional terminology and generalizations. This is no doubt because so much of the history of the investigation of clay as a material has been towards a creative application of that knowledge. It is not my intention to attempt to redefine ceramic theory for artists/craftspeople, but it is important to make the distinction.

For present purposes, it is only necessary to say that 'pure' clay is a hydrated compound of alumina and silica, although in fact a 'typical' analysis of one of the purer clays available would be the example shown in the table below.

Typical Composition of a China Clay		
SUBSTANCE	CHEMICAL NAME	PERCENTAGE
Silica	(SiO_2)	48.10
Alumina	(Al_2O_3)	36.74
Iron	(Fe_2O_3)	0.8
Titanium	(TiO_2)	0.04
Calcium	(CaO)	0.06
Magnesium	(MgO)	0.28
Potassium	(K_2O)	2.13
Sodium	(Na_2O) ·	0.11
L.O.I.*		11.94

*Note: L.O.I. – Loss on Ignition, material that burns away when the clay is fired, consisting of volatiles such as water and carbon from dead organic matter.

It can be seen from the above example that while the vast majority of the clay is in fact alumina and silica, there are small amounts of other materials that would be generally ignored for many of the calculations that a 'potter', as opposed to a scientist, might do.

Primary Clays

'Pure' china clay formed from the processes outlined above, which has not been transported at any point in geological time by glacial or other natural forces, is usually termed primary clay, or sometimes residual clay. Either way, these terms are relatively obvious, and define the material as one which has remained at its point of origin.

The china clays mined in Cornwall, England, are not in fact 'mined' in the usual sense of the word. The clay is blasted off the parent rock by high-powered water hoses, and then becomes a slurry or watery mixture which usually also contains some unwanted quartz and mica. This slurry is run off into settling tanks where these materials sink to the bottom, and the clay that is then skimmed off the top is good quality china clay.

This kind of china clay is used mainly in the pottery industry for its whiteness. It is also very refractory, with a melting point of over 1700° centigrade. As we will see later, it is usual for other ceramic materials to be added to it to achieve a clay body that has the right balance of properties appropriate to the making and firing processes. It is also worth pointing out that clay is a useful component in many other materials, such as high quality magazine papers for example, and even less well known is its use in household paints, and the fact that emulsion paint may make a passable white slip if fired on to ceramic.

However, although china clay is valued for its purity and whiteness, it cannot practically be used on its own. The reason for this is rooted in the manner of its geological origin and the very fact that it is residual. Because it has not been removed from its point of origin by glacial action, or washed away by a river, it has a comparatively large particle size, that is the microscopic particles in its make-up have not been ground to the extent required to make the clay plastic or workable.

For the potter, plasticity is one of the most important features of a clay body, and can be loosely defined as the ability of a material, in

this instance clay, to combine structural strength with fluidity. In practical terms, plasticity is best illustrated by the image of the potter throwing on the wheel, in which clay continuously changes shape in the potter's hands. If the potter stops and takes his or her hands away from the pot being formed, it should not crack, deform or collapse. A clay low in plasticity is likely to do all three of these things! Of course, different making processes require different degrees of plasticity, and throwing demands more than most, but plasticity is a crucial property of clay and is what makes it such a marvellous and versatile material to work with.

Secondary Clays

For our purposes, there is only one primary clay, which we know as china clay. Secondary clays are, by their nature, more various. They are so called because they are primary clays that have been removed from their point of origin, and in the process have been modified in both structure and composition. Those that have travelled the least are sometimes known as once-removed china clay.

The modifications which take place are made by glacial action, rivers and other geological forces over time. These grind the particles of the clay to a smaller size, giving ball clays their characteristically high plasticity. At the same time, secondary clays have also usually picked up impurities, usually caused by water flowing over and through the landscape carrying different minerals picked up on the journey, and by the process of sedimentation, the variety of organic matter that will settle on a lake or river bed. The most common and obvious impurity is iron, which when present in large quantities accounts for the vast quantities of clays that fire to the characteristic red 'terracotta' colour. In smaller amounts it gives the clay a creamier off-white colour.

Other 'impurities' are those mineral oxides that act as fluxes when fired, such as calcia, magnesia, potash and soda. These have the effect of bringing the firing temperature of secondary clay to much lower than that of primary (china) clay, to 1200°C or less.

Another major impurity in secondary clay is carbon from dead organic matter. This is an obvious component of any material which lies

below or at soil level, or at the bottom of a river. As a teacher of ceramics, I have often done the exercise of sending students off to dig clay from their own locality. Invariably someone comes up with a green or blue/purple coloured clay, and is very disappointed when it fires to the same red/brown terracotta colour as everyone else's clay. This is because the colour is caused by organic matter, which of course burns out on firing. This does not mean that we can ignore the carbon completely, however, because during the burning off it turns into a gas which can cause problems if the firing cycle does not take it into account (this will be explained in greater detail later). Also, the dead organic matter, though sometimes extremely offensive in its smell, makes a contribution to the plasticity of the clay.

Wheel throwing aptly demonstrates the plastic qualities of clay.

Types of Secondary Clays

Ball Clays

Ball clay is probably the most important of the secondary clays, and is so called because of the method of extraction. This is a good example of the many exasperatingly misleading terms used in ceramics. It is called ball clay because it is dug from the ground in 'balls' – except that it is not. In modern times it is taken from the ground by excavators, but even before mechanical extraction it was dug with spades, making cubes rather than balls. However, this misnomer has stuck and is applied to those clays that are the purer of the secondary clays and are also sometimes termed 'once removed' china clay.

Ball clays usually contain iron – to a far lesser extent than a common red clay, but appreciably more than a china clay – and titanium, which combine to give a creamy off-white colour to the fired body. This type of clay will contain enough fluxing material to make the clay begin to soften and deform at around 1200°C. These are the same fluxes that are found in smaller quantities in china clays, less than 0.5 per cent by weight of calcium, magnesium, sodium and 2 to 2.5 per cent of potassium, which has a strong fluxing effect.

Most ball clays contain some carbon, and a few contain a considerable amount, indeed, some are even called blue or black ball clays, after the coloration they get from the carbon they contain. Although problematic during firing, the carbon does actually contribute to the plasticity of the clay, and ball clays are usually very high in plasticity. In that sense, they are complementary to china clay, which is low in plasticity because of the larger particles it contains. The fine particles in ball clay make it accordingly much more plastic, so much so that it can be too sticky for use as a clay body on its own.

The finer clay particles in ball clay mean that it can absorb a comparatively large amount of water. This is because there is a greater surface area around lots of small particles than there is around fewer larger particles. As a result, shrinkage is also very high, in the region of 20 per cent or even more, which is unacceptably high for most pottery purposes, when shrinkage would normally be expected to be around 10 to 20 per cent.

Ball clay deposits are relatively widespread, but the best deposits in Britain are, like china clays, in south-west England, in Devon and Dorset.

Fireclays

This is an interesting group of clays in that they have some plasticity and are also refractory. They are associated with coal deposits, and it is possible that when the coal was actually living trees growing in the clay soil, they removed those minerals from it that they needed for growth, such as potassium, sodium, magnesium and calcium. These are also fluxes, and this contributes to the ability of some fireclays to withstand very high temperatures, up to 1700°C before melting. The most important feature of fireclays is that, after china clays, they contain the highest proportion of alumina in relation to silica, and this is crucial in giving them their high temperature capabilities.

Not surprisingly, given their origins, fireclays tend to have as much carbon as ball clays, and also some iron that can give them a warm, creamy yellow colour when fired, and iron pyrites which gives a strong speckle. Fireclays have comparatively good plasticity but are also low in shrinkage, and these unique properties make them essential as a component of bodies that have to withstand high temperatures and thermal shock, such as fire backs, saggars and kiln furniture.

Red Clays

These are the commonest group of secondary clays and can be found in almost any area of the country. They share many of the same characteristics of ball clay, but have a large iron content which gives the orange/brown colour of 'red terracotta' when fired. They can also contain similar amounts of carbon to ball clay and fireclay, and this can give the misleading unfired colours mentioned above, of green, purple or even ochre.

The finer red clays are very versatile and are used for a whole range of purposes that are familiar to most of us, for example in relatively refined garden plant pots, architectural embellishments and even tableware, while the coarser ones are used for bricks and roof tiles. They are also used by contemporary ceramists, for

example by Martin Smith. He has worked for much of his career using red earthenware clay, achieving high levels of precision and sophistication, and breaking the stereotypical view of red clay as a 'rustic' medium.

The ubiquity of red clay makes it cheap and easily available and the large deposits in Staffordshire formed an area of pottery making which evolved in the eighteenth century into the centre of the English pottery industry. It remains there to this day, although most of the raw materials are no longer of local origin.

'Fact & Expectation' by Martin Smith, red clay with copper leaf.

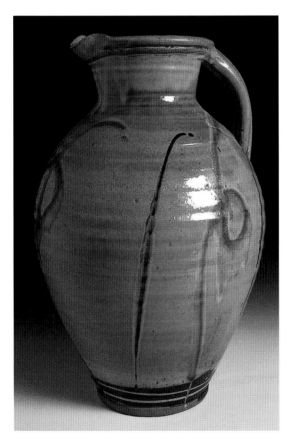

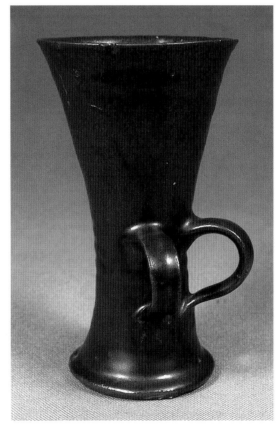

Large jug by Clive Bowen. Red clay, lead glaze over coloured slips. Collection of Jim Gladwin (far left). (Photo by Dick Brown.)

Staffordshire 'Iron glaze' two-handled 'tyg'. The Potteries Museum, Stoke-on-Trent (left).

Basic Structure & Composition of Clay

Electron microscope drawings of clay crystals.

Layered structure of the clay particle (right).

Layered structure of kaolinite (below).

Physical Properties

In looking at clay, and the ways in which we can use it as a plastic medium, it is important to try to gain a basic awareness of its physical and structural characteristics. Perhaps we can best begin by looking at the individual clay crystal or particle.

In simple terms, a clay crystal is a flat hexagon made up of many alternate layers of silica and alumina bonded by oxygen. The layers vary to a small degree which gives the complete crystal a slightly irregular appearance, but one that is still recognizable under the microscope as hexagonal. The typical size would be about 0.5 microns across, far too small to be seen by the naked eye. The clay crystals are formed into whole particles through electrostatic attraction, which has an important effect on many aspects of the behaviour of clay, with hundreds of crystals making up a single particle. These individual clay particles are also formed into flat, imperfect hexagonal shapes like the clay crystals, and are also usually too small to be seen without a microscope, although the largest ones can be seen as a fine dust.

It is the fact that clay crystals and particles have this characteristic 'plate' structure that gives them their unique properties for the potter. When pressure is applied to clay particles, which happens quite naturally for instance when a clay settles out in a river bed and becomes compressed under its own weight and the weight of the water above, the particles become formed into a layered overlapping structure. There are many popular analogies to explain this structure, but I feel that the analogy of the brick wall is a good one, where the ele-

ment of structural strength combined with the ability to survive some distortion can be easily recognized and understood.

When clay is in this formation it gets its strength from the millions of overlaps of one particle over another, which can be demonstrated very easily by rolling a handful of clay under the fingers. A large amount of downward pressure can be exerted without the clay rupturing or cracking, although it will deform and change shape, but if the two ends of the coil are pulled apart, the coil will quite easily break in two. This is because the brick wall structure is strong in one direction and weak in the other. But it is this strength gained through compression that makes clay so plastic and usable for the potter.

Factors Affecting Plasticity

A crucial element of plasticity is water. This may be an obvious statement, but in fact the role that water plays in the behaviour of clay is more complex than is immediately apparent. It is the presence of water molecules linking the layers of silica and alumina within the clay crystal that gives clay its unique properties – which of course cannot be simulated by simply combining alumina, silica and water! To begin with, water is the lubricant that allows the clay particles to slide. Ideally for the potter, the water content should be sufficient to achieve plasticity: too little and the clay is hard and unmalleable, too much and the clay becomes weak and sticky, and if enough water is added it will become completely fluid and without physical and structural strength at all. The figure above right shows water interspersed between the clay particles in just sufficient quantity to lubricate their movement but also in a sense to hold them together. The best analogy for this is to think of a flat-bottomed glass standing on a wet glass-topped table – the glass slides smoothly around the table top,

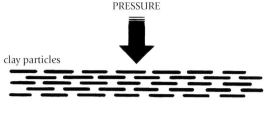

PRESSURE

clay particles

Overlapping clay particles in the compressed 'brick wall' structure.

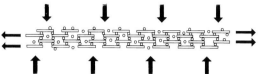

Suction created by the film of water between the particles allowing them to slide.

but when the glass is lifted, there is resistance from the suction created by the water. The figure above shows what happens when too much water is present in the clay. The clay particles are pushed too far apart for there to be any suction between them, resulting in a clay slop or slurry.

A key factor in the behaviour and plasticity of a clay and the part that water plays is the size of the clay particles it is made up from. In reality, any individual clay will contain a range of different sized particles, and a more plastic clay will tend to contain a greater percentage of the smallest particles. China clays have coarser clay particles because, as we have seen above, they are residual clays and have experienced less weathering, and would typically contain on average about 40 to 50 per cent of particles below 2 microns in diameter. Secondary clays will have smaller particles, with a ball clay having on average 70 to 80 per cent at 2 microns or less. There are two reasons why this affects plasticity. One is that a clay made up of a larger number of finer particles can absorb more water before losing plasticity, because there is a greater surface area for the water to occupy around the smaller particles. The second is that there is less friction created between smaller particles than between large ones, giving better 'slide' characteristics.

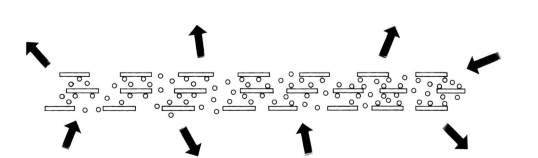

Too much water between the particles, suction is reduced and the clay loses cohesion.

Crater in vessel caused by steam 'explosion' through firing too quickly when the ware is still damp.

The Role of Water in Clay Bodies

While water fairly obviously affects the plasticity and texture of clay, it is important to be aware that it is still present in significant amounts even in apparently dry clay. The water content of a plastic clay can be split into three separate categories, as follows.

Water of Plasticity

This, as we have seen, is the water that allows the plastic movement of the clay body by surrounding the particles of clay, thereby allowing them to slide against each other. This water will normally account for about 20 per cent of the weight of a plastic clay, and as it dries out the clay becomes progressively firmer and less plastic. Clay that has lost its water of plasticity is usually described as being 'leather hard', although unlike leather it will bend very little without cracking.

Pore Water

It must be remembered that clay particles are imperfect shapes made up of large numbers of clay crystals. Within the particles themselves and also in the irregular surfaces around them are microscopic spaces that water can occupy without effect on plasticity. These 'pores' become filled with water, which, though it is taken into the clay initially as part of the water of plasticity, is superfluous for that function. It is not, however, an insignificant amount of water. It can be in the region of 10 per cent of the total weight of plastic clay, and can be so 'trapped' in these minute spaces that it is not released easily. Even apparently dry clay will still contain some of this pore water and needs to be heated to above 100°C to be expelled. It must not be ignored in the drying and firing processes, as we will see later. It is crucial that clay is slowly and carefully dried out up to a temperature of about 150°C to avoid problems like cracking and distortion. If damp clay is heated too quickly, without allowing the steam to pass slowly through the pores, the pressure created by the rapidly expanding steam can cause the ware to explode quite violently, and is the main cause of kiln 'explosions'. I once had the experience while teaching in Adult Education of a beginner sneaking a small, just finished thrown and turned pot into the glaze kiln that I had almost finished packing. This was a noisy, fan-assisted gas kiln, and I did not hear the explosion when it came, about one hour into the firing, although if I had been beside the kiln at the time I certainly would have. On opening the kiln, there was a completely empty space where the pot had been, but there was hardly a single pot in the kiln that did not have a fragment of the vanished pot stuck to it.

Chemically Combined Water

This may be difficult to appreciate fully, but even apparently dry powdered clay still has an intrinsic water content. This is perhaps not helped by the general practice in the pottery world of using the formula for 'pure' clay as $Al_2O_3.2SiO_2$ (alumina and silica oxides), when it should be correctly expressed as $Al_2O_3.2SiO_2.2H_2O$ (alumina, silica and water), where the water content is denoted by the easily recognized formula of H_2O. The formula for clay is often shortened to

omit the water in ceramic calculations and formulae because it plays no part in the ceramic fusions which occur at the temperatures of ceramic firings, but this can lead to the water content of dry, as opposed to fired clay, being overlooked.

Hard as it might be to believe, combined water has not been completely driven off until a temperature of about 600°C has been reached, although it might be easier to think of the process as the giving off of molecules of hydrogen and oxygen rather than water as we conventionally think of it. The steam escapes fairly easily during the early stages of firing because at these low temperatures the clay is very 'open' and porous. Burning off the combined water is therefore not unusually hazardous to the ware, but it is generally considered the rule to take care in firing up to 600°C. Chemically combined water is also sometimes known as water of crystallization, combination, constitution, hydration and bound water.

Shrinkage

Shrinkage is one of the most problematic characteristics of clay as a plastic medium. It creates stresses and strains in the form before and after firing. During the initial drying out, thinner and more exposed areas of pots, such as around rims and handles, can dry out more rapidly than areas such as the base of the pot. This can cause distortion of the form and even cracking, particularly in between the handle and body, and any areas around which air can circulate freely. This means that most pots dry out unevenly, and in complex forms with varying thicknesses, distortion and cracking is a common hazard.

There are two kinds of shrinkage in clay. The first is from drying out as the water evaporates, and the second is firing shrinkage, in which more complex changes take place at higher temperatures after it has become fired ceramic. The photograph of a 20cm (7.8in.) high clay extrusion illustrates not only the overall shrinkage from the plastic to the fired and vitreous state (1250°C), but also shows that shrinkage is not evenly progressive between the stages here at plastic state, leather hard, dry, biscuit fired to 960°C, then at 1060°C, and finally 1260°C.

Shrinkage from drying is most obvious from the plastic state to the leather hard. Here the water of plasticity disappears and the clay particles move closer together until eventually they touch, and even though the clay may still have some obvious dampness from the water existing

The progressive stages of shrinkage of a 20cm × 6.5cm extrusion from when first made (plastic), to leather hard, dry, and fired to 960°C, 1060°C and 1250°C.

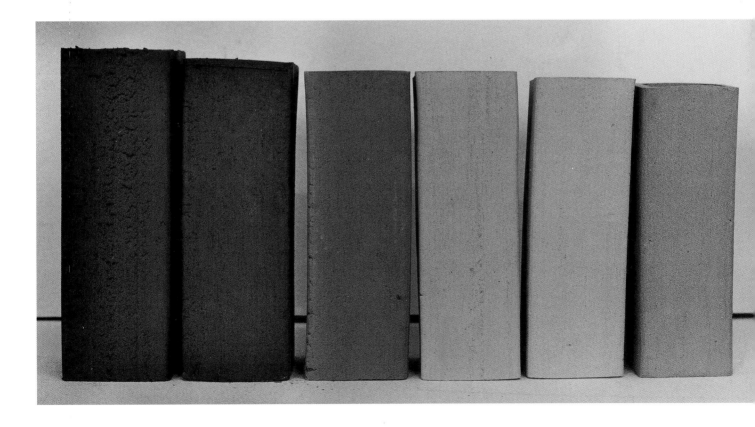

in the spaces between the particles, it cannot shrink much more at this stage because the particles are already beginning to touch, and any further drying shrinkage is caused by the clay particles compacting on each other.

The amount that a clay body shrinks is dependent upon several factors. Very fine clays, that is clays with more of the finer sized particles, will shrink more than a clay containing larger amounts of coarse particles. This is because there is more surface area to contain water in between fine particles than there is between large ones. It is important to stress that the coarse or fine texture of particles is not apparent to the touch. A typical porcelain clay made up of china clay, feldspar and quartz will feel deceptively smooth, but is in fact made up of materials which are, at the microscopic level, quite coarse.

As the clay particles begin to touch, shrinkage slows down even though there is still a considerable amount of water left.

Large clay sculpture drying on wooden slats. Cutaway view shows hole cut in base to facilitate further even drying.

As a general rule then, fine plastic clays shrink more in drying, and cause greater problems due to distortion and cracking. However, all clays need careful, slow and even drying to be certain of avoiding problems. The main factors that affect drying are: shape, size, air temperature, air circulation and humidity. Good air circulation is very important, particularly for large and/or complex pieces. For small pots, it is often enough simply to invert the ware, so that the base can be exposed to the air. Larger pieces, or those which it is not practical to turn upside down, can be placed on wooden slats, allowing air to get under the base. For work that is non-functional, it is still a good idea to have a 'base' or slab to stand on, as this acts as a raft to take the weight of the walls and allow them to move inwards evenly as contraction takes place. It is also a good idea to make a rounded hole in the base to allow air to get right inside the work.

Once dry, clay has the ability to take up water again from the atmosphere, so it is important that dry pots are not placed anywhere that this may happen. This process is known as readsorption, and as the clay once more expands with the moisture, cracking can occur. This phenomenon is the reason that it is not practical to attempt to damp down a dried and formed clay work in an effort to make it plastic again. Such an action is rarely successful as clay needs to be thoroughly mixed with water which fully penetrates between the particles before it can regain its full plasticity (*see* Chapter 4).

During firing, it is a common misconception to think that shrinkage is continuous and even as the temperature goes higher. This is not the case, and in fact some clays do not shrink significantly between the dry stage and 960°C, the common temperature for first or 'biscuit' firing. Firing shrinkage starts as the clay begins to 'melt' or 'fuse' together. This is a complex process which varies widely depending on the make-up of individual clays, but is a result of the fluxes present in the clay fusing the particles together. This is dealt with in greater detail in Chapter 6.

Clay Bodies

General

This chapter is concerned with the composition of 'manufactured' or prepared clay bodies, as opposed to basic types of raw clay taken straight from the ground. Some clays are usable without significant modification, but it is common practice to tailor a clay body to a particular use. For example, the requirements of a clay suitable for hand-thrown functional pottery and firing at high temperature will be very different from those of a clay used for industrial tableware.

To take china clay as an example again, because it is *the* primary clay, its chief characteristics are its large particle size and purity, which give poor plasticity. However, china clay has good whiteness because of its purity, and because of the absence of any significant amount of flux, it has a high melting point of above 1700°C. On the other hand, a commonly used secondary clay like ball clay has a fine particle size, which gives good plasticity. However, it contains impurities like fluxes, which make it melt at a much lower temperature (around 1200°C), as well as iron and titania, which give an off-white colour.

It is therefore common practice to blend different naturally occurring clays together to achieve the characteristics required, and this is very often an acceptable and satisfactory means of arriving at a workable clay body for use in studio ceramics. This is not always the case, however, and consideration must also be given to the fired characteristics a clay will need, and this often means the addition of other related, non-clay materials.

Types of Ingredient

Usually, a clay body will have three or four groups of ingredients. The first and often main ingredient (though not always) is clay, then flux, filler and opener. Some common examples from these categories are given in the table.

The Four Main Categories of Clay Body Ingredients			
CLAY	**FLUX**	**FILLER**	**OPENER**
China clay	Feldspars	Flint	Grog
Ball clay	Calcium	Quartz	Sand
Fireclay	Talc	Cristobalite	
Red clay	Bone ash	Calcined clay	
Bentonite			

(*See* example recipes later in this chapter.)

'Twist and Turn' by Felicity Aylieff (45 × 28 × 30in/114 × 70 × 75cm). Aylieff does not work with 'conventional' clay bodies. She describes her material as a ceramic terrazzo, a composite of fired clay and glass aggregates and finished in a manner similar to the techniques used for finishing marble. (Photograph by Sebastian Mylius.)

Clay

Clay is the essential plastic material that allows forms to be created. The various types have already been discussed, but bentonite is an interesting and unusual clay which is so high in plasticity that it is only used in small quantities to improve the handling characteristics of other clays or clay bodies. For this reason, bentonite is sometimes referred to as a *plasticizer.*

Fluxes

These act on the other ingredients to fuse the body together at a given temperature; the more flux there is, the lower this will be. Too much flux and the body will soften at too low a heat. Bodies based on ball clays and red clays need little added flux because they already contain fluxes as 'impurities'. Materials like feldspars have in some senses a dual function in that they will also contribute some filler in the form of the silica that they contain.

Fillers

As the name implies, these fill in the spaces in the body, giving hardness and density. Flint, quartz and cristobalite are all forms of silica, the main glass former in clays and glazes. They have the same chemical composition (SiO_2), but are different in the way the atoms combine, contributing different qualities to suit the needs and demands of particular clay bodies. One of the benefits silica brings is increased expansion and contraction of the body, which puts the glaze under compression and reduces crazing, but this has to be balanced against a greater tendency of the body to crack in both the heating and cooling cycles during firing (*see* Chapter 6). The amount of filler will also have an effect on porosity, dependent on there being sufficient flux present to fuse with it at the temperature to which it is fired.

Openers

These are materials added to the body for texture and strength at the plastic state. They also assist in drying and in reducing shrinkage during drying. For example, grog is simply fired clay which has been ground down, and if 20 per cent is added to a body, it follows that 20 per cent of any pot made from that body has already been fired and so shrinkage of the new pot will be reduced accordingly. It is common to use a grog that is more refractory than the clay to which it has been added so that it continues to reduce shrinkage and warping throughout the firing cycle. The effect a grog or sand has on the body during firing is dependent upon the type of clay from which the grog itself is made, and the firing temperature. A grog made from a lower temperature clay will begin to act as a filler at the temperature at which the surrounding body achieves the same density as the grog itself, and will therefore become a homogeneous part of the body.

Some materials are not always listed in the categories shown above. For example feldspars are sometimes listed as fluxes and sometimes as fillers; in fact, they can be both, as the potassium or sodium they contain are a flux, and the remaining alumina and silica would be regarded as filler. I would categorize it as a body flux because that is the primary reason for adding feldspar to a body.

Similarly, fillers and openers can be interchangeable, depending upon the nature of the particular materials and the firing temperatures involved. The important thing to remember is that the main function you intend the material to perform in your clay body is appropriate for the temperature to which it will be fired.

Ingredients for Clay Bodies

The following is a general summary of the more common materials used in clay bodies and their main characteristics.

Clays

BALL CLAYS

These give plasticity and better unfired strength. A wide range of ball clays is available – English

china clays, for example, have a range of slightly varying types from the Devon and Dorset deposits. The carbon content and the care in firing required of many ball clays should be borne in mind when using them (*see* Chapter 6).

BENTONITE

By some definitions Bentonite is not actually a clay, and on its own it is a greasy, sticky material, sometimes used as an industrial lubricant. Its contribution to ceramics is its extreme plasticity, and it is used in porcelains and other clays with a high content of non-plastic material. Additions of 3 to 5 per cent are usually sufficient.

CHINA CLAY

China clay gives whiteness and refractory characteristics, but the greater the china clay content, the lower the plasticity of the body. Where used, depending upon the type of body, it may form anywhere between 10 per cent and 60 per cent of the recipe total. In practice, china clays vary slightly in their plasticity, colour, and so on, and it is better to use a good quality one, such as English China Clay's 'Grolleg china clay' which is widely available.

FIRECLAY

Fireclays are good general purpose clays, useful in hand-building bodies where they contribute strength and ease of drying, yet plastic enough to be thrown. They are also highly suitable for raku bodies while still being refractory enough for high temperature firing. They can be used anywhere that their coarseness and 'toasted' fired colour is not a disadvantage, in quantities from 10 to 100 per cent.

RED CLAYS

These give plasticity and, obviously, colour. The percentage addition of red clay in bodies fired to temperatures over 1200°C is limited because of their fluxing properties. They can be up to 100 per cent of an earthenware body, and up to 50 per cent of a stoneware.

Fluxes

BONE ASH

The unique combination of calcium, which is the flux, and phosphate, which is a glass former, make bone ash an essential ingredient of bone china. In some senses, it plays a similar role to that of feldspar in a clay body, although it is finer and denser. The calcium also has some bleaching effect on any iron impurities present, allowing a whiter 'colour'.

CALCIUM

Added in the form of whiting (calcium carbonate), this material is rarely used in high temperature bodies because of its vigorous fluxing action. It is occasionally put into earthenware recipes, where its fluxing power is reduced but it can provide some bleaching of the iron content of ball clays.

FELDSPATHIC MATERIALS

Potash and soda feldspar, nepheline syenite and cornish stone are examples of feldspathic materials. These are generally used to contribute to fine, dense bodies such as industrial white earthenwares and bone china, and also to porcelains. Additions of 5 to 15 per cent are made in earthenware and stoneware clays. Up to a maximum of 30 per cent in porcelain and bone china is usual, as in large quantities they would reduce plasticity and could make the body vulnerable to thermal shock.

TALC

In white earthenware bodies with typically large amounts of free silica (flint or quartz), talc can encourage the formation of cristobalite from the silica, thereby improving the resistance in these bodies to crazing of the glaze. In stoneware bodies with less free silica, the magnesium that talc contains encourages a less fluid melt of the silica. This improves the thermal shock resistance of the fired body in everyday use, making it an important ingredient in oven to table stoneware bodies. It is used in quantities of up to 20 per cent.

Fillers

QUARTZ AND FLINT

These are similar forms of silica, which contribute whiteness and hardness and tend to make the body more refractory. They are often considered to be interchangeable, although flint is more suitable for earthenware and quartz for stoneware. Silica, especially when converted to cristobalite, increases the thermal expansion and contraction of the body, a factor in reducing the tendency of the glaze coating to craze. This is of great importance in porous earthenware bodies where crazing is a severe drawback. A body high in expansion due to the presence of silica will contract more on cooling, and therefore compress the glaze and deter crazing. It is used in quantities of up to 50 per cent.

CRISTOBALITE

Cristobalite can be added as a raw ingredient for the same reasons outlined above. This rarely occurs, however, because it is manufactured by calcining flint or quartz sand, which makes it a comparatively expensive ingredient which may form in the clay body anyway.

Close up of work by Martin Smith, 'Seen and Unseen', made from red clay with platinum leaf. Smith uses a grog made from the same clay as the pieces. This gives all the benefits of low shrinkage and unfired strength, but then becomes homogeneous with the body when fired.

Openers

GROG

Grog is simply ground-up fired clay. It can be fine or coarse and is usually made of refractory clays. Fireclay grog is known as chamotte, china clay grog as molochite. Grog made of less refractory material will act more as a filler in higher temperature firings, but will have the same beneficial effects on the making strength and on easing drying and shrinkage difficulties. Up to 40 per cent additions are common.

SAND

Sand is simply naturally ground quartz, although some sands will contain impurities like calcium and iron. Its coarseness makes it useful as a grog, although it does not aid drying as much as a more porous grog. It acts as a filler at higher temperatures. It is used in similar quantities to grog.

Types of Clay Bodies

There are many different categories and types of clay bodies designed for a diversity of applications and making processes. Most people will have heard of the terms earthenware and stoneware, porcelain and bone china, and will have some idea of the kind of ware those terms would indicate, but of course in studio ceramics and industry there is a large diversity of clays designed to give all kinds of texture, performance and application. Among these might be bodies for raku, handbuilding and sculpture, modelling, sanitary ware, tile bodies, Egyptian Paste, and so on.

Earthenware

These are bodies that *mature* below 1200°C, that is the clay, flux and filler have fully interacted and the body would begin to soften if fired any higher. This category encompasses a wide range, including common red clays at one extreme to commercially produced earthenware bodies at the other. A typical recipe for an industrial-type

white earthenware for firing between 1150°C and 1200°C is given below.

Industrial-type White Earthenware		
CLAY	FLUX	FILLER
China clay – 25%	Feldspar – 15%	Flint – 35%
Ball clay – 25%		

The china clay would contribute its qualities of whiteness and refractoriness, while the ball clay would give plasticity. The flux might also be a cornish stone or even perhaps nepheline syenite, and the filler could be either flint or quartz. It should be noted that bodies such as the above can be more suited to casting and pressing rather than hand or wheel techniques, not only because of their low ball clay content, but also because of the high content of non-clay material.

The clay content could be varied with the part substitution or addition of a common red clay (a naturally occurring 'ready made' earthenware body), or fireclay, although these would change the colour to brown or buff.

Stoneware

Stoneware bodies are a large category of clays characterized by an ability to stand temperatures of between 1200°C and 1300°C, sometimes even higher. It is possible for some high quality red clays to survive 1200°C without distortion, and these are termed red stonewares. Stoneware clays are commonly used in studio ceramics in a wide variety of processes.

A stoneware clay is one that is usually required to vitrify slowly up to around 1250°C, without distortion, and with a porosity of about 5 per cent. Good plasticity for throwing and other hand-building techniques is usually required, and stoneware clays are therefore often ball-clay based, with other clays such as china clay and fireclay added because of their colour and refractoriness.

Depending upon the quantity of refractory clay in the body, flux in the form of a feldspar might also be included to reduce the porosity of the fired product or, alternatively, talc can be used as a flux, which has the added advantage of increasing resistance to thermal shock.

Elers ware teapot, Staffs. Engine-turned decoration, 1770. The Potteries Museum, Stoke-on-Trent.

Fillers, in the form of flint or quartz, are used in smaller quantities in stoneware clay than in earthenware. Their role in increasing the expansion of the body and decreasing the tendency of the glaze to craze is less important at stoneware temperatures when the body is less porous.

The following are 'typical' example stoneware body recipes. Minor variations will occur depending on the type and quality of actual clays used.

WHITE STONEWARE

Ball clay	65
China clay	20
Quartz	15

Produces a pleasant off-white body in oxidation, pale grey in reduction, with good plasticity for throwing.

BROWN STONEWARE

Ball clay	60
China clay	20
Red clay	10
Quartz	10

This is a medium brown stoneware body with good throwing properties

FIRECLAY BODY FOR STONEWARE

Fireclay	60
China clay	20
Ball clay	20

This is a good hand-building body, creamy white in oxidation.

'Openers', or grogs, could be added to the above recipes to reduce shrinkage and give increased unfired strength, in quantities between 10 per cent and 40 per cent.

HAND-BUILDING BODY FOR STONEWARE

Ball clay	40
China clay	15
Feldspar	6
Quartz	6
Molochite	33 (30–80's mesh size)

This is a strong clay with good warp resistance.

Porcelain

Porcelain is in one sense really only a particular type of stoneware clay, but we have come to understand the name to signify a vitreous, off-white translucent body which is fired above 1250°C. Makers of domestic ware often fire porcelain in a reduction atmosphere to assist in the integration of body and glaze, and to ensure that any iron impurities are also reduced and to impart a blue-grey colour rather than a 'dirty' cream (*see* Chapter 11) which might result from an oxidation atmosphere.

Good quality china clay is essential for porcelain, but even so we have very few china clays of sufficient plasticity available to avoid the need for the addition of either ball clay, which tends to spoil the colour and translucency, or, more commonly, bentonite. Most porcelains are based around a recipe of about fifty parts china clay, thirty parts potash feldspar and twenty parts quartz. In practice, up to around 15 per cent ball clay, or 5 per cent bentonite, can be added to improve plasticity.

Here is the universally well known and used David Leach porcelain body:

China clay (English China Clay's Grolleg)	53
Potash feldspar	25
Quartz	17
Bentonite	5

Bone China

Bone china was developed in England by Josiah Spode around the turn of the eighteenth century, as an attempt to emulate the fine porcelains imported into the country from the Far East. The main ingredient of a bone china body is bone ash, usually from cattle, and forms 40 to 50 per cent of the recipe. The clay content is as low as 25 per cent, with a feldspathic material such as cornish stone making up the remaining 25 to 30 per cent. The secret of bone china is the unique manner in which the calcium and phosphate it contains fuse together gradually through firing up to 1260°C, giving a body of exceptional strength, whiteness and translucency. Technically, it surpasses the porcelains it sought to emulate, although some feel that it has a 'deadness' in comparison to porcelain.

Porcelain teapot by Edmund de Waal. The whiteness of the body enhances the quality of the reduction-fired celadon glaze.

Porcelain tableware by Joanna Constantinidis (below). (Photograph by Simon Birkett.)

The exceptionally low clay content of bone china bodies makes them very difficult to work by hand and very fragile when dry. For this reason, they are most suited to slip casting, although bentonite can be added to give some semblance of plasticity.

BONE CHINA BODY

China clay	25
Cornish stone	30
Bone ash	45

To convert this body to a slip-casting recipe, add 1,000g (2.2lb) of the dry ingredients, plus 3.3.g (0.17oz) of sodium silicate to 450cc (27cu.in) of water (*see* Slip Casting Bodies, page 33).

Raku Bodies

These are almost at the opposite end of the clay spectrum to porcelains and bone china. Raku is the name for the process we now know as fast firing, usually to about 1,000°C, then transferring the red-hot pots to a pit in the ground, or, more prosaically, a dustbin, containing a combustible material such as sawdust in which they are buried. After ten minutes or so they are removed. These events leave the exposed clay surface blackened from the trapped carbon as the pots burn the sawdust into themselves.

The essential property of a body to be fired in the raku process therefore is the ability to stand the resulting sudden extremes of temperature, or 'thermal shock'. In that sense, almost any body

*D*avid Robert's 'Large Black Vessel', raku-fired with carefully controlled post-firing reduction using fine sawdust.

could be converted to this use by the addition of up to 50 per cent opener or grog, but it must be noted that the biscuit temperature of a raku body should be low, about 1000°C or less, as few high-fired bodies can withstand the sudden extremes of temperature involved in the process. Another key point is the size of the ware to be fired – the larger the pieces, the more suitable and shock-resistant the clay has to be. Fireclay-based bodies are probably the best for raku, and the following recipes are good starting points.

RAKU RECIPE 1

Fireclay	40
Ball clay	40
Grog	20

RAKU RECIPE 2*

Fireclay	45
China clay	15
Ball clay	15
Grog	25

Note: This recipe is simply a conversion of the above stoneware fireclay body with an added thirty parts of grog, recalculated to a percentage recipe (*see* Useful Formulae in *Appendix*, page 176).

Paper Clay

This is a process that has become very popular in recent times. Potters have experimented with additions of materials to clays over the years for various reasons, from straw or coal to make them 'self-firing', to sawdust, wood shavings and even pasta for both decorative texture and for practical reasons such as enabling drying and reducing the fired weight of the pieces.

Paper clay has been mainly developed by ceramic sculptors as a hand-building material. It has many advantages in this respect in that it can be formed into large flat sheets that have excellent handling strength, warp resistance, and can be joined easily with much less danger of cracking than conventional clay bodies. Paper clay also avoids some of the other drawbacks of clay – its very low drying shrinkage allows thick and thin pieces to be joined easily at any stage, and damp or wet paper clay can be added or joined to dry without cracking. It can also be formed into plaster moulds, and other hand-building

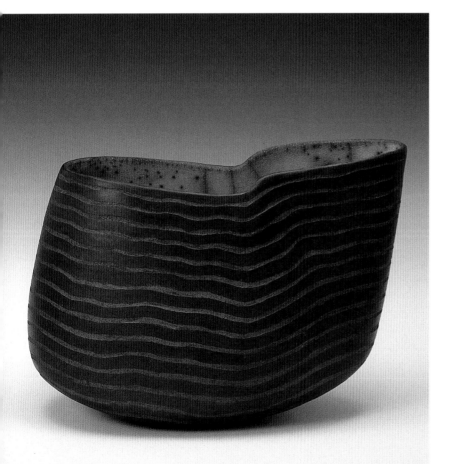

techniques can be used with it as well although its fibrous texture makes it very difficult to work in some traditional techniques like the potter's wheel. It does have a distinct 'lumpy' texture, although this is minimized when formed against a flat surface or sandwiched between two plaster batts or other absorbent smooth surfaces.

The technique of making paper clay is very simple and will work with most clay bodies. The paper pulp can be made from common cheap papers such as newsprint, tissue and photocopying paper. Shiny papers and cardboard are not recommended because they do not break down very easily due to the additives they contain. The best results are obtained from good quality papers made with natural fibres, such as heavy water colour and other artists' papers. These are necessary when making a clay/pulp mix for larger scale work or when difficult pieces are attempted, as their longer fibres give much more strength and better handling qualities.

To make the pulp, access to an office paper shredder is useful, but otherwise the paper can be torn to shreds and placed in hot water. A mixing device of some sort will take the effort out of stirring it into a pulp. A dough mixer is most suitable, but a mixing paddle attachment for an electric drill will also work quite well. The pulp should be mixed to a thick porridge-like consistency, after which it can be pressed into a large sieve to squeeze out the water and to take on a mashed potato appearance and texture. This is then combined with a clay slip at about 20 to 30 per cent pulp to clay, to a maximum of 50 per cent by volume until the mix again begins to look uncannily like porridge. It is then ready to be poured out on the plaster slabs to dry out to leather-hard consistency when it can then be cut, joined and formed. It works very well with casting slips where the deflocculant contributes to the drying and handling strength properties of the paper clay.

Slip Casting

Slip Casting Bodies

Slip casting developed as a means of forming from clay bodies – bone china is a good example, in that it is not sufficiently plastic to be worked easily by traditional methods. The single most important benefit of casting into plaster moulds is that many identical casts can be made from a single mould.

It is important to remember that clay casting slips are poured into plaster moulds, and need to flow freely enough to take up any detail. A

Untitled – bone china/paper pulp body by Angela Vedon.

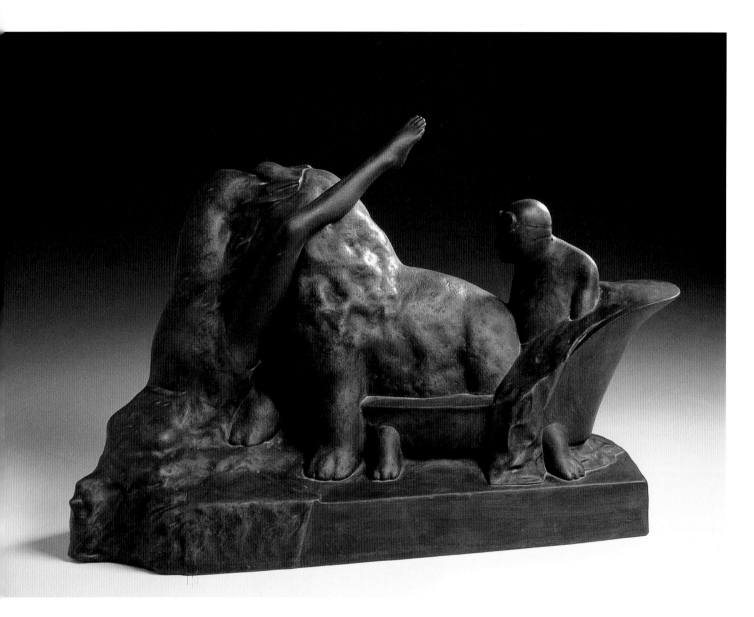

*S*lip cast figure group in the Staffordshire flatback tradition by Neal Malkin. The modelling is softened in low relief to allow easier casting. (Photograph by Dick Brown.)

clay diluted with sufficient water to allow it to flow so freely would have a very high shrinkage rate, and would also have very low dry strength. A further complication is that plaster is slowly destroyed by the water it absorbs in the casting process, so ways have to be found to reduce the water content of the slip without losing the fluidity. This is achieved by the use of materials known as deflocculants, and those that are more frequently used in ceramics are sodium carbonate (soda ash) and sodium silicate. Commercially produced mixtures of these deflocculants are available which help to simplify the process of creating a casting slip. They go under various commercial names, for example sodium dispex, supplied by Potclays.

These materials have an electrolytic action, which increases the electrostatic charge of the clay particles, causing them to hold each other apart in the same way that the like poles of magnets do. This reduces friction and drag within the slip, giving greater fluidity with less water. It is quite surprising to see how great a difference a small amount of deflocculant makes to the flow properties of a slip, although with sodium carbonate there is an optimum point before further additions begin to reduce fluidity again.

Another important task of a casting slip is to retain the shape it is cast into while still damp in the mould, a property known as thixotropy. This is generally defined as the ability of a liquid to become more viscous when left undisturbed, and while it is a property shared to some extent by most clays and glazes, it is crucial in a casting slip. It is an easy mistake to add

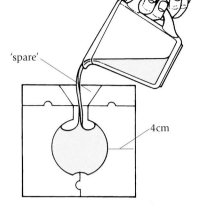

'spare'

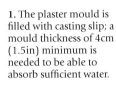

1. The plaster mould is filled with casting slip; a mould thickness of 4cm (1.5in) minimum is needed to be able to absorb sufficient water.

4cm

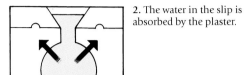

2. The water in the slip is absorbed by the plaster.

Slip casting from a plaster mould.

3. After about 20 minutes (depending on the required cast thickness) a lining of solid clay is formed on the inside of the mould.

4. The mould is drained slowly and carefully to avoid trapping air.

5. The cast is left in the mould for a further short period of time to dry out the inside surface of the cast before cutting away the spare and dismantling the mould.

6. The finished cast.

Close-up of deterioration in a plaster mould after many casts.

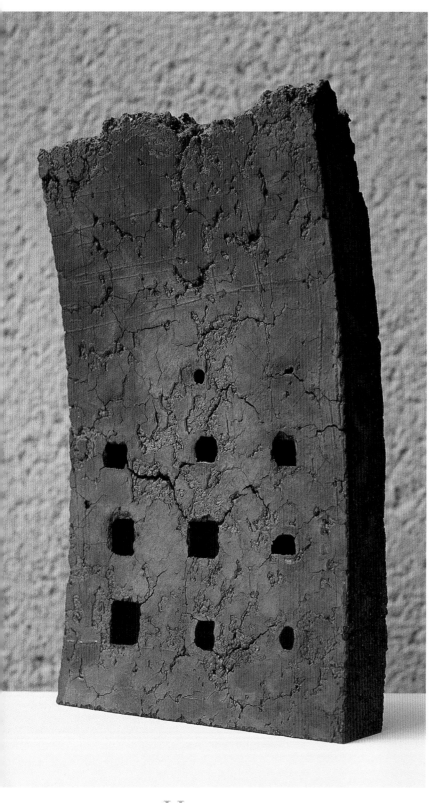

*U*ntitled sculpture by Jim Gladwin. This piece is made from conventional clay that has been deflocculated to allow it to be formed in a semi-liquid state.

water to an apparently excessively thick glaze mix, only to discover on stirring that it has become over diluted, but it is a much harder task to correct a casting slip if the same mistake is made.

The two deflocculants used in casting slips are different in their action and effect on thixotropy, in that sodium carbonate has little effect on this property, while sodium silicate reduces thixotropy. In practice, a balance of sodium carbonate and silicate is used in most slips. To make matters even more complicated, sodium silicate is a gel-like substance which is supplied in differing strengths of specific gravity measured on the Twaddle scale, and is commonly supplied at 75, 100 and 140°TW.

Most clays can be converted to casting bodies, although those with a high content of very fine particled clay (such as red clays and ball clays) can be difficult. The fine particles pack so closely together on contact with the mould that the water is trapped behind this surface layer, preventing the plaster of Paris from absorbing any more (*see* opposite). In these cases, a filler can be added, such as fine quartz, which will create 'gaps' between the clay particles and allow the water through.

Plaster of Paris

Plaster of Paris is partially calcined calcium sulphate. It is made in various grades for different purposes; that most suitable for clay casting is sold as potter's plaster. When added to water and mixed it begins to set in five to ten minutes, depending upon the strength of the mix. The setting time can be reduced by adding a very small amount of powdered plaster (1 per cent) that has previously set, but this is usually avoided in normal pottery moulding.

When making moulds for clay casting it is important that the plaster is mixed at a uniform density, so that casting times will be consistent, and that absorbency will be even in moulds made in multiple pieces. Soft soap is used to coat mould parts or plaster models to prevent them sticking to each other and to allow easier separation. The density recommended for slip casting moulds is 1 litre (1.76 pints) of water to 1,300g (2.86lb) of plaster. Plaster does not keep indefinitely, and if stored in damp conditions it will absorb moisture and will have a much reduced setting time.

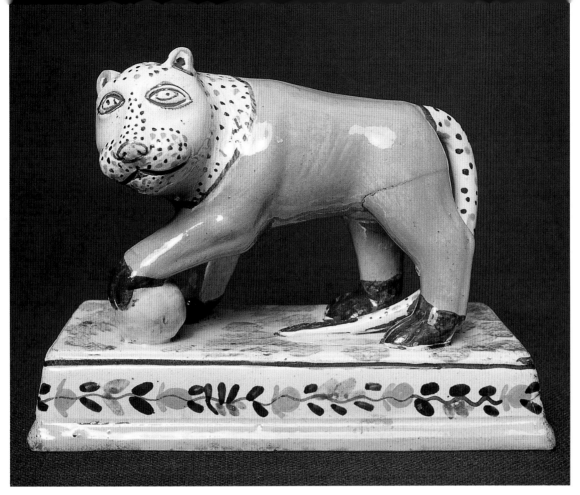

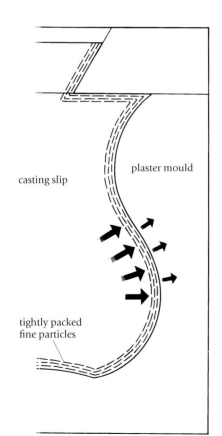

casting slip

plaster mould

tightly packed
fine particles

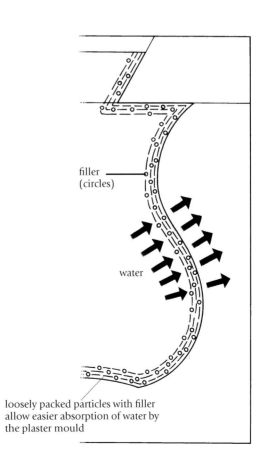

filler
(circles)

water

loosely packed particles with filler
allow easier absorption of water by
the plaster mould

*F*ine-particled clays
can make casting
difficult by close
packing against the
sides of the mould,
restricting absorption by
the plaster. The
addition of some fine
filler may help this
process.

Plaster moulds deteriorate after several castings, but their lifespan may vary depending on the amount of detail in the mould and the amount of deflocculant in the clay.

CASTING SLIP RECIPES

Any powdered clay*	10kg (22lb)
Sodium silicate (140°TW)	12g (0.42oz)
Soda ash	12g (0.42oz)
Water	2,850cc (173.85cu.in)

Plastic white earthenware*	10kg (22lb)
Sodium silicate (140° TW)	10.6g (0.374oz)
Soda ash	6.3g (0.222oz)
Water	800cc (48.8cu.in)

Plastic red clay*	10kg (22lb)
Sodium silicate (75°TW)	17.5g (0.618oz)
Soda ash	17.5g (0.618oz)
Water	1,100cc (67.1cu.in)

* Note: Good suppliers will provide specific casting recipes for their clay bodies (*see* Appendix).

Fine adjustments may need to be made to any casting slip in everyday use and careful mixing is also essential. Firstly, a small amount of the water should be deducted from the recipe amount for the purpose of dissolving the deflocculants separately. If these are added to the slip in their raw state they do not disperse properly, and they are more easily assimilated into the slip after dissolving in boiled water. The method is to add the clay to the water, preferably in a purpose-built slip blunger, and add the deflocculant as the mixing progresses. When working on a clay without a recipe, some of the water and some of the deflocculant may be kept back for addition later if adjustments are necessary. The slip then needs blunging for some time, one or two hours at least, and this is hard work if done manually. When fully blended the pint weight of the slip should be measured and noted. A normal clay and water slip will weigh around 28oz (793.8g), a deflocculated slip will be significantly heavier at around 35oz per pint (992.3g per 0.55litre).

Casting slips do not keep indefinitely so it is better to mix only sufficient for immediate purposes. It is a good idea to pour the slip into the mould through a sieve as this helps to prevent air bubbles and subsequent pinholing at the surface of the cast. Moulds should be clean and dry, and it is very important not to contaminate the casting slip with plaster from the moulds as it is a flocculant and will therefore thicken the slip.

Blending of Clay Bodies

In experimenting with recipes for clays, it is important first of all to have a clear idea of the character and purpose for which the clay will be used. A simple method of combining two materials, i.e., two clay bodies, is to line blend them. This is a common method of combining and works well with glaze materials also:

MATERIAL A (%)	MATERIAL B (%)
100	0
90	10
80	20
70	30
60	40
50	50
40	60
30	70
20	80
10	90
0	100

Of course, if the materials are already known, then the 100 per cent quantities of each separate material need not be tested again, and if only a 'broad brush' approach is necessary then the blend can be in jumps of 20 per cent rather than 10, or perhaps only a few blends may be investigated, say 80/20–70/30–60/40, if a clay was being blended with an addition of grog, for example. The important point is that a systematic approach is required, and the tests can always become more detailed as the desired result gets closer.

A more complex method is the use of triaxial blends, in which three ingredients can be methodically investigated. This is a system in which an equilateral triangle, that is one with each side the same length and all angles of 60°, is used as a diagrammatic form in which each point of the triangle represents 100 per cent of any given material. In the example (*see* below) point A = clay, B = feldspar and C =

quartz. Each horizontal line parallel to the baseline opposite each one of these points represents a descending parallel quantity, 90, 80, 70 per cent etc., of that particular material along its whole length. This is more clearly seen for each of the ingredients if the triangle is rotated so that whichever ingredient is in question is at the apex. The intersections of these lines give varying mixtures which always add up to 100 per cent. In the example, point 18 represents 50 per cent clay, 30 per cent feldspar and 20 per cent quartz; point 13 would be 60 per cent clay, 20 per cent feldspar and 20 per cent quartz.

The example given is in fact a blend of suitable ingredients for a porcelain type clay, and with some basic knowledge it should thankfully not be necessary to make up all the sixty-six possible blends in this example! Instead, a group of likely adjacent points can be made up and tested. Those chosen in this diagram are possible porcelain recipes.

A triaxial blend like this can be made more sophisticated by allowing one letter to symbolize two materials, for instance material a, which here represents clay, could itself be made up of 70 per cent china clay and 30 per cent ball clay. This would make the final body recipe more inherently plastic, and more of a white stoneware than a translucent porcelain.

A promising triaxial blend can also be further developed by line blending with a fourth material, perhaps with another flux material, such as talc, or an opener. In these ways, specific recipes can be developed in logical sequence.

For a more detailed description of triaxial and other blending methods, *see* Chapter 13.

The key to success in this area of ceramics is well kept notes, methodical and careful testing, and clearly labelled test pieces. The pleasure and satisfaction in such work comes from achieving familiarization with the materials and understanding what their individual characteristics contribute to the final results.

A = 100% clay
B = 100% feldspar
C = 100% quartz

Point 13 = 60% clay, 20% feldspar, 20% quartz
Point 18 = 50% clay, 30% feldspar, 20% quartz

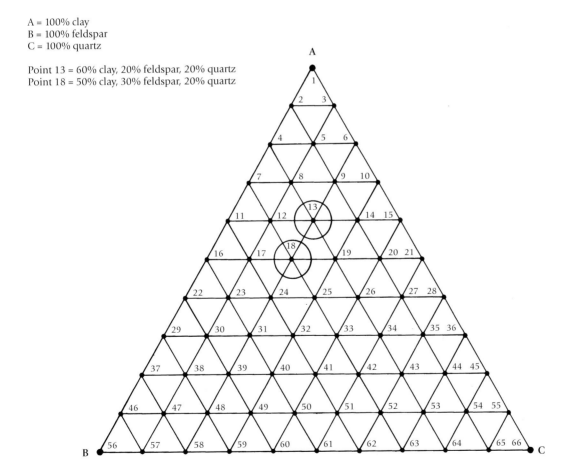

Triaxial blend of materials for a porcelain body.

\diamond Preparation & Mixing of Clay

The plasticity of clay is crucial to its working properties. It is essential for any given clay that its plasticity is maximized, and this is particularly true in studio ceramics where workability is usually of prime concern. In throwing it is essential.

A natural, unrefined clay, providing it was not too dry when it was dug, will possess maximum plasticity. This is because it will have settled and compacted, and the water will have had plenty of time to have penetrated completely the particle structure, giving maximum slide. However, a naturally dug clay is unlikely to be of an even consistency and will certainly contain some natural debris such as rocks and pebbles and, even more detrimental, limestone and soluble alkali. These last two are the most problematic, as limestone remains in the fired body in a highly porous state, rehydrating as it expands and often breaking away a portion of the surrounding surface. This problem is known as 'lime spit-out'. The presence of soluble alkali, potassium and sodium creates the effect known as 'scumming'. A 1 per cent addition of barium carbonate, a commonly used glaze ingredient, can neutralize the alkali, but clays with a strong tendency to this condition are best avoided.

Mixing a Clay Batch by Hand

When preparing an unrefined clay, larger impurities are more efficiently removed by allowing the clay to dry as much as possible, before slaking down in water. With raw clay ingredients from a supplier, this is not necessary as the materials are supplied in dry form, although there is usually a deliberate small moisture content to minimize dust. Slaking of dry materials is more easily achieved by adding the powder to water in a container. This prevents lumps forming, which is particularly useful if no heavy duty mixing device such as a dough mixer or high speed blunger is available (*see* below). The clay will settle at the bottom of the container and should be left as long as possible – twenty-four hours at the least. Some of the water can then be poured or siphoned off and the remaining water and clay mixed together to make a free-running liquid slip. This can then be sieved through a 30–60's mesh to remove lumps and large impurities and can if necessary be passed over a powerful magnet to remove any stray iron present. A further period of settlement before drawing off the excess water can be followed by pouring on to an absorbent surface. Plaster, wood, concrete or heavy canvas are all suitable, although particularly with plaster, care must be taken not to allow fragments to become mixed with the clay as this causes the same problems as limestone contamination, as they are both forms of calcium.

Once the clay has dried out sufficiently to become firm and not sticky, it should be wedged and kneaded thoroughly before being stored for as long as possible to allow once more the gradual penetration of the clay particles by the water of plasticity.

Wedging

This is a commonly used method of preparing clay for use. Its purpose is to ensure that the clay is homogeneous, that is of even

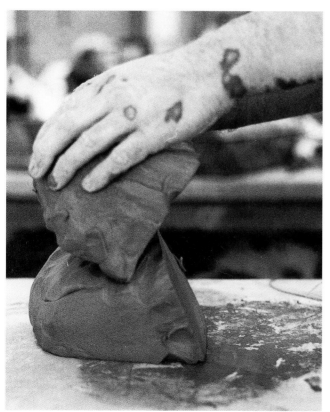
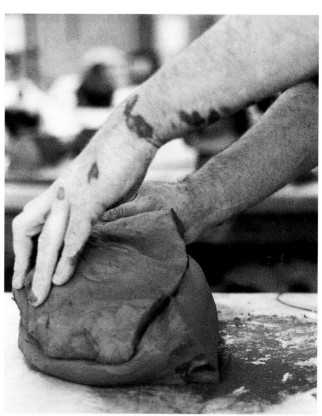

Cut wedging – sequence showing the full process, and a close-up of a 'wedge' of clay driven into the other half.

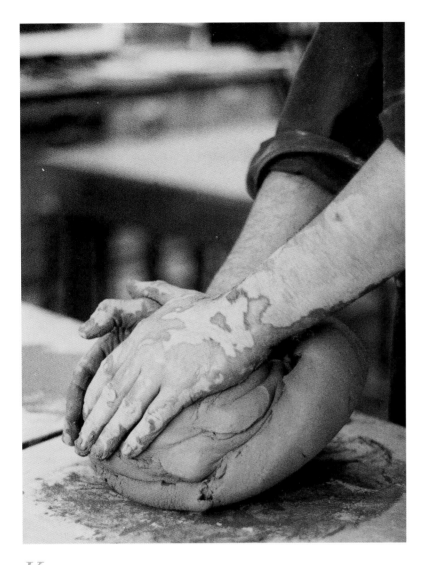

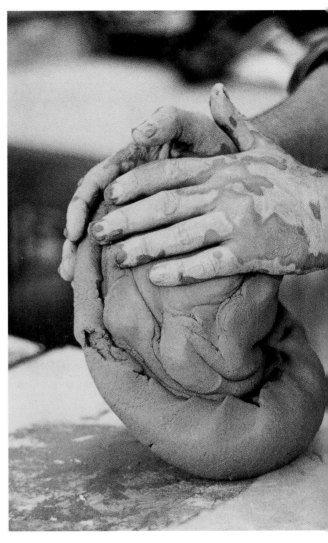

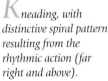
Kneading, with distinctive spiral pattern resulting from the rhythmic action (far right and above).

consistency and moisture content, and free of pockets of air. A clay that is naturally low in plasticity can have that property maximized by careful preparation.

In wedging, a large oval 'loaf' of clay, as big as can comfortably be handled, is cut in two with a wire, then one half is brought down forcefully on top of the other in the manner shown. The derivation of the term 'wedging' can be seen in the side view, as the half of the clay in the hands takes on the appearance of a wedge in profile. The whole piece is then turned over, given a quarter turn, and the process is repeated until the desired consistency and condition are achieved. Done in this manner, with the bottom of one cut half brought down on the top of the other, with both cut surfaces facing, and the quarter turn ensuring that each cut is at right angles to the one before, maximum efficiency will be brought to what is a particularly tedious task.

Kneading

This is sometimes called spiral wedging and is almost impossible to describe, although it is a similar process to the kneading of dough. The aim when kneading clay is to expel as much of the air as possible. The clay is held in one hand and subjected to a rhythmic pressure by the other hand as the clay is rocked back and forth, being turned very slightly before each forward motion. This is a surprisingly efficient method provided that the clay is not too hard, and is far quicker and more efficient than wedging. Kneading is also sometimes called 'bull's head kneading' in that the equal use of both hands when leaning on to the clay creates a shape similar, if you are imaginative, to a bull's head.

What wedging and kneading have in common is the expulsion of air and the achievement of a consistent texture. The exertion of pressure is of

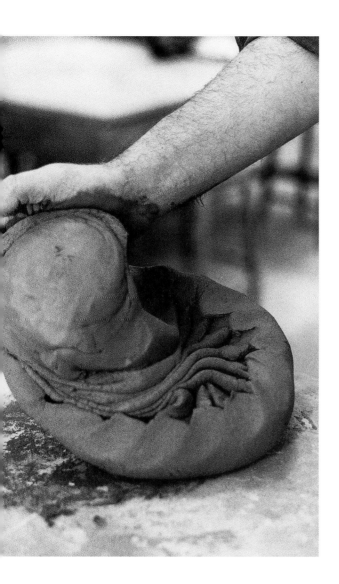

of the clay is effected. Dough-mixed clay is consequently relatively low in plasticity and should ideally be pug-milled (*see* below) before wedging, kneading and storage.

Blunging and Filter Press

This method is mainly used by the pottery industry for large batch quantities where precise control of consistency and plasticity is required. The raw materials are added to water in the blunger, and mixed by the slow rotation paddle into a smooth, free-flowing slip. The paddle is at the bottom of the tank to prevent the surface from becoming aerated, and the rotating action also creates constant collision of the clay parti-

prime importance in aligning the clay particles and thus improving plasticity.

Mechanical Methods

Dough mixing involves the use of a slow rotating blade which moves around the inside of a large bowl. Many potteries use actual dough mixers from the baking industry, as these are as suited to clay working as they are to dough. They provide a fast, immediate method of mixing clay because they avoid the need to turn the clay into a liquid slurry first. The motors are powerful enough to mix plastic or dry clay powder together with the water surprisingly quickly, but their drawback is that air is allowed into the mixture rather than excluded, and no compression

*D**ough mixer with a rotating paddle.*

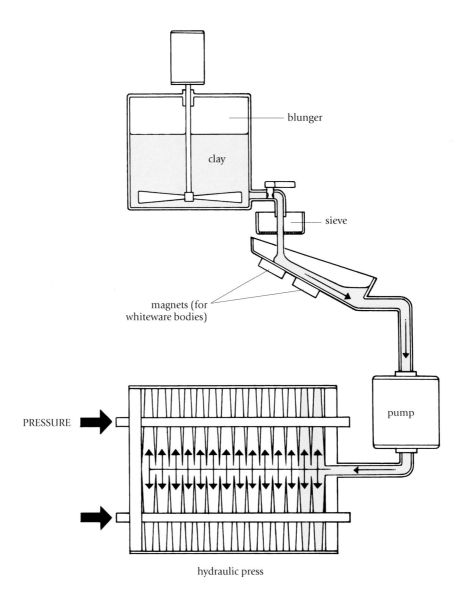

blunger

clay

sieve

magnets (for whiteware bodies)

PRESSURE

pump

hydraulic press

cles in the water, breaking them down in size and coarseness. After blunging, the clay is passed through appropriate sieves and over magnets to remove debris and iron, and then pumped into fabric 'pockets' within a hydraulic press, which is then squeezed to remove the excess water, while at the same time compressing the clay body.

Clay prepared in this way is usually also pug-milled and is probably the most thorough method available. It is less suitable for clay bodies with a very fine particle size as these can clog the fabric in the press and prevent efficient separation of the water.

Pug-milling

Pug-mills in ceramics studios and workshops are largely used to reclaim scrap clay left over from the various forming processes. The clay is pressed into the mill, where it is thoroughly mixed by the revolving blades and becomes more homogeneous. At the same time, the clay is compressed as it exits the machine by means of the tapered aperture. De-airing pug-mills have a vacuum pump fitted to remove the air, thus giving another stage of compression (*see* above). Pug-mills improve the plasticity of the clay to an extent, although only mills with a de-airing

pump give out clay which is usable without the need for further wedging and kneading.

In summary, it is quite possible to make up clay bodies by hand in a studio environment if the amounts used are not on a production scale; otherwise, appropriate machine assistance is necessary. The type of machine needed depends upon the clay and the production methods used. For general studio ceramics, especially throwing, and if money and space are no object, blunging, filter pressing and finally a de-airing pug-mill are ideal, and the de-airing mill could also be used to reclaim the scrap plastic clay. This kind of set-up is very expensive, but provides long-term economies in that it is generally cheaper to buy clay (and any ceramic materials) in powder form than ready-mixed.

A more modest production set-up might use a dough mixer and pug-mill, although this would involve finishing the clay by hand-wedging or kneading. Whatever methods are used, it is worth remembering that any plastic clay will benefit from damp storage.

When making is by slip casting, a blunger is essential. These are available in sizes suitable for small-scale production, and although slip can be bought ready prepared, it is comparatively expensive and still needs thorough stirring before use.

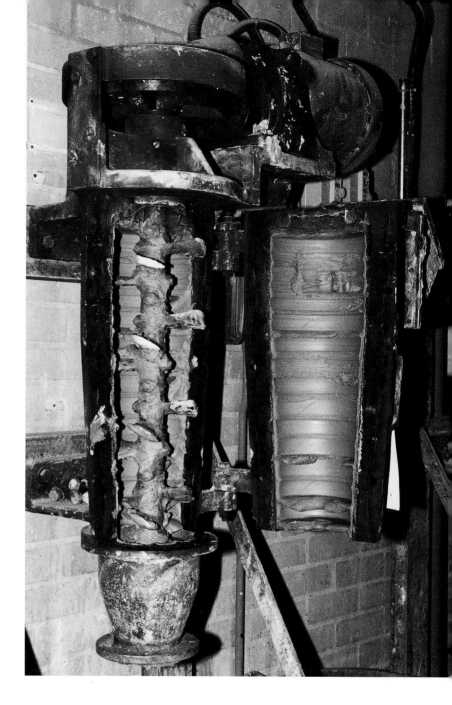

*T*he interior of a vertical pug-mill; the clay is compressed as it exits the tapered nozzle of the machine (above).

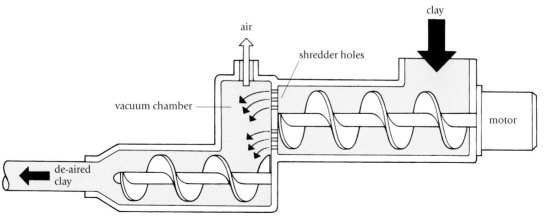

*D*e-airing pug-mill showing vacuum chamber.

Slips & Engobes

A slip is simply a clay that is mixed with sufficient water so that it becomes fluid. It is then usually sieved to render it smooth and homogeneous. Slips are often used as decorative coatings to disguise or improve an unsatisfactory clay. A small amount of oxide or stain can be used to achieve a colour in a thin coating of slip where it would be impractical or too expensive to colour the whole body. Sometimes a fine white slip can be used under a glaze to enhance any colour and translucency which would be lost when applied directly to a coarse stoneware. Engobes, in particular, are perhaps more commonly used as coatings for non-functional ceramics, in that they can provide a practical, dirt-resistant surface that appears more integral to the object than glazes sometimes can, and with the advantage that they can be easily and successfully applied with a brush.

An engobe is in some ways to a slip what a prepared or manufactured clay body is to a natural 'dug' clay, that is, it has been modified to achieve certain desired fired characteristics. The terms slip and engobe are in practice often interchangeable and used loosely, but I would define an engobe as a clay slip that has been modified by the addition of non-clay materials. In a sense, it is halfway between a slip and a glaze.

It is important when using slips and engobes that they are 'matched' to the state of the clay they are applied to, that is, plastic, leather hard, dry or bisque. This is relatively simple to achieve in that as a general rule the amount of plastic clay content in the engobe may be decreased when intended for application to dry or biscuit-fired ware, because of the comparative shrinkage of the engobe to the body. An engobe with non-clay ingredients will shrink less than the plastic body to which it is applied, and may consequently 'flake' or 'shell' off. Another reason for the engobe failing to adhere to the body can be when it is low in clay and high in refractory material, which causes its maturing or vitrification point to be higher than that of the body. When this is the case, the engobe undergoes less shrinkage than the body in the firing process, and also does not fuse to the body sufficiently. As a result, engobes are often composed to vitrify at a slightly lower temperature than the clay to which they are applied, thus ensuring good fusion of engobe to body.

Slip and Engobe Composition

The simplest slips can be made up from the clay body itself, or a pure secondary clay such as ball clay or red clay, blunged with water and sieved. An 80's mesh is usual, but a finer or coarser mesh can be used to suit the desired characteristics. Slips such as these should preferably be applied at the damp to leather-hard stage to maintain compatibility of shrinkage; normal amounts of colouring oxide or stain should not affect this unduly.

The non-clay ingredients that are added to slips and engobes are generally the same as those added to clay bodies, with the exception of grogs of course, although even these can be included to produce texture in the surface. Fluxes and fillers fulfil the same roles and purpose of promoting fusion, whiteness and density.

The table on page 48 gives recipes for basic white engobes that are mature and semi-

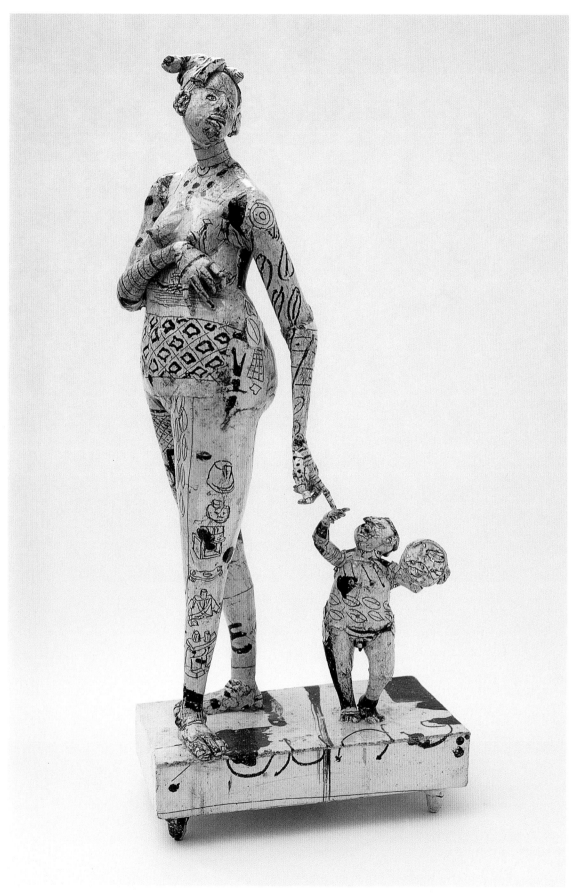

'Venus et Amour' by Phil Eglin. Eglin paints the figures loosely with oxides and slips, and also uses a monprinting technique where slip is painted onto tissue paper and transferred to the sculpture by drawing on the back of the paper.

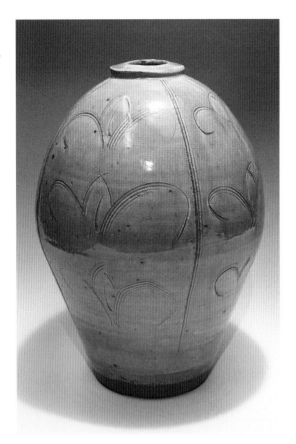

*T*all bottle by Phil Rogers. A white engobe beneath the beech ash glaze enhances the clarity and subtlety of the glaze.

Vitreous White Engobe Recipes

FOR APPLICATION TO LEATHER-HARD WARE

	1060°C	1150°C	1250°C
China clay	30	50	30
Ball clay	40	20	30
Standard borax frit	30	30	–
Potash feldspar	–	–	20
Flint	–	–	10
Zirconium silicate	–	–	10

FOR APPLICATION TO DRY OR LOW BISCUIT-FIRED WARE

	1060°C	1150°C	1250°C
China clay	30	25	25
Calcined china clay	10	25	25
Ball clay	10	–	–
Standard borax frit	30	20	–
Nepheline syenite	–	10	–
Potash feldspar	–	–	20
Whiting	10	10	–
Flint	–	–	20
Zirconium silicate	10	10	10

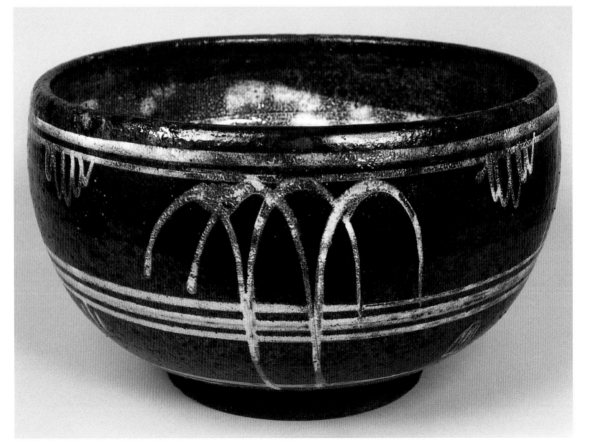

*'F*ountains' bowl' by Michael Cardew. Lead-glazed red earthenware decorated with a white slip. The Potteries Museum, Stoke-on Trent.

vitreous at around the temperatures indicated and for application at the dry or low bisque stage. They are designed as decorating or painting engobes and should be sufficiently vitreous not to require a covering of glaze. The variations in the amounts of ball clay and china clay used are partly the result of balancing the fluxing action and shrinkage that ball clay contributes against the loss of whiteness.

There are many adjustments and variations possible on these recipes. The different frits, feldspars and secondary fluxes, and of course the clays used, will have a large influence on both the colour and the vitreousness of the engobe.

The clay content could be any clay, but for whiteness good quality china clay is best. When calcined clay is used it is usually china clay as this can be bought ready calcined, although it is a simple matter to do so yourself by filling a suitable biscuit bowl with china clay and firing it to 800°C; other clays may also be calcined in this way when required. Calcination removes all the chemically combined water and therefore reduces shrinkage.

Colour in Slips and Engobes

Colour can be added in the form of metal colouring oxides and commercially prepared stains. Colouring oxides (*see* Chapter 11) give a limited range of colour to slips, basically greens, blues and browns, but they can have a wonderful richness and subtlety, as in the piece by Ken Eastman. Prepared stains give a wider variety of colours, although strong true reds are not available. Stains need to be added in larger quantities than colouring oxides because they are generally weaker in strength, and they also tend to give 'flatter' colours. It should be remembered that the colour in a slip or engobe is not always fully developed until it has become sufficiently fluxed, or, alternatively, the colour is brought out by a glaze applied on top of it. The quantities of stain required are between 5 and 15 per cent for full saturation. Because stains are added in larger quantities, the accuracy in weighing is less critical.

'Still Life with 7 Forms' by Ken Eastman, painted with several layers of engobes and colouring oxides.

Stains can be added to a basic white slip or engobe on the basis that 130ml (7.93cu.in) of engobe of a normal creamy consistency will contain about 100g (3.53oz) of dry material, and percentage additions of 5 to 15g (0.177 to 0.53oz) of stain can therefore be added to the liquid slip with sufficient accuracy for general purposes. This method means that when only relatively small amounts of coloured slip are required it is much easier to have one large quantity of white slip and stain up small amounts of it as needed. This allows the creation of a palette of colours without the bulk and potential waste of mixing each colour in large amounts. The slip should always be sieved again after the addition of colour to ensure its even distribution.

When using the strong colouring oxides the amounts are more critical and therefore better weighed and added into the dry mix along with the other ingredients. In the table (right) are some suggested additions of colouring oxides to slips and engobes.

A combination of almost any three different oxides in sufficient quantity will usually produce a black, for example:

Copper carbonate	2%	
Cobalt carbonate	2%	
Red iron oxide	6%	

Additions of Colouring Oxides to Slips and Engobes

COLOURING OXIDE	COLOUR AMOUNT	COLOUR ACHIEVED
Cobalt carbonate	0.5–3%	Pale to dark blue
Copper carbonate	2–4%	Pale to dark green
Manganese dioxide	4–10%	Pale to dark brown/purple
Red iron oxide	2–8%	Pale to dark rich red/brown

or

Cobalt carbonate	2%
Manganese dioxide	4%
Red iron oxide	8%

Many subtle variations of blue/black, brown/black, and so on are possible. A black can also be produced by the addition of a commercial stain, but this can result in a rather 'flat' tone. Oxide blacks give richer and more vitreous results because of their extra fluxing action.

Roman Samian ware, second-century AD. The Potteries Museum, Stoke-on-Trent.

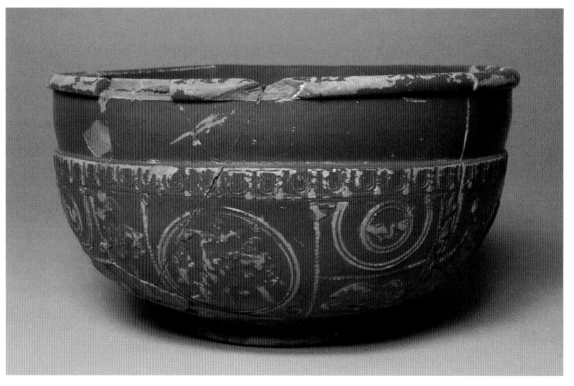

Terra Sigillata

Terra sigillata is really a form of engobe made from the smallest particles of a clay. It was first used by the Greeks and developed by the Romans during the empire, and was used to cover their 'Samian' ware, which was virtually mass-produced and exported throughout the empire. A variation on the technique is illustrated by ancient Etruscan pottery where a red *terra sigillata* was applied over the red clay body. When fired in a reducing atmosphere both body and slip would turn black, but before cooling the kiln would be given plenty of air, thereby reoxidizing the relatively coarse body which would regain its red colour. The *sigillata*, however, would remain black because the very fine particles fuse more readily and therefore resist reoxidation, thus achieving two colours from one. Though typically thought of as a red slip, *terra sigillata* can be made from fine white burning clays.

The technique for making *terra sigillata* is to take a fine clay and mix it with water to form a simple slip. This is left to stand for a period of time to allow the heavier coarse particles to settle towards the bottom. The addition of a small amount of deflocculant helps to keep the particles suspended – commercial water softeners such as 'calgon' are often used for this, or a chemical such as sodium hydroxide. The top layer of smaller and finer particles which are still floating is then siphoned off and the process is repeated until the slip is as fine as possible.

The end result should be a slip made up from only the very finest clay particles that will consequently pack together very tightly on the surface of the ware, giving a dense, smooth surface with a dull sheen. It is applied to the ware at the leather-hard to dry stage and can be burnished with the back of a spoon or a smooth pebble to enhance the smoothness and density. Even so, it is not a fully impervious layer and would allow liquids to seep through, and by modern hygiene standards would not be suitable for everyday food use either.

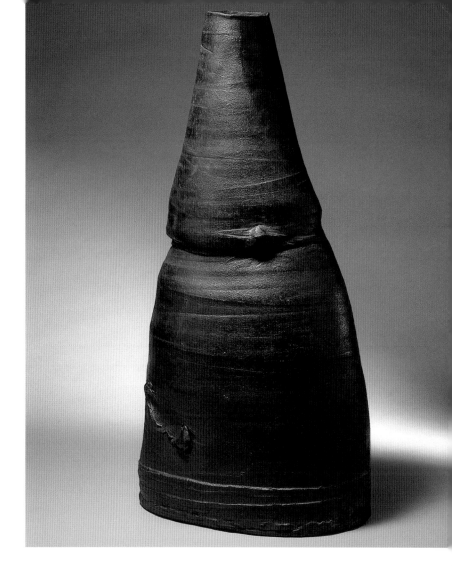

*T*hrown and altered vessel by Dan Kelly. Iron, manganese and cobalt oxides are used to create a rich black colour over the coarse stoneware body. Fired to 1260 °C oxidation (above right).

*C*oiled vessel by Magdalene Odundo, with burnished terra sigillata. *Oxidation fired (right).*

6 Firing Clay Bodies

Ceramic Change

Firing is the process that transforms clay irrevocably into ceramic. A temperature of 600°C is required to effect 'ceramic change', and once this has been done the material is no longer clay and cannot be slaked down in water and made plastic once more. In practice, most clays need to be fired to at least 900°C to have sufficient strength to survive any handling or use. As higher temperatures are reached a clay will shrink, become harder, more dense and less porous, and eventually fuse to such an extent that it becomes like a glaze. This is eventually true for all clay bodies given sufficient heat, although very refractory fireclays may reach as high as 1700°C before beginning to soften, which is well above most practically achievable temperatures for studio ceramics. At the other extreme, a crude red clay may melt as low as 1200°C.

Removal of Water

The first stage of firing is the removal of water, which is usually a continuation of the drying process. Any remaining water of plasticity is volatilized at 100°C, and throughout the early stages it is crucial that time is allowed for the steam generated to escape the ware. This is still the case whilst the pore water is removed between about 100 to 250°C, and, lastly, the chemically combined water which is completely released by 600°C.

It is the removal of the chemically combined water which is inextricably linked to 'ceramic change'. It is the unique manner in which the layers of alumina and silica molecules are linked by those of water that give clay its particular plastic qualities, and it is only when the heat has broken down those molecular links that the clay becomes ceramic.

G raph showing the sudden expansion of the cristobalite and quartz crystal at approximately 220° and 573°C respectively; it occurs on heating and cooling.

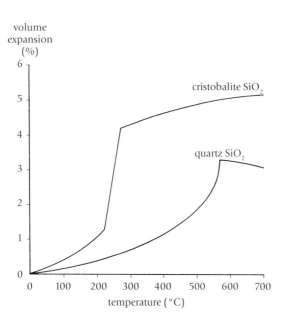

Changes in Crystal Structure

As heat rises, the molecular structures of the materials begin to adjust. Of most significance here are the changes to silica, from its common forms as flint and quartz, to others, in particular cristobalite. Cristobalite is chemically identical to these other forms of silica, and is created more readily from flint than quartz at temperatures over 1150°C.

Where present, cristobalite undergoes a sudden 3 per cent volume increase (*see* diagram left) and decrease in crystal size on going above or below 225°C. This causes severe strain on the ware being

fired and can cause cracking or 'dunting'. This is true for heating and cooling at this temperature each time the ware is fired, and is a major cause of cracking when kilns are opened too early.

Silica in the form of quartz crystals undergoes a similar, though slightly less severe expansion at 573°C. Again, this is a change which occurs on heating and is reversed on cooling at each time of firing, creating a risk of cracking if this temperature point is passed too quickly.

The combination of water removal and silica expansions dictates that first firings of clay bodies should always be cautious up to 600°C, and although the removal of water is a once-only process, the repetition of silica inversions requires the early stages of any firing to be taken slowly. By 600°C the process of 'ceramic change' can be said to be complete and this state cannot be reversed.

Carbon Decomposition, Sintering and Vitrification

Above 600°C it is generally true that firing can proceed more rapidly, although between 400°C and 900°C those clays that contain larger amounts of carbon are prone to the carbon gas that is burnt off being trapped, particularly in a low temperature clay as the fluxes begin to melt or 'sinter' the clay particles together, forming a barrier to the escaping gas. This results in the faults known as bloating, and black core crude red clays high in carbon are particularly prone to this hazard.

Sintering is really the beginning of the gradual process of vitrification as the temperature increases and the fluxes present interact more and more with the alumina and silica combinations within the body, gradually filling up the pores between the particles of clay and any other non-flux materials.

In the early stages, around 800°C, most bodies are only just fused together, and if the firing is halted at this stage there is a danger that a network of cracks will form, caused by the incomplete fusion. These cracks will not disappear even if the ware is fired to a higher temperature subsequently; annoyingly they may not in fact be noticed until the glaze firing, incurring wasted time, effort and energy.

It is worth noting that most clays shrink very little below 900°C, and then shrink progressively as vitrification proceeds. It is a common mistake to think that clay shrinks gradually and evenly throughout the drying and firing process.

Example of bloating in a body high in iron and carbon. Early reduction has fluxed the iron on the surface of the body and prevented the carbon from escaping, causing the ugly swelling at the surface.

Example of black core or carbon entrapment in a red body causing local reduction of the red iron oxide to black iron oxide.

Rather, it does so in stages, and shrinkage due to loss of the water of plasticity is a very separate process to shrinkage due to vitrification.

In the later stages of vitrification, between 1200°C and 1300°C for stoneware clays, the body is virtually non-porous but has not become deformed under its own weight. At this stage, it is said to be pyroplastic. The molecular structure of the body undergoes many changes, particularly the silica molecules, which are of particular concern here, of which some can convert to the cristobalite form, while others become involved in the creation of mullite crystals. These sub-compounds have significant effects on the thermal expansion and body strength of the ware respectively.

Further heat rise then creates increasing deformation, with the ceramic eventually becoming a molten 'glassy' material.

Temperature Measurement and Heat Work

It would be misleading to attempt to indicate how long firings should take, as there are so many variable factors which determine individual firing cycles, such as size, thickness, shape, clay type, kiln design, and so on. A great deal is a matter of judgment, the factors outlined above giving warning of the most common problems. It is worth remembering that the more 'difficult' the ware in terms of size, thickness, and so on, the more care should be taken in relation to problem stages in firing. Most important is understanding the difference between a recorded temperature on the kiln pyrometer, and the

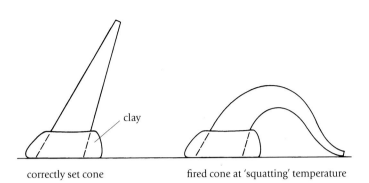

correctly set cone fired cone at 'squatting' temperature

Setting a temperature cone. The angle on the base of the cone determines the correct angle of lean.

temperature within the ware itself. A pyrometer measures the temperature of the atmosphere inside the kiln, and does not take into account the time lag involved in the heat conduction into the ware, especially when it is comparatively thick. For this reason, most ceramicists think of 'heat work' done, as well as temperature. Heat work takes into account the time taken for the heat to penetrate, so that all parts of the ware – inside, outside and within the walls and structure – have been subjected to the same amount of heat.

A good example of when this does not happen is with modern ceramic fibre raku kilns. Ceramic fibre is an incredible insulator compared to conventional heavy firebrick, or even top quality HTI (High Temperature Insulating) bricks. Consequently, it holds heat extremely effectively, making very fast firings possible, with 0–1000°C in 30 minutes now quite common, and probably not quite what the early Japanese masters had in mind! The result can sometimes be underfiring of ceramics on the inside because the heat has not had time to 'soak' through. Soaking is in fact the answer in this particular example, and is common practice in many types of kiln firing. The analogy is a good one, and the idea is to maintain sufficient heat input to hold the atmospheric pressure steady, while giving sufficient time for the heat to 'soak' or penetrate right into the ware.

The two most common forms of heat measurement in studio ceramics are pyrometers and pyrometric cones. Pyrometry is the study and recording of temperature and heat work. A pyrometer gives the read-out from a thermocouple inserted through the wall of the kiln. The thermocouple consists of two wires of different metals, platinum and rhodium, and the heat within the kiln produces an electrical 'difference' between these two wires which is measured and translated into a temperature in °C on the pyrometer. These are generally very reliable indicators of temperature, although the temperature indicated should always be related to the duration of firing and consequent heat work done on the ware. I have also found them to be less accurate in reducing conditions in fuel burning (as opposed to electric) kilns.

Pyrometric cones are precise compositions of ceramic materials that deform at various specific temperatures. By their nature and similarity in make-up to ceramics they give a more realistic indication of heat work done, although it is important to stress that the information given by any such means should be related to the thickness and size of the ware being fired. Other forms of pyrometric indicators are 'Bullers' rings and mini-bars. In practice, pyrometers and cones are used in conjunction, the pyrometer giving notice of the approach to a required temperature, and the deformation of a cone signalling the precise quantity of heat work done.

Key Points in Clay Body Firing Cycle

Clay, to become pottery, must be heated to at least 600°C. Below this temperature the clay body is not permanent and will still break down in water (*see* table overleaf).

Key Events When Heating and Cooling Clay

TEMP. (°C)	EVENT OCCURRING	TEMP. (°C)	EVENT OCCURRING
0–100	Water of plasticity is volatilized.		heat distortion, and help the thermal shock resistance of the body in use.
100–250	Pore water is volatilized.	1150+	Cristobalite forms out of any free silica, particularly from the flint form, increasing the thermal expansion/contraction (and therefore craze resistance) of the body, but also lowering the thermal shock resistance of the body.
200–300	Alpha (α) cristobalite, where present, is converted into Beta (β) cristobalite, accompanied by an increase in crystal size.		
400–600	Chemically combined water (water of crystallization) volatilizes. During this period, the steam from the ware can be many times the interior volume of the kiln and must be allowed to escape.	1200 –1300	Vitrification is completed, and the body becomes increasingly pyroplastic.
510+	Sulphur burns off.	*Cooling Cycle*	
573	Alpha (a) quartz changes to Beta quartz, with a 1 per cent increase in crystal size.	1300 –1000	The body is pyroplastic. Some cristobalite may crystallize out from the high silica liquid phase if the cooling cycle is slow. A rapid cooling in this range for stoneware bodies is often recommended to inhibit the formation of cristobalite and increase thermal shock resistance.
600	'Bound water,' or chemically combined water, is removed, and 'ceramic change' is completed.		
400–900	Carbonaceous matter decomposes, releasing CO_2. If the ware is heated too rapidly, causing the surface to vitrify before these gases escape, bloating may result.	1000	The body becomes a solid again.
		800–600	Glaze, where present, is still soft.
800	By this temperature the clay is highly porous and at its lightest weight. No water is left, but readjustment of the materials may not have commenced.	573	Beta quartz changes back to alpha quartz with a sudden 1 per cent contraction. This can cause cracking or dunting if cooling takes place too quickly at this point.
800+	Sintering begins.	300–200	Beta cristobalite changes to Alpha cristobalite with about 3 per cent linear contraction. Again there is a danger of cracking if cooling is too rapid.
950+	Vitrification begins.		
1000+	Mullite crystals begin to form from some of the alumina and silica. These progressively give strength to the body during the later stages of firing and prevent	100–room temperature	Pots may be removed.

Firing Summary

Removal of Water – This takes place up to 600°C. Up to this temperature on first firings the bungs should be left open to allow the water vapour to escape. If firing is too rapid while water is still present, the expanding steam can explode the ware.

Cristobalite inversion – Occurs specifically between 227 and 280°C. It is a sharp change in crystal size and happens on heating and cooling. Firing should proceed slowly at this stage.

Decomposition – Occurs between 400–900°C. Refers to the burning out of the organic matter in the clay. In a clay with a large amount of carbon, slow firing is necessary.

Quartz inversion – Exactly the same problem as cristobalite inversion, and cracking may occur if the temperature of 573°C is passed too quickly, either on heating or cooling.

Ceramic change – Occurs at about 600°C. All water is gone by this temperature and firing may proceed more rapidly.

Sintering – Begins around 800°C. The fluxes in the body begin to melt the free silica, gradually reducing porosity.

Vitrification – Progressively from 950°C upwards until the clay becomes glassified at a high enough temperature. Many changes to the silica content take place depending on the forms of silica present and other body constituents, such as talc and bone ash.

Part 2
Glazes

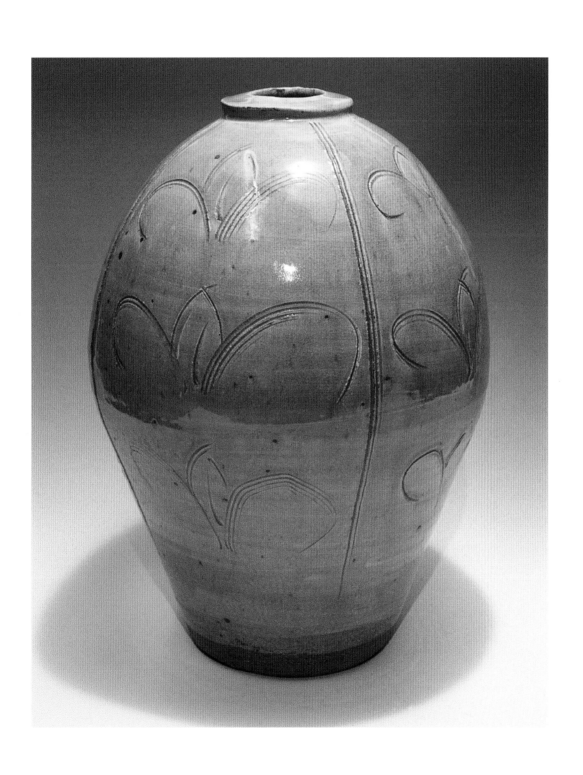

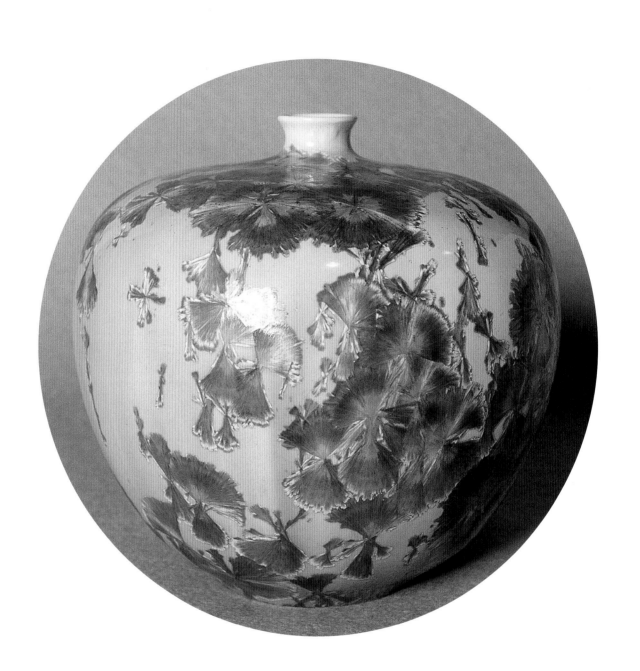

Introduction to Glazes

When we begin to look at glazes, it is important to remember that the materials from which they are composed originate largely from the same 'family' of materials as clays. A glaze may not necessarily even be different in composition from a clay, except perhaps in the proportions of the constituent ingredients. As we have already seen, a low-firing red clay can melt sufficiently to form a glaze at normal stoneware temperatures.

The main glass-forming oxide that is used in studio ceramics is silica, obtained in the form of either ground flint or quartz. These are chemically identical and are treated as interchangeable by most studio ceramicists, although they do have some differing characteristics under certain conditions. There are other glass-forming oxides, of which the borates are the most useful, and others, while technically glass formers, are not practical for this purpose and are more useful in other functions.

Silica, our principal glass former, is a refractory material, with a melting point of 1710°C, which is too high for the purposes of most pottery making. It is obviously more practical and economical to fire at as low a temperature as possible without jeopardizing the strength and durability of the ware.

Because of this, the vast majority of pottery products are fired at between 1000°C and 1300°C. Therefore, to make silica work for us as the glass former in ceramic glazes, other ingredients are required to a) make it melt at lower temperatures, b) to ensure that when it melts it sticks to the side of the pot. Fortunately, this is not such a difficult proposition.

To lower the melting point of the glass we need that group of materials known as fluxes, which in some ways are the most varied and interesting group of ceramic oxides. To 'hold' the glaze on the side of the ware we need those materials sometimes called intermediate or amphoteric oxides. Fortunately, as is the case for glass formers, there is similarly one oxide that suits this function perfectly, alumina oxide.

The Essential Components

To summarize, three basic categories of ingredient are sufficient to fulfil the essential requirements of a ceramic glaze:

- Silica – glass former
- Flux – to melt the glass
- Alumina – to stiffen the melt

Unfortunately, this is where the simplicity ends. It is not possible to have just three bins in the studio labelled accordingly and to mix them in varying proportions to suit different temperatures. It is theoretically possible, but in reality it would be very limiting and impractical, and would deny the huge variety of surface, colour and texture that makes the whole exercise worthwhile in the first place.

This variety occurs for the very reason that the majority of ceramic materials are so closely associated, and that mineral oxides are found in a whole range of materials, sometimes in a pure form (such as silica from flint or quartz) and at other times in compounds with two, three and more oxides linked together. To complicate matters further still, the same oxide may also appear in many different compounds (*see* materials list).

We should be clear at this point that here we are looking at the basic 'melt' of the glaze, that is without consideration of those oxides which I would

say are 'modifiers' of the basic glaze, such as opacifiers and colouring oxides, and as such can be considered as 'add-ons' to the glaze. It is important first of all to gain an understanding and familiarity of the *essential* or main glaze oxides.

Eutectics

A eutectic mixture is a balanced proportion of two or more materials that allows them to combine and melt at the lowest possible temperature. Certain ceramic materials when combined do not behave as might be expected from their superficial categorization as fluxes, stabilisers and glass formers.

For instance, alumina and silica form a eutectic mixture which can melt at a temperature as low as 1545°C. The significance of that figure is that it is lower than the melting point of either alumina or silica whose individual melting points are 2050°C and 1710°C respectively. It occurs at a mixture of 10 per cent alumina to 90 per cent silica.

What this illustrates is that materials which in everyday terms in the studio or workshop are not thought of as fluxes can still promote fusion in one another and effectively operate as such. There are many such recognized eutectic mixtures in ceramics that can occur in such complex forms in the glaze fusion process that they are difficult to predict and manipulate in practice. For the intended purposes here of a practical understanding of glaze chemistry I would emphasize only that they occur and that fusion does not always increase as on a straight line graph when flux is added to alumina and silica.

8 The Main Glaze Oxides

This section is chiefly concerned with those oxides that are essential to forming stable glazes for ceramics. Not all of them are used in pure form in practice, because the raw materials in which they are found and supplied contain them in many different combinations. It is useful to consider them in isolation to understand some of their most important characteristics and how they affect the materials and glazes in which they are present.

The oxides are considered under their generally recognized groupings, that is, as fluxes, glass formers, and so on. This is a simplification in that the chemistry is a much more complicated science than as it is presented here. I do not apologize for this – glaze chemistry and its practical manipulation in the studio do not necessarily require advanced and detailed understanding, but an awareness of the implications of some of the more complex and sophisticated reactions is worth having.

It is a convention to consider the three categories of glaze ingredients in a particular order: flux, stiffener (usually alumina) and glass (usually silica), particularly when expressing a glaze as a formula. In keeping with this rule, I will look in greater detail at the ingredients in the same order.

Fluxes

The fluxes are indeed the most varied group in these three categories, and play a crucial role in determining not only the temperature at which the glaze will melt, but also, by influencing the surface quality, colour and texture of the glaze, the way in which they interact with other ingredients, particularly the colouring oxides. The photographs below illustrates the influence that different fluxes can have on colour at earthenware and stoneware temperatures. The eight very simple glazes are each in turn stained with copper, cobalt and manganese and the glazes are each also shown without colour. The variation

Copper, cobalt and manganese in a range of fluxes showing the variation in colour responses.

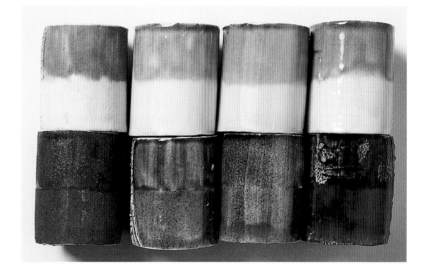

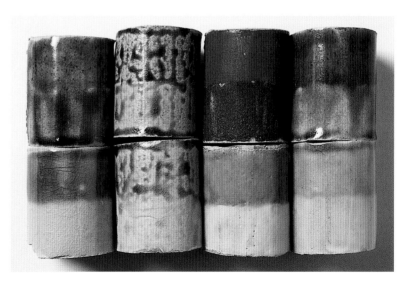

in response can be seen most clearly with copper, and in more complex glazes the influence of the flux oxides can be very marked, with totally different colours obtained from the same oxide (*see* Chapter 11).

Some of the fluxes work perfectly well when used as the only flux in the glaze, while others are sometimes called secondary or auxiliary fluxes because they are more effective in combination with another, preferably more powerful, one. The fluxes are sometimes referred to as basic oxides, or grouped together under the general heading of 'alkalis', and can be identified as fluxes from their chemical symbol, in that most of the fluxes we use are monoxides, that is one or two atoms of an element, linked with only one atom of oxygen, for example. Pb<u>O</u>, K<u>2O</u>. There is, of course, one major exception to this otherwise very useful rule of identification of this particular function, and that is boric oxide. An explanation is given under the heading for boric oxide, but for now I will consider it alongside the other fluxes.

There are nine oxides commonly used specifically as fluxes in glazes, and these are:

OXIDE	CHEMICAL SYMBOL
Lead	PbO
Potassium	K_2O
Sodium	Na_2O
Lithium	Li_2O
Barium	BaO
Calcium	CaO
Magnesium	MgO
Zinc	ZnO
Boric oxide	B_2O_3

They are listed above with their chemical nomenclature or symbol. This is a shorthand system for identifying chemicals easily, and no two oxides have exactly the same combination of letters. Sometimes the connection is obvious, as in CaO for Calcium Oxide. PbO for lead oxide is less obvious, but not entirely unfamiliar in that Pb is short for the Latin *plumbic*, hence the name plumber for someone who works with lead piping. Potassium and sodium are also represented by their latin names, *Kalium* and *Natrium* respectively.

Throughout this chapter, the symbols are shown for the purpose of familiarization, and a fuller explanation of the specific information that these symbols convey is given later in Chapter 10.

Lead Oxide (PbO)

Lead has always been widely used as a flux, and is still popular today. It was first used in its raw forms, the most common of which is galena, and this was used widely throughout Europe during the Middle Ages. It was simply dusted onto the damp ware and fired where it combined with the clay (which contains the other essential ingredients, alumina and silica) to form a crude but satisfactory glaze surface which can be quite beautiful.

Unfortunately, lead in all its raw forms is poisonous. It can be absorbed through the stomach lining and ingested through breathing, building up in the system incrementally and possibly leading eventually to death. When fired, lead glazes are potentially soluble in everyday use, and can release lead into acidic foodstuffs such as citric acids and vinegar. It was a major health hazard, particularly in the pottery industry until the end of the last century and beyond, until ways were found of melting it with other materials, principally silica, and then regrinding to render it resistant to acid attack. This process is known as fritting (*see* Chapter 9) and has been used by potters for centuries, but is now specifically applied to produce safe lead glazes, which are termed low solubility glazes.

Caution should still be exercised even with lead glazes composed from 'safe' lead frits, as other materials, notably borates and copper oxide, can reverse the advantages gained by the fritting process. As a general rule, I would say that it is wise to stay completely away from raw lead compounds, and err on the side of caution in the use of lead glazes which will be in contact with food.

In most other respects lead is an ideal material for fluxing lower temperature glazes. It works well as a flux between 800°C and 1100°C, but above this temperature it begins to volatilize and is therefore not used in stoneware temperature glazes. Its principal benefit is its ability to produce clear, bright and smooth gloss surfaces that take colour well. They give beautiful subtle apple greens with copper oxide and can produce coloured glazes with a wonderful softness about them. Without added colour, a glaze high in lead will tend to have a warm yellowish tinge to it.

Another reason for its widespread use is that lead also contributes to a low thermal expansion factor for the glaze, which helps in reducing

Drinking vessel – sixteenth century, raw lead glaze with copper. The Potteries Museum, Stoke-on-Trent.

crazing. It can also be used as the only flux present in the glaze; most of the other fluxes work better in conjunction with another flux.

The forms in which lead is introduced into glazes nowadays is restricted to commercially produced and carefully tested frits.

Materials in which Lead Occurs

MATERIAL (OTHER NAMES)	SYMBOL/FORMULA
Raw Materials	
Galena (lead sulphide)	PbS
White lead (lead carbonate)	$2PbCO_3.Pb(OH)_2$
Red lead	Pb_3O_4
Litharge (yellow lead)	PbO
(All above are poisonous.)	
Commercial Frits	
Lead sesquisilicate	$PbO.1.5SiO_2$*
Lead bisilicate	$PbO.2SiO_2$*
Other commercial frits	Various

*Note: 'Ideal' formula; actual formula may vary. Small amounts of alumina and/or titanium are included in commercial frits to improve stability and to reduce the risk of lead solubility; *see* Chapter 9.

'Dogdaze II' lead-glazed teapot by Martin Moore.

Potassium Oxide (K₂O)

Potassium is one of the three so-called strong alkalis (along with sodium and lithium) which have a very strong fluxing action right across the temperature range, from 800–1300°C

In its purer forms it tends to be highly soluble and is therefore mainly introduced into glazes in either fritted form, for low temperatures, and for higher temperatures in its naturally insoluble form in feldspars.

Potassium oxide is a strong flux and can be used as the only flux. In practice, however, this is rarely the case because the two main sources of it in glazes are frits and feldspars, materials which invariably contain more than one flux.

Potassium gives good colour and brightness to the glaze and is a very commonly used glaze flux whose main drawback is a very high coefficient of thermal expansion giving a strong tendency to crazing, a particular drawback at lower temperatures if the body itself is still open and porous.

Sodium Oxide (Na₂O)

Sodium is often grouped together with potassium, to which it is very similar, to the extent that in some formulae the two oxides are represented by the symbol KNaO as if totally interchangeable. Their fluxing power is roughly the same, although sodium is slightly stronger, and the coefficient of expansion of sodium is also higher, but in response to colour they can be very different and this particularly should be borne in mind when deciding which to use. Sodium is also more volatile than potassium and begins to volatilize over 1200°C, although this does not prevent its use at stoneware temperature.

Soda is readily available in a greater variety of different compounds than potassium, many of them soluble and so like potassium is also generally introduced into the glaze in the form of a frit or feldspar, although it must not be overlooked that in one soluble form, common salt, it is more widely used as a vapour glaze (*see* Chapter 12).

Raw Materials in which Potassium Occurs

MATERIAL (OTHER NAMES)	SYMBOL/FORMULA		
Potassium carbonate (pearl ash)	K_2CO_3		
Potassium dichromate	$K_2Cr_2O_7$		
Alkaline frits – potclays	$0.5Na_2O.$ $0.33K_2O.$ $0.17CaO$	$0.1Al_2O_3.$ $0.1B_2O_3$	$1.5SiO_2$
Nepheline syenite	$0.46K_2O.$ $0.54Na_2O$	$1.2Al_2O_3.$	$4.5SiO_2$
Potash feldspar	$K_2O.$	$Al_2O_3.$	$6SiO_2$
Wood ash (variable)	$0.05K_2O.$ $0.05Na_2O$ $0.8CaO$ $0.1MgO_2$	—	$0.1SiO_2$

Raw Materials in which Sodium Occurs

MATERIAL (OTHER NAMES)	SYMBOL/FORMULA		
Soda ash (sodium carbonate)	Na_2CO_3		
Salt (sodium chloride)	$NaCl$		
Alkaline frits – potclays	$0.5Na_2O.$ $0.33K_2O.$ $0.17CaO$	$0.1Al_2O_3.$ $0.1B_2O_3$	$1.5SiO_2$
Borax	$Na_2O.$	$2B_2O_3.$	$10H_2O$
Cryolite	Na_3AlF_6		
Nepheline syenite	$0.46K_2O.$ $0.54Na_2O$	$1.2Al_2O_3.$	$4.5SiO_2$
Soda feldspar	$Na_2O.$	$Al_2O_3.$	$6SiO_2$
Wood ash (variable)	$0.05K_2O.$ $0.05Na_2O$ $0.8CaO$ $0.1MgO_2$	—	$0.1SiO_2$

Lithium Oxide (Li$_2$O)

Lithium is the third strong alkali used in ceramics, but less often because of its comparative rarity and cost. It has a similar fluxing power to sodium and potassium, and operates over the whole temperature range. The main value of lithium in glazes is that it is available, unlike potassium and sodium, in its pure form as an insoluble material, lithium carbonate, and that its coefficient of expansion is much lower. Therefore, lithium carbonate can be used as a direct substitute for either of the other strong alkalis to counteract their tendency to cause crazing of the glaze. It is the only one of the three strong alkaline fluxes that is available in a pure *and* insoluble form.

Lithium gives similar colour responses to potassium and sodium – turquoise blue with copper and delicate pinks with small amounts of cobalt – but tends to develop a more crystalline surface on cooling. Glazes which are very high in lithium can experience the very opposite of crazing, in that, because of its low expansion, the glaze shrinks less than the body and fails to 'grip' the form. It is almost as if the glaze is a size too big for the pot, which, in effect, it is.

The following four fluxing oxides fall into a group with certain characteristics in common. They are sometimes variously referred to as alkaline earths, secondary fluxes or auxiliary fluxes. In practical terms, their important characteristics are that they do not have a good fluxing action when used alone, and are only really effective when used in conjunction with one or more of the other strong fluxes, such as lead,

Raw Materials in which Lithium Occurs			
MATERIAL	SYMBOL/FORMULA		
Lithium carbonate	Li$_2$CO$_3$		
Lepidolite	Li$_2$F$_2$.	Al$_2$O$_3$.	3SiO$_2$
Petalite	Li$_2$O.	Al$_2$O$_3$.	8SiO$_2$
Spodumene	Li$_2$O.	Al$_2$O$_3$.	4SiO$_2$

Wedgewood 'pineapple' teapot, lead-glazed earthenware, circa 1760. The Potteries Museum, Stoke-on-Trent.

potassium, sodium, lithium or boric oxide. They are also less useful as fluxes at lower temperatures and are more often used at higher temperatures (above 1100°C). In large quantities they will promote crystalline opaque/matt glaze surfaces. They occasionally appear in low temperature glazes, playing the role of an alternative opacifier, which they achieve through being relatively inert in earthenware glazes. For this reason, they are sometimes described as anti-fluxes when used in low temperature glazes, although this is not always entirely true as in small quantities they can assist the fluxing of earthenware glazes also.

Barium Oxide (BaO)

In certain specialized circumstances, barium will act as a flux at low temperatures if it has first been fritted at high temperature with soda or potash, but this is not usual in studio ceramics. In practice, barium is used as a secondary flux at high temperatures, in small quantities or in combination with borax, if a clear, bright glaze is required, and more often in larger quantities of 10 per cent or more when it will produce a fine, dense crystal structure upon cooling in glazes without borax (the presence of borax will inhibit this reaction) (*see* Chapter 12).

Barium glazes, then, are characteristically opaque and matt, but it is important to remember that this is as a result of crystallization taking place as the molten glaze cools, rather than the glaze clouded by an inert, refractory material. These glazes can have a wonderfully luminous stone-like appearance, and Barium can give strong colour development – in combination with soda it can produce very intense blues and even purples with copper. It can also give greater intensity to other colouring oxides.

Two points are worth noting here. Firstly, barium is a toxic material which should be handled with care, and, secondly, in its most commonly used carbonate form it is usually taken to be insoluble. This is true to a point, but the presence of an acidic material such as calcium chloride (added to glazes as a flocculant to give greater hardness to the unfired glaze) can render it partially soluble. This does not cause significant problems except in relationship to its toxicity, in that it may be more readily assimilated into the body through the skin when soluble.

Sensible precautions should always be taken when handling barium. It is also wise to avoid barium in glazes for ware to be used for eating or drinking, as, although not enough is known about its solubility in food acids, it is potentially hazardous.

Raw Material in which Barium Occurs	
MATERIAL	SYMBOL/FORMULA
Barium carbonate	$BaCO_3$

Calcium Oxide (CaO)

Calcium is the most widely used of the secondary fluxes, partly because of its cheapness and availability. It has some value as a flux at earthenware temperatures, and is commercially fritted with borax for use as a flux for earthenware. Used in combination with lead and/or potassium and sodium it also has the advantage

Raw Materials in which Calcium Occurs		
MATERIAL (OTHER NAMES)	SYMBOL/FORMULA	
Whiting (calcium carbonate)	$CaCO_3$	
Dolomite	$CaCO_3$.	$MgCO_3$
Colemanite (Gerstley borate)	$2CaO$. $3B_2O_3$.	$5H_2O$
Wollastonite	$CaSiO_3$	
Calcium feldspar (anorthite, lime feldspar)	CaO. Al_2O_3.	$2SiO_2$
Cornish stone	$0.7KNaO$. Al_2O_3. $0.3CaO$	$8.4SiO_2$
Wood ash (variable)	$0.05K_2O$. $0.05Na_2O$ $0.8CaO$ $0.1MgO_2$	— $0.1SiO_2$
Calcium borate frit	CaO. $0.1Al_2O_3$. $1.5B_2O_3$	$0.6SiO_2$

of making the fired glaze harder and more durable, as well as more acid resistant. It becomes more powerful and usefully active as a flux above 1100°C.

It can be used in larger amounts than barium in a stoneware glaze (up to 20 per cent) without causing crystallization, but in larger quantities will begin to produce an increasingly crystalline opaque/matt surface.

Calcium does not have any particularly remarkable colour responses with the colouring oxides, although I have seen a pleasant soft violet colour result from cobalt in glazes high in dolomite, and it does have a bleaching effect on iron in some circumstances.

Calcium has a medium to high expansion coefficient and therefore will not act as an anti-craze ingredient in a soda or potash feldspar based glaze. If crazing is to be avoided, other secondary fluxes have lower expansion rates and may be better for this purpose.

Magnesium Oxide (MgO)

Magnesium oxide is really only used as a high temperature flux, above 1180°C. It is similar in effect to calcium and barium, producing crystalline surfaces and increasing mattness when used in large quantities, but in smaller amounts it aids fluidity. Magnesia has a low coefficient of expansion and therefore has some value in counteracting crazing in stoneware glazes.

Raw Materials in which Magnesium Occurs	
MATERIAL (OTHER NAMES)	SYMBOL/FORMULA
Magnesium carbonate	$MgCO_3$
Dolomite	$CaCO_3.MgCO_3$
Talc (magnesium silicate, steatite, soapstone, French chalk)	$3MgO. \quad — \quad 4SiO_2$

Strontium Oxide (SrO)

This is a less widely used flux, and is not available from all suppliers, and therefore is not included in the above list of important glaze fluxes. As it is used on occasion, and does turn up in some recipes, it is mentioned here for reference and comparison. It is similar in many of its properties to calcium and this may be substituted for strontium in recipes if none is available. Like calcium, strontium is to be had in the carbonate form, although strontium carbonate is more expensive than whiting (calcium carbonate).

Raw Material in which Strontium Occurs	
MATERIAL (OTHER NAMES)	SYMBOL/FORMULA
Strontium carbonate (strontianate)	$SrCO_3$

Zinc Oxide (ZnO)

Zinc is not active as a flux below 1100°C, except in very small amounts of around 1 per cent when it may act as a catalyst to aid fusion in the other materials, and like the other secondary fluxes is used only in smaller quantities in high temperature glazes which are intended to be clear. Zinc is often thought of as an opacifier as much as a flux, and is used in low and high temperature glazes to help produce shiny opaque surfaces, as it has less of a detrimental effect on brightness than other opacifiers.

In larger quantities it will produce increasing opacity and crystalline mattness, but it can induce a tendency for the glaze to crawl because of its high surface tension.

Raw Material in which Zinc Occurs	
MATERIAL	SYMBOL/FORMULA
Zinc Oxide	ZnO

Boric Oxide (B$_2$O$_3$)

Boric oxide is the principal exception to the useful but general rule that the glaze fluxes are monoxides; that is, when the element combines with only *one* atom of oxygen. Boric oxide is a compound in which the element boron combines with oxygen in the ratio of 2:3, which identifies it as a sesquioxide. This makes it an amphoteric or intermediate oxide like alumina, the principal glaze stiffener, but it is also a very useful glass former as well! This is all very confusing, but I think it is important to stress that in studio ceramics, boric oxide is used principally for its fluxing action and that the fact that it provides an additional glass-forming material of excellent quality should be seen separately. It is important, however, to allow for this extra contribution of glass in relation to the silica content when formulating glaze recipes (*see* Chapters 10 and 13).

Boric oxide is useful from low to high temperatures, although it progressively volatilizes above 1200°C and is not used so much in glazes fired above 1250°C. It is most often used in earthenware and mid-temperature glazes, and is particularly good in combination with lead where its low expansion coefficient is useful in reducing crazing. Boric oxide also has the advantage over lead of producing very clear glazes, without the characteristic yellow tinge that is unavoidable with lead, and can therefore give good clean colour responses.

Like lead, soda and potassium, boric oxide is generally not available in a pure, insoluble form. It is therefore most often introduced in a commercially fritted form, and is also often included in lead and alkaline frits. The only commonly available natural mineral forms of boric oxide are colemanite and Gerstley borate (an American mineral of similar composition).

Aluminium Oxide (Al$_2$O$_3$)

Alumina, although not the only oxide with intermediate or amphoteric properties, is the main oxide that is used in glazes as a stabilizer, its principal function being to prevent the glaze from flowing off the ware. Alumina links the fluxes and silica and allows a stable glass to form which adheres to vertical surfaces while still being fully molten and 'fluid'. In itself it is a very refractory substance, hence its importance in high temperature clays, but in glazes it will cause increasing mattness and roughness in the glaze, effectively rendering the glaze underfired.

It is rarely introduced into glazes in its pure form, but is a common component of many of the raw material compounds used in ceramics, and in a particularly appropriate form in clay. Adding alumina through clay to the glaze has the advantage of utilizing the unique properties of clay to help 'float' the other ingredients and prevent them from settling to the bottom of the glaze bucket too quickly. It also contributes some strength to the unfired glaze coating. This is an invaluable property, as a glaze that has no clay content is much more likely to be damaged in handling, which means that other artificial 'floatatives' or 'suspenders' have to be added. Adding the alumina in the form of clay therefore kills two birds with one stone. China clay has the highest proportion of alumina to silica and is the most common choice of material through which alumina is added to glazes.

Alumina generally comprises between 5 to 15 per cent of the recipe total. In larger amounts it begins to matt the glaze surface,

Raw Materials in which Boric Oxide Occurs

MATERIAL (OTHER NAMES)	SYMBOL/FORMULA		
Boric acid	B(OH)$_3$		
Borax	Na$_2$O.	2B$_2$O$_3$.	10H$_2$O
Colemanite (and Gerstley borate)	2CaO.	B$_2$O$_3$.	5H$_2$O
Calcium borate frit*	CaO.	0.1Al$_2$O$_3$. 1.5B$_2$O$_3$	0.6SiO$_2$
Borax frits, various; e.g. potclays standard borax frit	0.033K$_2$O. 0.330Na$_2$O. 0.634CaO 0.003MgO	0.173Al$_2$O$_3$. 0.63B$_2$O$_3$	1.88SiO$_2$

*Note: A useful substitute for colemanite; as a frit it has no chemically combined water to cause firing problems

<table>
<tr><td colspan="3">Raw Materials in which
Alumina Occurs</td></tr>
<tr><td>MATERIAL
(OTHER NAMES)</td><td colspan="2">SYMBOL/FORMULA</td></tr>
<tr><td>Alumina hydrate</td><td colspan="2">$Al_2(OH)_6$</td></tr>
<tr><td>Calcined alumina
(alumina
sesquioxide)</td><td colspan="2">Al_2O_3</td></tr>
<tr><td>China clay
(kaolinite)</td><td>$Al_2O_3.$</td><td>$2SiO_2.$ $2H_2O$</td></tr>
<tr><td>Ball clays</td><td colspan="2">Various</td></tr>
<tr><td>Feldspars</td><td colspan="2">Various</td></tr>
<tr><td>Frits</td><td colspan="2">Various</td></tr>
</table>

<table>
<tr><td colspan="3">Raw Materials in which
Silica Occurs</td></tr>
<tr><td>MATERIAL
(OTHER NAMES)</td><td colspan="2">SYMBOL/FORMULA</td></tr>
<tr><td>Flint (silica
dioxide)</td><td>SiO_2</td><td rowspan="3">⎫
⎬ chemically
⎭ identical</td></tr>
<tr><td>Quartz (silica
dioxide)</td><td>SiO_2</td></tr>
<tr><td>Cristobalite
(silica dioxide)</td><td>SiO_2</td></tr>
<tr><td>China clays
(kaolinite)</td><td colspan="2">$Al_2O_3.$ $2SiO_2.$ $2H_2O$</td></tr>
<tr><td>Ball clays</td><td colspan="2">Various</td></tr>
<tr><td>Feldspars</td><td colspan="2">Various</td></tr>
<tr><td>All frits</td><td colspan="2">Various</td></tr>
</table>

while in smaller amounts the glaze will become increasingly runny.

Silica Oxide (SiO₂)

Silica is the main glass-forming oxide in ceramics, often the majority oxide in a glaze. In a sense, a glaze can be seen as silica modified by other materials. While the fluxes are often grouped together under the umbrella term 'alkalis', the glass formers are similarly grouped as 'acidic oxides', and can be identified as such by their chemical nomenclature as dioxides, for example SiO_2. Boric oxide (B_2O_3) is the most notable exception to this rule and is the only other glass former in glazes of any real significance.

The total amount of silica in a glaze can be up to 60 to 70 per cent, and the more silica a glaze contains, the harder and more durable it is likely to be when fired, providing it has fully melted. A high silica content also reduces crazing in the fired glaze.

Silica is often added to glazes in the form of flint or quartz, which are useful and plentiful sources of pure silica oxide in non-soluble form, but it is also found in many other materials such as commercial frits, feldspars and, of course, clay. If materials like these are used in the glaze there is sometimes no need for additional silica in its pure form.

The Glaze Modifiers

I have separated this small group of materials under this heading because, although they are grouped with silica as dioxides, and like silica are acidic oxides, their principal use in glazes is to make them opaque and/or matt. In that sense, they are not strictly essential to a glaze in the way that the fluxes, alumina and silica are, but their role is an important one and they are used widely.

Tin Oxide (SnO₂)

Tin is considered to be one of the best opacifiers for glazes, and has been used for this purpose for centuries. It has even given its name to the classification of certain styles of ware, such as Majolica and Delft, and other 'Tin glazed' wares. In amounts of 5 to 15 per cent, tin will make the glaze whiter and more opaque, which it achieves by remaining in suspension in the fired glaze without dissolving, creating a 'fog' of white particles which results in the characteristic soft bluish-white of a tin glaze.

Titanium Dioxide (TiO$_2$)

Titanium is an interesting material, in that, unlike tin and zirconium, it creates opacity and mattness through crystallization of the glaze in cooling. It also gives a distinctly different character to the glaze compared to tin or zirconium, and creates mottled effects with colouring oxides. It has the ability to 'pull' colour into the glaze from the clay body below, an action known as transmutation. In a sense it contradicts the purpose of using an opacifier, which is usually to cover up unwanted colour seen through the glaze, but it can produce interesting qualities. It is used in quantities from 2 to 10 per cent Titanium is used widely in the impure forms of rutile and ilmenite (*see* Chapter 11).

Zirconium Oxide (ZrO$_2$)

Zirconium performs the same function in more or less the same way as tin oxide, and is principally used as an alternative because of its relative cheapness. It gives a harder white than tin, is a highly refractory oxide (2700°C melting point (MP)) and will increase the hardness and viscosity of the glaze. It is most often introduced into glazes by zirconium silicate (*see* Chapter 9). Additions of 4 to 12 per cent will give partial to full opacity.

The Colouring Oxides

Like the glaze modifiers, these can be considered superfluous to the essential glaze composition, but their importance to the visual quality of a glaze is crucial in practice. Some of them are monoxides and where this is the case they can be quite strong fluxes, even in the comparatively small amounts that they are used.

Colouring oxides can be used individually or in combination to produce a surprisingly wide range of colours and surfaces. It would be counter-productive in a book of this nature to specify the colour that each of these oxides may give as this varies enormously depending upon several factors, including firing cycles and atmospheres, type of glaze and even body composition. The following is a list of those most widely used, and I have indicated with an asterisk (*) those that are restricted in their availability, usually because of their health and safety implications. Further detailed information is listed in Chapters 9, 11 and 12.

SUBSTANCE	CHEMICAL SYMBOL
Antimony	Sb_2O_3*
Cerium	CeO_2*
Chromium oxide	Cr_2O_3
Cobalt oxide	CoO
Copper oxide	CuO
Ilmenite	$FeO.TiO_2$
Black iron oxide	FeO
Red iron oxide	Fe_2O_3
Manganese dioxide	MnO_2
Nickel oxide	NiO
Praseodymium oxide	PrO_2*
Rutile	TiO_2 (+ small amount of iron)
Uranium	U_3O_8*
Vanadium pentoxide	V_2O_5

The Raw Materials for Glazes

In looking at the main glaze oxides in the previous chapter, we were considering their individual and most important functions in isolation. In practice, the principal oxides that we use are found in many different compounds. As we have seen, some oxides occur in several combinations, while others may be found in only one or two compounds. A simple example would be calcium, which occurs in quite a few common materials in insoluble form, while barium, though similar to calcium in its most important functions, is only available to us in insoluble form as barium carbonate.

It is also true that some oxides have more than one function in ceramics. Sodium, for example, whose most important function is as a flux, is available in many forms, including sodium carbonate and sodium silicate. In these forms, sodium is used for a quite different purpose, as a deflocculant for casting slips. The quantities used for this function are small enough that its fluxing power is of little consequence, while its effect on the fluidity of the raw clay slip is of greater importance.

This section will summarize the main characteristics and functions of the various compounds that are commonly used in studio ceramics, with particular reference to their usefulness in glazes. The suggested percentage additions should only be taken as a rough guide, as many factors can affect the behaviour of materials in firing and cooling, and it must also be remembered that different materials may add more of the same oxide to a recipe. It is important to cross-reference this information with that given for the relevant constituent oxides in Chapter 8.

Clay $(Al_2O_3.2SiO_2.2H_2O)$

Clays are the basic material from which we form ceramic objects, but they are also very useful as glaze ingredients. They always contain alumina and silica, of course, and, depending upon the particular clay used, may also contribute small amounts of flux. One of the advantages of using clay in a glaze recipe, apart from its usefulness as a convenient source of alumina and silica, is that it will help the glaze stay in suspension in water. It will also contribute unfired strength to the glaze coating, thereby helping to reduce the risk of damage when handling or decorating or when placing in the kiln.

When a glaze recipe includes clay, but is not specific, it is usually safe to assume that china clay should be used. It is the purest and probably most frequently used clay in glazes, and has a higher ratio of alumina to silica than any other clay. It is sometimes used in calcined form (*see* molochite below). Calcination removes the chemically combined water, which in turn removes some of the advantageous plastic properties but also reduces shrinkage when this is desirable, such as when it is applied to high-fired biscuitware. Other clays will contribute different characteristics according to their main impurities, and ball clays are also widely used in glazes, where their small flux content and lower proportion of alumina to silica contribute to a lower melting point when used instead of china clay. It is also perfectly possible, for instance, to use a red earthenware clay in a glaze, but this will inevitably introduce a strong colouring effect because of the iron it contains.

A high clay content is desirable in glazes intended for application to un-biscuited ware. Depending upon the type of glaze, clay may compose up to 50 per cent or more of the recipe content.

When china clay is incorporated in a recipe it is acceptable to use the 'ideal' or theoretical formula for china clay of $Al_2O_3.2SiO_2$ for the purposes of calculation, and the water content ($2H_2O$) may be omitted because it plays no part in fusion. The table [below] shows some 'typical' examples of secondary clays with simplified formulae which can be used as a working basis for reference and calculation. While strictly speaking the actual formula of the clay being used in a glaze recipe should be known, in practice a similar or simplified formula can be used if this is not possible.

Examples of Typical Clay Formulae

SUBSTANCE	CHEMICAL SYMBOL			MOLECULAR WEIGHT
China clay		$Al_2O_3.$	$2SiO_2$	258.2
Low silica/ high iron ball clay	$0.08KNaO.$ $0.03MgO.$	$Al_2O_3.$ $0.06Fe_2O_3$	$2.5SiO_2$	296
High silica/ low iron ball clay	$0.15KNaO.$ $0.05MgO.$	$Al_2O_3.$ $0.02Fe_2O_3.$	$6.5SiO_2$ $0.1TiO_2$	546
Fireclay	$0.08KNaO.$ $0.08MgO.$	$Al_2O_3.$ $0.04Fe_2O_3$	$4.0SiO_2$	394
Red clay	$0.16KNaO.$ $0.08CaO.$ $0.07MgO$	$Al_2O_3.$ $0.3Fe_2O_3$	$4.5SiO_2$	441

Bentonite ($Al_2O_3.4SiO_2.H_2O$)

This is a highly plastic clay. It is sometimes added to glazes to help prevent settling of the ingredients. Settling is a particular problem in glazes that have large amounts of heavy materials like lead frits or flint, and do not contain clay in any form. Small amounts of 2 to 3 per cent of bentonite are sufficient to help suspend a glaze. Bentonite does not slake down very easily in water and forms lumps in the glaze if added separately, but thorough sieving of the glaze mix will disperse it and is preferable to the alternative sometimes recommended of dry mixing with the other ingredients before adding to the water. It is sometimes used in conjunction with calcium chloride (*see* Chapter 14).

Borax ($Na_2O.2B_2O_3.10H_2O$)

Borax is a partially soluble source of sodium and boric oxide and is therefore not usually the best source of these oxides. Alkaline/borax frits are more practical, but borax provides a strong combination of low temperature flux for occasional specialist use in low temperature or crystalline glazes where the ratio of alumina and silica in alkaline and borax frits is too high. Borax is sometimes added to slips and glazes (3 to 5 per cent) to increase their pre-fired strength.

Pearl Ash (Potassium Carbonate) (K_2CO_3)

Pearl ash is a 'pure' source of potassium, but it is highly soluble and therefore somewhat impractical and rarely used except in 'exotic' low temperature glazes that require higher concentrations of alkaline flux than can be obtained by the use of insoluble forms such as feldspars and frits.

Salt (Sodium Chloride) (2NaCl)

Common salt is only used in the firing technique known as 'salt glazing' (*see* Chapter 12). In this technique its solubility is a positive advantage, but environmental concerns have led many to use soda ash instead (*see* below).

Soda Ash (Sodium Carbonate) (Na_2CO_3)

Like pearl ash, soda ash is a pure source of strong alkali flux, in this case sodium, and like pearl ash it is also very soluble and infrequently used in glazes for the same reasons, although it is used as an ingredient in Egyptian Paste recipes. It is mainly used in ceramics as a casting slip deflocculant. Soda ash and other soluble forms of soda are increasingly being used as alternatives to salt glazing.

Lithium Carbonate (Li_2CO_3)

This is a useful but expensive source of pure lithium, the only one of the three strong alkaline fluxes readily available in non-soluble form. The other two strong alkaline fluxes, potassium and sodium, are not available in both a pure *and* non-soluble form. It is used as a strong flux at all temperatures, in particular for its low expansion and therefore anti-crazing characteristics. It can be used up to 30 per cent of the total, but in these quantities it may cause the fired glaze to shale off of the outside of the ware, the very opposite of crazing. The practical effect is as if the glaze is a size too big for the pot.

Galena (Lead Sulphide) (PbS)

Galena is the least poisonous of the sources of raw lead available, but should be treated with extreme caution, both in handling and when disposing of unwanted glaze batches. It is now used only for low temperature glazes that require higher concentrations of lead flux than can be obtained by the use of safe lead frits. It can be used at up to 70 per cent of the total in low temperature glazes.

Cryolite ($Na_3.AlF_6$)

Cryolite is most frequently often incorporated into glazes to create 'lava' or 'crater' effects, which are the result of large amounts of fluorine escaping as a gas when the glaze is beginning to melt; if the kiln is shut down at this point and cooled quickly the bubbles are frozen in place. Cryolite can sometimes also be a handy source of insoluble sodium which does not automatically add extra silica. It will also help to induce crazing because of the high expansion of sodium. Amounts of between 2 to 15 per cent are a rough guide for this rarely used material.

Feldspars

These contain the three essential categories of ingredients of a glaze and are the most important and common sources of the three strong alkaline fluxes in insoluble form. The proportion of flux to the alumina and silica in feldspars is such that they are ideal as a basis for higher temperature glazes, and are considered as flux materials. They may constitute up to 90 per cent of the total recipe. Strictly speaking, some of the materials listed here, nepheline syenite for instance, are not true feldspars, but they are very like them and in ceramic terms can be considered as feldspathic. Those most often used are:

SUBSTANCE	CHEMICAL NAME		
Potash feldspar	$K_2O.$	$Al_2O_3.$	$6SiO_2$
Soda feldspar	$Na_2O.$	$Al_2O_3.$	$6SiO_2$
Mixed feldspar	$0.5K_2O.$	$Al_2O_3.$	$6SiO_2$
	$0.5Na_2O$		
Calcium feldspar	$CaO.$	$Al_2O_3.$	$2SiO_2$
Cornish stone	$0.28K_2O.$	$1.02Al_2O_3.$	$8.43SiO_2$
	$0.44Na_2O$		
	$0.26CaO$		
	$0.02MgO$		
Nepheline syenite	$0.46K_2O.$	$1.2Al_2O_3.$	$4.5SiO_2$
	$0.54Na_2O$		
Spodumene	$Li_2O.$	$Al_2O_3.$	$4SiO_2$
Petalite	$Li_2O.$	$Al_2O_3.$	$8SiO_2$
Lepidolite	$Li_2F_2^*.$	$Al_2O_3.$	$3SiO_2$

Note: The fluorine in lepidolite decomposes to a gas during firing and can cause bubbling and pitting of the fired glaze.

Most of the above formulae are ideal or typical, but usable for general glaze calculation purposes; in practice, the actual materials are variable in composition. It is worth noting, for instance, that a potash feldspar will actually contain some soda, and soda feldspar in turn will contain some potash.

Wood Ash

Some wood ashes and plant ashes could almost be grouped with the feldspathic minerals, in that they are similar in their broad characteristics and constituent oxides. Almost any plant ash may produce usable glaze material, and of course trees are immensely varied in their growth and structure, and the composition of the residual ash from burnt wood will depend upon the kind of soil it was grown in. Typically, a mixed wood ash from a pottery materials supplier will have a comparatively high content of alkali fluxes, particularly calcium, and a very much lower alumina and silica content than found in a feldspar.

This may cause crystallization of a glaze if large quantities of ash are used.

Ash can be prepared from any burned plant material (even coal ash gives usable material), but it is a laborious, though rewarding, task if you have the inclination. It is better to burn the wood or plant material in a brick stove to reduce the risk of iron contamination from iron gratings and the like. The ash will then need thorough 'washing' to remove the large amounts of soluble alkali, but there will still be enough alkaline flux left in relatively insoluble form to make the ash a useful glaze material (*see* Chapter 12). Ash 'glazing' can also occur in wood-fired kilns where the ash is pulled through the chamber by the hot air and deposited on the surface of the ware, a much prized quality in certain styles of making and commonly referred to as 'fly ash'.

Wood ashes can be used in smaller amounts than feldspars due to their strong fluxing action, but their lower levels of alumina and silica may need to be compensated for by the addition of extra clay.

Because wood ashes vary so much it is often thought not worthwhile to give a formula. While this is broadly true, I believe the following theoretical formula is useful, with the rider that it ignores small amounts of impurities, and actual ashes may differ quite significantly.

Wood ash $0.1KNaO.0.1SiO_2$
 $0.1MgO$
 $0.8CaO$

This ash would have a molecular weight of 63.

Frits

These can be regarded as artificially made feldspathic materials. They have been developed because so many of the fluxes that will work at lower temperatures are only found in soluble and therefore impractical form, or are combined with more refractory oxides in proportions that make them more suitable for high temperature glazes, such as feldspars. Fritting is also essential for lead compounds in order to render them non-toxic and safe against lead release when used with acidic food and liquids.

A frit is made by melting the raw materials together in a special furnace; the molten 'glass' is then fast cooled by being discharged into water where it shatters, making the subsequent regrinding into a fine powder more easy.

The commonest frits are lead, borax and alkaline frits. These are all strong low temperature fluxes that are soluble in their raw forms, and, in the case of lead, poisonous. The material with which they are fritted is essentially silica, usually with a small amount of alumina. When their proportions are carefully balanced, the resulting frit is a material in which the borax, lead, soda or potassium is no longer soluble because it has become 'locked' into the molecular structure of the alumina and silica. Poisonous materials like lead are also rendered less harmful, or even completely safe, by this process. Early frits were fairly crude mixtures of, for example, lead, clay and flint, but now they can be sophisticated blends of several oxides and fluxes designed for specific temperatures. In the same way that a feldspar is an ideal basis for a high temperature glaze, a frit can be the same for a low temperature glaze, and may constitute up to 80 or even 100 per cent of the glaze.

Some examples of common frit recipes are given below (courtesy of Potclays Ltd):

SUBSTANCE	CHEMICAL FORMULA		
Lead bisilicate frit	$PbO.$	$0.086Al_2O_3.$	$1.85SiO_2$
Lead sesquisilicate frit	$PbO.$	—	$1.54SiO_2$ $0.125TiO_2$
Alkali frit	$0.5Na_2O.$ $0.33K_2O.$ $0.17CaO$	$0.236Al_2O_3.$	$1.5SiO_2$
Calcium borate frit	$CaO.$	$0.097Al_2O_3.$ $1.5B_2O_3$	$0.609SiO_2$
Borax frit	$0.033K_2O.$ $0.330Na_2O.$ $0.634CaO$ $0.003MgO$	$0.173Al_2O_3.$ $0.630B_2O_3*$	$1.88SiO_2$

**Note*: Although boric oxide is the flux that gives its name to this frit, it may be grouped with either the other intermediate sesquioxides or with silica because of its secondary role as a glass-forming oxide when written into formulae (*see* Chapters 8 and 10).

Barium Carbonate (BaCO₃)

Barium carbonate provides the universal source of barium for use in glazes. It is a poisonous

material and should be handled carefully to prevent contact with the skin and inhalation. It is an important secondary flux for higher temperatures in amounts up to 10 per cent and is useful for creating crystalline matt glazes when added in larger quantities, up to 25 to 30 per cent of the recipe total.

It is sometimes added to clays in quantities of 1 to 2 per cent to neutralize the soluble salts that can cause unattractive 'scumming'.

Whiting (CaCO₃)

Whiting is a cheap and 'pure' source of calcium oxide. It is properly called calcium carbonate, but as with all the carbonates it should be remembered that the carbon is given out as a gas (CO_2) at low temperatures and plays no part in the fusion process. For this reason, the carbon is sometimes ignored in the formula, which is then written as simply CaO.

Calcium in the form of whiting is a useful secondary flux which can create crystalline mattness in larger quantities, up to 10 per cent in earthenware glazes and up to 30 per cent for stoneware glazes. It is also used as a body flux.

Colemanite (2CaO.3B₂O₃.5H₂O)

Colemanite provides a natural source of calcium and boric oxide, in which the boric oxide is in an insoluble form. In combination, they form a very strong fluxing agent whose main drawback is their large amount of chemically combined water. This can cause the glaze to fall off the pot in the early stages of firing as the water turns to steam. Many people use calcium borate frit as a substitute, although its fluxing properties are not quite as strong.

In America the material Gerstley borate is used. This is a variety of colemanite; the two substances are very similar and are interchangeable in recipes.

Wollastonite (CaSiO₃)

This is an alternative source of calcium in higher temperature glazes. It combines calcium with silica and is sometimes preferred to whiting,

because it has less tendency to cause pinholing in the fired glaze surface.

Bone Ash (Ca₃.[PO₄]₂)

More accurately termed calcium phosphate, bone ash comes from calcined cattle bones (it is now available in synthetic form), and is used, like other forms of calcium, as a secondary flux. The phosphate it contains is a glass-forming oxide, and in this combination it encourages a 'milky' opacity in the glazes in which it is present. It is a useful ingredient in achieving the beautiful opalescent blue that is characteristic of chun glazes.

Dolomite (CaCO₃.MgCO₃)

Dolomite combines calcium and magnesium carbonate in roughly equal measure, making it a material which is only useful as a glaze flux at higher temperatures, 1180°C and above. It conveniently combines the qualities contributed by calcium carbonate and magnesium carbonate individually, and is particularly useful in creating smooth, crystalline matt glazes for high temperatures when used in amounts up to 25 to 30 per cent. It is rarely used in low temperature glazes.

Fluorspar (CaF₂)

This is the mineral known as Blue John, a form of calcium combined with fluorine, which is given off as a gas during firing. Fluorspar contributes the fluxing properties of calcium, but the presence of fluorine gas causes problems of bubbling and blistering, which, unless desired (*see* Cryolite), makes it an unwise choice when there are more practical sources of calcium available.

Magnesium Carbonate (MgCO₃)

This is a pure source of magnesium oxide. It is a secondary flux, but does not become active as one until even higher temperatures than calcium, and so is not really useful at all in low

temperature glazes, except possibly as an inert opacifier and matting agent. Also like calcium, it creates crystalline mattness in larger quantities in a glaze, and can consist of up to 25 per cent of the glaze total. It is sometimes called magnesite in its purest form.

Talc (3MgO.4SiO$_2$)

Talc is used in glazes to introduce magnesium and silica, and is also known as steatite, soapstone or French chalk. These are all variations of a mineral which is roughly composed of three parts magnesium to four parts of silica, and is more accurately termed as magnesium silicate. Talc can make up more than twice as much of the recipe as magnesium carbonate because it is 'diluted' by the more than 50 per cent silica it contains, which would reduce the need for silica supplied by clay or flint and quartz.

Talc is sometimes introduced into earthenware clay bodies as a catalyst, encouraging the conversion of silica into cristobalite to increase the expansion/contraction coefficient of the body and to reduce crazing. Paradoxically, talc reduces the expansion/contraction characteristics of stoneware bodies and therefore improves their thermal shock resistance.

Zinc (ZnO)

Zinc does not occur in other compounds that are used in studio ceramics, and the pure form in which it is widely available provides the only practical source of zinc. It is a secondary flux and causes crystalline mattness in quantities above 10 per cent (20 per cent maximum). It is an essential ingredient of those crystalline glazes in which larger sized crystals are desired.

Calcined Alumina (Al$_2$O$_3$)

This can also be obtained in hydrated form (Al$_2$O$_3$.2H$_2$O) and is the pure source of alumina oxide, the most important glaze stabilizer. However, it is rarely added in this form because of its coarse and gritty nature, and also because so many of the raw mineral compounds used in ceramics contain alumina in any case. For this

reason, the alumina content of a glaze is usually satisfied by clays, feldspars or frits.

It is a very refractory material and its main use, when mixed with china clay, is as a protective coating on kiln furniture to prevent 'fusing on' of the ware to the shelves in firing. It is also good as a placing material to support ware that might warp during firing.

Flint (SiO$_2$) and Quartz (SiO$_2$)

Flint and quartz are both sources of silica, and in glazes the two are interchangeable. Both forms provide pure silica, the main glass-forming oxide, although it is not always necessary to add either, as often the silica content of the feldspars, clays and other minerals that are used can be sufficient. Increasing the silica in either the clay body or the glaze (or both) can help to reduce crazing.

Cristobalite (SiO$_2$)

Cristobalite is another silica formation that is created naturally from quartz and in particular from flint, during the firing process within clay bodies. It can also be obtained commercially, but is only added to earthenware bodies in small quantities of 2 to 5 per cent to reduce subsequent crazing of the glaze. It is of no extra value in glazes as it will behave in exactly the same way as quartz and flint.

Zirconium Silicate (ZrO$_2$.SiO$_2$)

This is the most frequently used material for adding zirconium into a glaze. It is also available as pure zirconium oxide (ZrO$_2$), but this does not disperse so well in the glaze. The principal use of zirconium is as an opacifier, with the silicate form obviously being weaker than the pure oxide form – 10 to 15 per cent will usually be sufficient to opacify a glaze. When using zirconium silicate in large quantities it may be necessary to adjust downwards the silica content supplied by other materials like flint or quartz.

Zirconium is a very refractory oxide, and the silicate can be used as a protective 'bat-wash' if mixed with around 10 per cent of china clay. It

is also a very hard material and improves the scratch resistance of the glaze.

Tin Oxide (SnO₂)

Tin has tended to be the traditional choice of opacifier, but is now used less often on cost grounds. It is however, generally held to be the best material for opacification, giving a pleasant, softer white than zirconium; 10 to 12 per cent is usually sufficient for full opacity. Tin has an interesting reaction with small amounts of chromium oxide, an oxide that usually gives green, and produces a soft pink when added to a recipe in quantities of 5 to 10 per cent tin, to 0.1 to 1 per cent chrome. It is also useful in developing and stabilizing the colour in copper red reduction glazes.

Titanium Dioxide (TiO₂)

As a dioxide like zirconium and tin, titanium can also be grouped with the glass-forming oxides, although these three substances are more often thought of as glaze modifiers in that they produce whiteness and therefore opacity. Titanium, however, is a bit more interesting than the other two modifiers in that it interacts with the other materials in the glaze more readily. Zirconium and tin opacify glazes by being evenly dispersed as a cloud of inert white particles in the melt.

Titanium creates opacity by forming small crystals in the glaze in a similar way to the secondary fluxes, calcium, barium, magnesium and zinc. It also has the ability to 'pull' colour from the body into the glaze. A glaze opacified with tin or zirconium over, say, an iron red body, might dimly reveal that colour through the glaze, but one opacified with titanium will have taken up some of the iron into the glaze, causing it to be streaked with brown. Titanium tends to encourage mottled effects where colour is present, but can also subdue colours when used in large percentages, although it is not often used in amounts over 10 per cent.

Titanium is also crucial when more obvious crystal formations are required in crystalline glazes (*see* Chapter 12), and in conjunction with zinc in particular can produce spectacular effects.

Titanium also occurs in impure forms known as rutile and ilmenite. These are contaminated with iron and are often thought of as colouring oxides, and are used in the same way.

Silicon Carbide (SiC)

This is strictly speaking not really a glaze material, in that it is an artificially manufactured dust. It is used as an abrasive, which when incorporated in a glaze in small quantities, say 1 to 5 per cent, can cause 'local reduction' effects and/or crater glazes (*see* Chapter 12).

10 ◆ The Basic Chemistry of Glazes

Before we look more closely at how glazes work it is necessary to become familiar with some of the language and terminology of ceramic chemistry. It is very useful to develop a familiarity with the chemical symbols for the materials that are used in ceramics, as these symbols give information about which oxides are present in the material, and are the key to a greater depth of understanding of how the oxides interact with each other, the functions they perform and how we can use them.

It is probably true to say that many creative people have a fear of science, and long experience of teaching art students has confirmed this. However, I have also found that if the initial unfamiliarity can be overcome, ceramic chemistry and creative manipulation of the materials can add a whole new layer of meaning and aesthetic pleasure to the objects made in clay.

The chemistry dealt with in the following sections is very basic, and the maths that is involved consists largely of addition, subtraction, multiplication and division, albeit sometimes of very small decimals.

The basic substances that make up the world are called elements (*see* Table of Elements, page 173). An element is a pure substance and most materials we see and touch are composed of many different elements in combination – it is quite rare to encounter one in isolation. Most of the elements used in ceramics are in the form of oxides, that is, combined with oxygen. A simple example would be cobalt oxide represented by the symbol, CoO, where Co represents the element cobalt, and O represents oxygen. When only the letters are present, this means that for every single atom of cobalt in cobalt oxide, there is a single atom of oxygen. When there is a subscript number after an element symbol, for example Li_2O (lithium oxide) it signifies that there are two atoms of lithium combined with one atom of oxygen. Both of these examples would be correctly termed monoxides because this term identifies them as belonging to the group of materials with this characteristic in common of combining with only one atom of oxygen. This gives us useful information regarding how the particular oxide might behave when used in ceramic processes (*see* Grouping of Oxides According to Function, page 80). The other most important combinations for us are the sesquioxides, that is, two atoms of one element combined with three atoms of oxygen, for example Al_2O_3 (alumina sesquioxide), and the dioxides, for example SiO_2 (silica dioxide). It is worth noting that in practice it is common in ceramics to be lazy when speaking about the various materials such as monoxides, sesquioxides, dioxides, pentoxides, and so on, and generally to refer to them simply as 'oxides'.

It is also very important to remember that we deal with real materials that are dug from the ground, with many impurities and variations. The many different sources of the materials used in ceramics ensure that materials with the same name may not be completely identical. Many of the chemical formulae used in this book are 'theoretical', in the sense that the actual material may be variable or have a slightly different composition depending upon its origin. Usually, however, these theoretical formulae are quite

adequate for most of the calculations that are required in studio ceramics; greater accuracy can be achieved by obtaining precise analyses from suppliers if required.

Formation of Compounds

We have already seen that the elements are the basic substances from which everything is made up, and the smallest indivisible part of any element is the atom. The weight of the atoms of different elements is never the same and is based on the weight of an atom of hydrogen.

As the lightest element, hydrogen was ascribed the arbitrary but convenient value of 1, and the weights of all other elements are related to it. Therefore oxygen, whose atomic weight is 16, is sixteen times heavier than hydrogen, and so on. These numbers are known as atomic weights (aw) and are unique to each element (*see* page 173).

When the atoms of two or more elements combine they form a compound, in which the atoms are linked in molecules. A simple example is:

$$silicon\ dioxide = SiO_2$$

The chemical formula SiO_2 is used for both flint and quartz, the two minerals that provide a pure source of silica for clays and glazes. The elements are identified by either one or two letters, the first of which is always a capital. Subsequent capitals in the formula denote the presence of another element. In this example above, Si represents the element Silicon; the next capital, O, represents oxygen; and the subscript $_2$ indicates the number of atoms of that element present in the compound. Silicon dioxide – SiO_2 – is therefore a compound consisting of:

$$One\ atom\ of\ silicon\ (Si) + two\ atoms\ of \\ oxygen\ (O \times _2)$$

More complicated materials are expressed to indicate the proportions of the individual compounds to each other. For example, the formula for talc is:

$$3MgO.4SiO_2.H_2O$$

The formula breaks down thus:

$$MgO = one\ atom\ of\ magnesium + one\ atom\ of \\ oxygen = one\ molecule\ of\ magnesium\ oxide;$$

$$SiO_2 = one\ atom\ of\ silicon + two\ atoms\ of\ oxygen = \\ one\ molecule\ of\ silicon\ dioxide;$$

$$H_2O = two\ atoms\ of\ hydrogen + one\ atom\ of \\ oxygen = one\ molecule\ of\ water.$$

The large numbers in front of the capital letters, for example, **3**MgO, refer to the relative number of molecules of magnesium oxide present in relation to the other materials in the compound. When there is no number before the capital, it is important to remember that this signifies that there is only one molecule of the oxide.

Therefore, talc ($3MgO.4SiO_2.H_2O$) is a compound in which for every:

three molecules of magnesium oxide

there are: four molecules of silicon dioxide

and: one molecule of hydrogen oxide (water).

The full stops indicate the separation of one oxide from another. Talc, in fact, is more accurately described as hydrated magnesium silicate.

A formula like the above usefully shows the ratio of the oxides to each other. Disregarding the water (H_2O), which though it may affect the physical properties of talc before firing, will obviously play no part in the high temperature fusion in a glaze fire, the formula shows clearly that for every three parts of magnesium (flux) added to a glaze by talc, four parts of silica (glass former) will also be added.

Sometimes this relationship is expressed in a different way. For instance, lead sesquisilicate ($2PbO.3SiO_2$) is the name given to the fritted compound of lead and silica melted together in the ratio of three parts of silica to every two parts of lead. It is equally accurate and perhaps easier to see when it is expressed as $PbO.1.5SiO_2$, or one part lead to one and a half parts of silica. The ratio is the same whichever way it is expressed, but it is important to be aware that the same formula can be written down in different ways, and that in glaze chemistry there is as yet not always a standard expression for all the materials.

Molecular Weight of Compounds

The molecular weight of a compound is simply the combined total of the atomic weights of the individual elements that make up the compound.

The molecular weight (MW) of a material is crucial because it has a direct bearing on the physical weight in grammes or ounces, as used in the glaze (*see* Molecular Equivalent Formula and Glaze Calculation, page 82).

Example: Soda Feldspar mw 524.6

Formula = $Na_2O.Al_2O_3.6SiO_2$*

**Note*: Theoretical formula; analysis of actual material may vary.

The elements present in this material are indicated by the capital letters in the formula:

Sodium:	Na,	aw = 23
Oxygen:	O,	aw = 16
Aluminium:	Al,	aw = 27
Silica:	Si,	aw = 28.1

The numbers of atoms of each element are indicated by the subscript numerals, and where the number of molecules is greater than one, it is indicated by a large numeral.

Calculation

$$Na_2O = 23 \times 2 + 16 = 62.0$$
$$Al_2O_3 = 27 \times 2 + 16 \times 3 = 102.0$$
$$\underline{6SiO_2} = \underline{6} \times (28.1 + 16 \times 2) = \underline{360.6}$$
$$\text{Molecular Weight} = 524.6$$

Therefore the molecular weight of soda feldspar is simply the combined weights of the atoms that make up this particular compound. The calculation is straightforward, but remember that the subscript numbers refer to the elements preceding them, and the large numerals refer to the number of molecules of any particular oxide. In this case, the weight of silica, 60.1 is multiplied by six, the number of molecules of silica oxide indicated by the formula.

The RO Formula

Grouping Oxides According to their Function in Glazes

Grouping oxides together according to the functions they perform is a way of conveying information in a simple and compact form. It is a common convention in ceramics to group the oxides in a particular order: flux first, followed by the amphoteric sesquioxides, and finally the dioxide glass formers.

Boric oxide is a notable exception to this rule and presents some difficulty in that although it is a sesquioxide (like alumina), its primary function is that of a flux, but it is also an important secondary glass former (like silica). For these reasons, it can occur in any of the three categories. My own preference is to list it in the middle sesquioxide column, while remembering that it has a dual role.

The method commonly used for notating materials and glaze formulae is the RO formula, and this has been used consistently in this book already. The ingredients in a material or glaze are listed in the order of monoxides (RO), followed by the sesquioxides (R_2O_3), and finally the dioxides (RO_2). The R is actually short for Radical, and its function here is to stand in for any appropriate monoxide, sesquioxide or dioxide, in the same way that x or y function in algebra.

The RO table opposite consists of the main glaze oxides that make up the glazes that we use. There are many other oxides that we use that also fit these categories, but they are ignored here because their prime function is not that of a main glaze oxide (that is, flux, stabilizer or glass former). For example, some of the colouring oxides are monoxides (RO) and powerful fluxes. They are largely ignored in this context because they are primarily used to add colour to the glaze, and their strength as a colouring agent precludes their use in large enough quantities to be thought of as significant fluxes. Similarly, tin oxide is a dioxide (RO_2) and would be properly listed with silica, although its prime role is that of an opacifier.

The first group (RO) fluxes can in fact be recognized by their chemical symbols, as they are all (with the one notable exception) monoxides, that is, an element which has combined with only one atom of oxygen (*see* table above right).

The R_2O_3 group consists of those compounds which combine with oxygen in the

RO Table

	RO		R₂O₃		RO₂
		alumina	Al_2O_3	silica	SiO_2
Lead oxide	PbO	(sesquioxide)		(dioxide)	
Potassium oxide	K_2O	boric	B_2O_3		
Sodium oxide	Na_2O	(sesquioxide)			
Lithium oxide	Li_2O				
Barium oxide	BaO				
Calcium oxide	CaO				
Magnesium oxide	MgO				
Zinc oxide	ZnO				

Example

If we take three commonly used glaze materials:

Feldspar potash	$K_2O.Al_2O_3.6SiO_2$
Whiting	CaO
China clay	$Al_2O_3.2SiO_2$

The RO formula applies in this way:

	RO	R₂O₃	RO₂
Feldspar potash	$K_2O.$	$Al_2O_3.$	$6SiO_2$
Whiting	CaO.	–	–
China clay	–	$Al_2O_3.$	$2SiO_2$
	(fluxes)	(stiffener)	(glass)

ratio of 2:3, that is two atoms of element to three atoms of oxygen. This group forms the sesquioxides, which normally act as the glaze stiffener (the oxide normally used in this context is alumina).

The RO_2 group are compounds where the ratio of element to oxygen is 1:2, or one atom of element to two atoms of oxygen. These are the dioxides and are glass formers, the most important being silica.

We can now see clearly the functions that the individual oxides in the materials are performing. Glaze materials are always written out according to this rule.

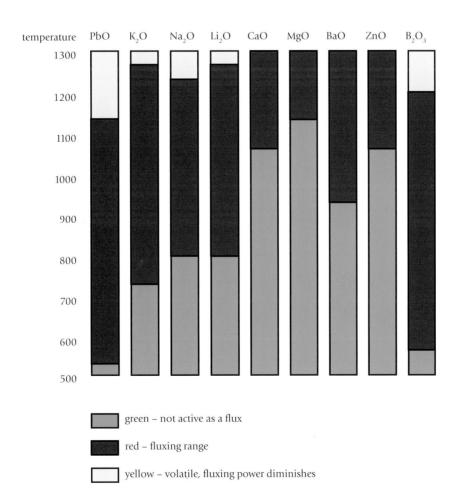

Effective firing range of main flux oxides.

green – not active as a flux

red – fluxing range

yellow – volatile, fluxing power diminishes

Molecular Equivalent Unity Formula, and Glaze Calculation

We have already looked at the materials used in glazes, and how to group them according to function, but to devise and manipulate glazes a system has been developed which will tell us clearly the relative quantities of each oxide.

Because many of the materials used in glazes are complicated compounds involving many of the oxides in varying forms and quantities, it is hard when looking at a percentage recipe to be able to see at a glance accurately what the relative amounts of flux, alumina and glass actually are. Molecular equivalent formulae are a way of showing the precise relationships of these materials.

Example of a Molecular Equivalent Formula

If we take a simple percentage recipe we can contrast the information given by the different ways in which such glazes are presented for example:

Lead bisilicate	90
China clay	10
Total	**100%**

The lead bisilicate used here is a fritted compound of lead and silica in the ratio of one part lead to two parts silica.

China clay is a natural compound of alumina and silica, also in the ratio of 1:2.

If we now arrange these constituent oxides according to the RO formula to show their functions as either flux, stabilizer or glass:

	RO (FLUX)	R_2O_3 (STABILIZER)	RO_2 (GLASS)
Lead bisilicate supplies	PbO	–	$2SiO_2$
China clay supplies	–	Al_2O_3	$2SiO_2$

On the face of it, it looks as though we might have a glaze which has four times as much silica as lead, and similarly one part alumina to four parts silica. Unfortunately, it is not as simple as

this, as these materials are composed of oxides and elements of very different atomic weights, and it is the different molecular weights of the raw materials that finally determine the relative composition of the glaze batch.

A system is therefore needed which can show these 'molecular' relationships, that is the relative or equivalent number of molecules of one oxide to another. To arrive at these equivalent numbers of molecules is in fact very simple, in that the percentage amount in the recipe is divided by the molecular weight (*see* materials list) of that particular material:

Lead bisilicate $90 \div 343.5$ MW = 0.262
(0.262 is the molecular equivalent number for lead bisilicate)

China clay $10 \div 258.2$ MW = 0.040
(0.040 is the molecular equivalent number for china clay)

The molecular equivalent number can be used to express the relative number of molecules of one oxide to another in the same material by multiplying it by the number of molecules of each oxide in the material:

Lead bisilicate (1) PbO \times 0.262 = 0.262
($PbO.2SiO_2$)
 $2SiO_2 \times 0.262 = 0.524$

China clay (1) $Al_2O_3 \times 0.040 = 0.040$
($Al_2O_3.2SiO_2$)
 $2SiO_2 \times 0.040 = 0.080$

If we now place the molecular equivalent amounts in a table in their correct categories we can see the equivalent of how many molecules of each oxide there are in the recipe relative to each other:

	RO	R_2O_3	RO_2
Lead bisilicate ($PbO.2SiO_2$)	PbO 0.262	–	$2SiO_2$ 0.524
China clay ($Al_2O_3.2SiO_2$)	–	Al_2O_3 0.040	$2SiO_2$ 0.080
Totals	0.262	0.040	0.604

Bringing the Fluxes to Unity

To make it easier to see the relative quantities of oxides it is a standard practice to divide these

numbers through by the total in the flux column. This is called bringing the recipe to 'unity'. Molecular equivalent formulae are sometimes referred to as unity formulae because of this:

$$0.262 / 0.262 = 1$$
$$0.040 / 0.262 = 0.153$$
$$0.604 / 0.262 = 2.305$$

RO	R_2O_3	RO_2
PbO	$0.153 Al_2O_3$	$2.305 SiO_2$

Comparing the formula to the percentage recipe, it can be seen more clearly from the formula the amount of each of the essential ingredients that we have in proportion to one another.

The Limit Formulae

In itself the above might still not be that helpful without the experience and knowledge of the raw materials and the oxides they contain, but we do also have a framework of formulae from which glazes can be constructed. These are known as the 'Limit Formulae' (*see* table on page 177) and lay down guidelines, rather than absolute limits, for the molecular equivalent amounts of each of the essential glaze oxides needed to form various types of glazes at a range of temperatures.

Glazes can be easily formulated by choosing from the selection offered. The golden rule to remember is that in choosing the fluxes they must always add up to one or 'unity'.

EXAMPLE – SELECTING A SUITABLE GLAZE FORMULA FROM THE LIMIT FORMULAE

Following is the limit formula for earthenware alkaline-dominated glazes for the temperature range 950°C–1050°C

PbO	0.0–0.5	Al_2O_3 0.10–0.25	SiO_2 1.5–2.5
KNaO*	0.4–0.8		
CaO	0.0–0.3		
ZnO	0.0–0.2		

A possible selection might be:

PbO	0.3	Al_2O_3 0.15	SiO_2 2.2
KnaO*	0.6		
ZnO	0.1		
	1.0		

*Note: KNaO is the symbol used to denote the presence of *either* potassium (K_2O) or soda (Na_2O), or a combination of both. This combined symbol is used because they are similar in strength and so in this sense they are interchangeable. This is a confusing convention, but it is very widely used and should not cause undue problems once known. Similarly, lithium is not specifically mentioned in the limit formulae; again this is a common convention, but the guideline limits for KNaO can be taken to apply to lithium also.

The use of the limit formulae at least ensures that we get a workable glaze, and adherence to them will produce a stable glassy melt. The above possible glaze formula could be converted to a recipe by reversing the procedure outlined in Molecular Equivalent Unity Formula above, and examples calculations will be shown later in this section.

In studio ceramics it is quite common to exceed the limits in the so-called limit formulae and a few points should be borne in mind:

- High amounts of primary flux (lead and alkali) will increase fluidity and brightness.
- High amounts of the secondary fluxes will increase opacity and encourage crystalline mattness.
- Low amounts of alumina will increase fluidity, high amounts will decrease fluidity and increase mattness.
- Low amounts of alumina and silica will produce soft glaze surfaces that are easily scratched.
- Higher amounts of silica increase strength, durability and craze resistance.

Converting From a Molecular Equivalent Formula to a Recipe

To make good use of the information in the previous sections and the limit formulae, a method is needed of calculating back to a percentage or batch recipe that can be made up from the various mineral and metal oxides in everyday workshop use.

In this section, the same example which has been given previously, a percentage recipe converted to a molecular equivalent formula, is used. The example below is worked back to a percentage recipe and then goes on to illustrate how alternative recipes can be produced from

the same formula. More complex examples are also given in Chapter 13.

Example	%
Lead bisilicate	90
China clay	10
Total	**100%**

whose molecular equivalent formula is:

PbO	Al_2O_3	SiO_2
1	0.153	2.305

(A comparison with the limit formulae will show that this glaze conforms to the limits for an earthenware lead glaze.)

This type of formula can be converted back to a recipe by reversing the procedure of dividing the recipe amount by the molecular weight of each compound, to multiplying the molecular equivalent amounts in the formula by the molecular weights of the selected materials. This will give us batch quantities that can be expressed in percentage terms if required. In this first instance, the compounds used will be the same as in the recipe to the formula example given earlier so as to illustrate the methodology clearly.

First, suitable materials that contain the oxides included in the formula are chosen (and this is when familiarity with materials and their chemical symbols is so useful). In this case, it is simple as we already know that we are to use lead bisilicate and china clay, and are simply reversing the procedure.

Let us begin with the first (and in this case only) flux oxide, lead. There is one whole molecular equivalent of this oxide required in the formula. Lead bisilicate is the material chosen to supply the lead, with a known formula of $PbO.2SiO_2$. If this is compared with the glaze formula by writing it out underneath, what the glaze needs can be compared with what lead bisilicate provides:

Oxides required	PbO	Al_2O_3	SiO_2
Equivalent amount required	1	0.153	2.305
Lead bisilicate supplies	1	–	2
Oxides remaining	–	0.153	0.305

If the oxides supplied are subtracted from the oxides required, it can be seen that lead bisilicate provides all the lead oxide, none of the alumina and most of the silica. The next step is to find a material (or materials) to satisfy the outstanding molecular equivalents required in the formula. In this case, that material is china clay, with the formula $Al_2O_3.2SiO_2$. China clay will add the equivalent of two molecules of silica for every one molecule of alumina. In this formula, only 0.15 molecular equivalents of alumina are required, but the same ratio of silica to alumina still applies, that is for any given amount of alumina, china clay will also contribute twice as much silica:

Oxides required	PbO	Al_2O_3	SiO_2
Equivalent amount required	1	0.153	2.305
Lead bisilicate supplies	1	–	2.0
Oxides remaining	–	0.153	0.305
China clay provides	–	0.153	0.305
All oxides supplied	–	–	–

All that remains is to reverse the procedure undertaken when the recipe was first converted into formula (by division of the recipe amount by the molecular weight of the material). This time, the molecular equivalent numbers of the prime oxide of each selected material is *multiplied* by its molecular weight.

The prime oxide in a formula is the oxide that determines the molecular equivalent (ME) amount of the raw material that the formula represents. In the example, lead is the prime oxide that lead bisilicate ($PbO.2SiO_2$) will supply to the formula. Alumina is the prime oxide that china clay ($Al_2O_3.2SiO_2$) is to supply.

The prime oxide that lead bisilicate is being used to supply is lead. The molecular equivalent amount of lead required by the formula is 1. The molecular weight of lead bisilicate is 343.5. Therefore, the calculation is:

1 (PbO) × 343.5MW = 343.5 parts lead bisilicate.

The prime oxide of china clay is alumina. The molecular weight of china clay is 258.2.

0.153 (Al_2O_3) × 258.2MW = 39.5 parts china clay.

Therefore the batch recipe will be:

Lead bisilicate	343.5 parts
China clay	39.5 parts
Total	**383.0** parts (ounces, grams, tonnes, and so on)

To convert to a percentage recipe, we divide each batch item by the batch total and multiply by 100:

$$\frac{\text{batch item}}{\text{batch total}} \times 100 = \%$$

For example
$$\frac{\text{(item) } 343.5}{\text{(total) } 383.0} \times 100 = 90$$

$$\frac{39.5}{383} \times 100 = 10$$

This brings the formula finally back to its original percentage recipe of:

Lead bisilicate	90
China clay	10
Total	**100%**

So far then, we have seen that dividing the recipe amounts of the raw materials by their molecular weight will give a molecular formula that can be compared to the guidelines given by the limit formulae, and how a limit formula can be used as a starting point and converted back to a batch and percentage recipe.

The next example will show how to substitute different materials from the original recipe, without changing the molecular formula. Working in this way, the possibilities for using the limit formulae to originate a large variety of different recipes becomes apparent.

EXAMPLE OF NEW RECIPE FROM THE SAME FORMULA

	PbO	Al_2O_3	SiO_2
Molecular equivalents	1	0.153	2.305

This time, the formula will be satisfied by different materials. Obviously, the choice is limited to those materials that a) contain the oxides in the formula, and b) do not add extra unwanted oxides. For this example there are only a few materials that will fit the bill:

SUBSTANCE	CHEMICAL SYMBOL
Lead carbonate	$PbO.(CO_2)$*
Lead bisilicate	$PbO.2SiO_2$
Lead sesquisilicate	$PbO.1.5SiO_2$
China clay	$Al_2O_3.2SiO_2.(2H_2O)$*
Flint	SiO_2

*Note: $PbCO_3$ is the full formula for lead carbonate, but it is common practice to disregard those elements that will burn away in firing. In this case, the carbon is ignored as it will play no part in the melt. The same is true for china clay, from which the water (H_2O) is omitted for the same reasons.

Lead bisilicate and china clay have already been tried successfully. This time, different choices are made. It is usually easier to choose materials which supply the fluxes first, and work from left to right.

This time, lead carbonate is chosen because it is a 'pure' source of lead oxide, and this is the only oxide it will contribute to the glaze.

Oxides required	PbO	Al_2O_3	SiO_2
Equivalent amount required	1	0.153	2.305
Lead carbonate supplies	1	–	–
Oxides remaining	–	0.153	2.305

The lead carbonate supplies the required lead and adds no other materials. Moving from left to right, having supplied the lead, the next oxide required is alumina. Bearing in mind the usefulness of having clay in the recipe, china clay can again be used to supply the alumina:

Oxides required	PbO	Al_2O_3	SiO_2
Equivalent amount required	1	0.153	2.305
Lead carbonate supplies	1	–	–
Oxides remaining	–	0.153	2.305
China clay supplies	–	0.153	0.305
Oxides remaining	–	–	2.0

This time, the same molecular quantity of clay is added as last time, dictated by the 0.153 molecular equivalent requirement of alumina. This automatically adds twice as much silica, while still leaving two 'whole' molecules of silica to be found.

Looking at the list of possible materials, flint is the ideal choice because it is a pure form of silica and will add no other unwanted oxides:

Oxides required	PbO	Al₂O₃	SiO₂
Equivalent amount required	1	0.153	2.305
Lead carbonate supplies	1	–	–
Oxides remaining	–	0.153	2.305
China clay supplies	–	0.153	0.305
Oxides remaining	–	–	2.0
Flint supplies	–	–	2.0
All oxides supplied	–	–	–

The batch recipe is again calculated by multiplying the molecular equivalents by the molecular weights of the chosen materials:

$$PbO \ (1) \ ME \times 267.2 \ MW \ of \ lead \ carb = 267.2$$
$$Al_2O_3 \ 0.153 \ ME \times 258.2 \ MW \ of \ china \ clay = 39.5$$
$$SiO_2 \ 2.0 \ ME \times 60.1 \ MW \ of \ china \ clay = \underline{120.2}$$
$$426.9$$

The percentage recipe is calculated from:

$$\frac{batch \ item}{batch \ total} \times 100$$

Final recipe:	Lead carbonate	63
	China clay	9
	Flint	28
	Total	**100%**

The above examples are here to make the methodology familiar and to illustrate the possibilities for the origination of glazes from molecular equivalent formulae. I think it is important to grasp the principles involved in them, in particular the relationship between the molecular weight of a material and the molecular equivalent amounts in the formula in determining the actual recipe quantities of these materials. Even if computer glaze calculation programmes are used to avoid the mathematics, a good knowledge and familiarity with the raw materials and the oxides they contain will enhance the results obtained and improve your understanding of the make-up and behaviour of ceramic glazes.

Further examples of how to exploit these formulae are given in Chapter 13.

11 Sources of Colour in Glazes

Colour is usually achieved in glazes by the addition of colouring oxides or commercial stains. More rarely, it can be created from combinations of the glaze oxides causing refraction of light within the glaze layer. This sometimes gives a distinctive opalescence that often occurs in boric alkaline glazes and deliberately in 'chun' glazes. Any transparent glaze will reveal the colour of the clay body or slip beneath. Colour is also possible through the use

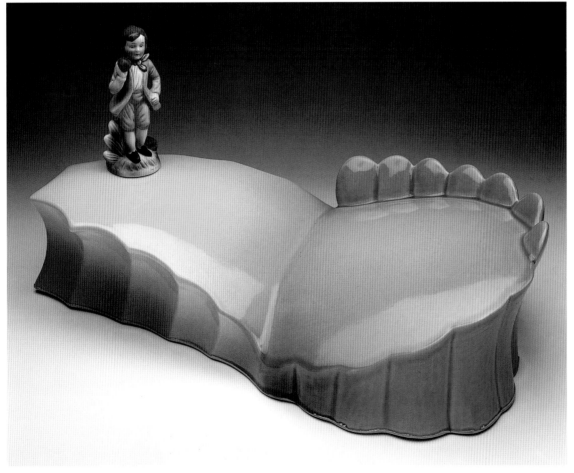

'Boy in Field' by Richard Slee. Slee uses his own recipe, white earthenware body made from ball clay, dolomite and cristobalite that gives brightness to the glaze which is coloured with commercial stains. (Photograph by Zul Mukhida.)

*C*obalt decorated
plate by Phil Eglin.
Collection of the
author. (Photograph by
Dick Brown.)

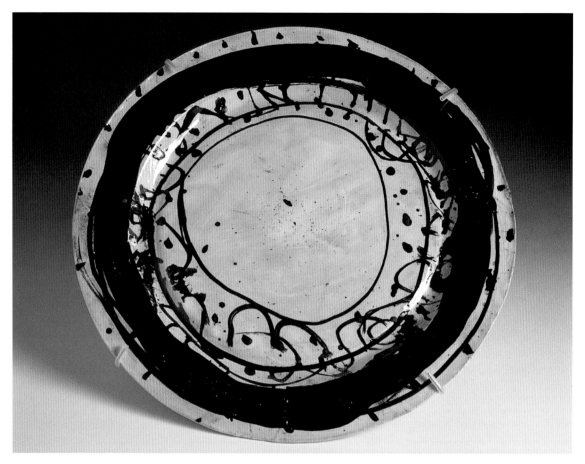

*O*palescence in a
high alkaline/borax
glaze.

of 'impure' materials which can contribute colour, often through iron, but also limestone (calcia) which produced the green flecks in the example shown. The very pleasant soft peach-coloured glaze illustrated is made from standard stoneware glaze ingredients and again has no 'added' colour.

It is important to remember that glaze composition, additions of opacifiers, temperature, methods and types of firing atmospheres can all vary the final colour of a fired glaze. In the case of the example recipes in this chapter and in other parts of this book, I would stress that the recipes should be seen as starting points. They are intended to give an indication of the variety and breadth of clay and glaze qualities that can be obtained, and to demonstrate some 'typical' and popular glaze types

All the recipes given have been developed and tested by the author using the various methodologies set out in Chapter 13, but beware! Other people's glaze recipes have an annoying habit of not working out when you try them yourself. The truth is that different materials, different suppliers and different kilns and firing cycles all contribute to subtle (and sometimes not so subtle) variations in the results obtained.

Further examples of colour effects can be found in the following chapter, *Glaze Types*, and it must be remembered that there is a large range of subtle variations possible by using the colouring oxides in combination. This number of variables produces an enormous range of possibilities, not only for colour, but also for texture, tone and surface, which few other materials can match.

T est bowl with stoneware glaze fired to 1250°C with no added colour.
Recipe:

Nepheline syenite	26
Wollastonite	19
Magnesium carbonate	14
China clay	28
Flint	13

used, either because of a tendency to be unreliable outside of laboratory conditions, or toxicity, or both. For that reason, they are not so readily available and I will therefore concentrate on the more common colouring oxides

I have not included a general table for suggested oxide additions to glazes for specific colour results for the reason, as I hope the examples given above show, that colour responses from oxides are so dependent upon the constitution of the glaze that any prescribed list would be at best vague, and at worst misleading.

The Colouring Oxides

The colouring oxides are those metal oxides that when melted in a glaze give colour to it. They are a relatively small group of oxides, each one characteristically associated with one particular colour, but also able to create other colours in combination with other glaze oxides.

Copper, cobalt, iron and manganese are very commonly used as colouring oxides, with chrome, nickel and vanadium less so but in enough quantities to be generally available from pottery suppliers. There are a number of colouring oxides, such as antimony, cadmium, cerium, selenium, uranium and others that are rarely

Chromium Oxide (Cr_2O_3)

As a sesquioxide like alumina, chromium oxide is a refractory material that mainly gives strong opaque greens. The opacity occurs partly because it is a sesquioxide and does not dissolve so easily in the melt and can sometimes result in a particularly unattractive shade and quality of green. It tends to be better in glazes fluxed with boric oxide or soda, and if 1 per cent chrome is combined with 1 per cent of cobalt in a glaze, a

*T*eapot by Walter
Keeler (above).

*T*ureen by Whieldon,
eighteenth century. The
Potteries Museum,
Stoke-on-Trent.

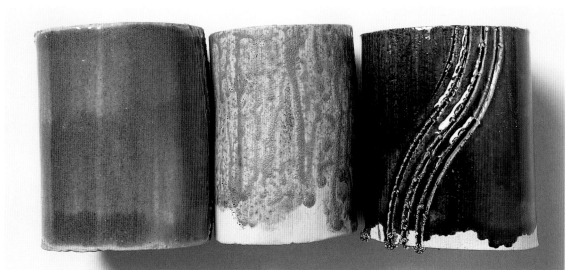

Chrome tin pink, chrome orange and chrome/cobalt 'peacock blue'.

Mug with painted handles by Whieldon, eighteenth century (below). The Potteries Museum, Stoke-on-Trent.

distinctive blue green (very different from turquoise), aptly described as 'peacock' (*see* photograph above) can be obtained.

At low temperatures, chrome can give yellow, orange and red, but the production of these colours is dependent upon glazes fluxed with lead that are also very low in alumina and therefore unstable. As lead frits contain alumina, it is difficult to achieve these colours without using toxic raw lead compounds which are best avoided. However, below is an example recipe for a matt chrome orange that should be fired at 750–800°C; at higher temperatures the colour becomes unstable and the glaze can run badly.

Chrome can give gentle soft pinks at stoneware temperatures between 1200–1250°C in glazes that also contain tin. This colour is dependent upon having only a very small amount of chrome (as low as 0.1 per cent) with about 5 per cent of tin oxide, but there is the drawback that chrome becomes volatile above 1200°C, and in any glaze at that temperature it is also liable to colour or stain other ware in the same firing. Chrome is itself a toxic material that should be stored and handled with care.

Chromium oxide (Cr_2O_3) can be bought in its pure oxide form and it also occurs in other materials useful in ceramics, such as iron chromate ($FeO.Cr_2O_3$) which is a natural combination of iron and chrome that produces greys when mixed with a glaze and is mainly used as a painting pigment. Potassium dichromate ($K_2Cr_2O_7$) is a soluble form combined with a flux which disperses the chrome better in the glaze. It is often used to help achieve chrome reds in low temperature glazes, but is a greater toxic hazard because of its solubility and should be avoided if possible.

*C*ushion dish with two handles by Takeshi Yasuda. Oxidized stoneware with 'sansai' glaze.

*P*ratt ware elephant circa 1800. The Potteries Museum, Stoke-on-Trent.

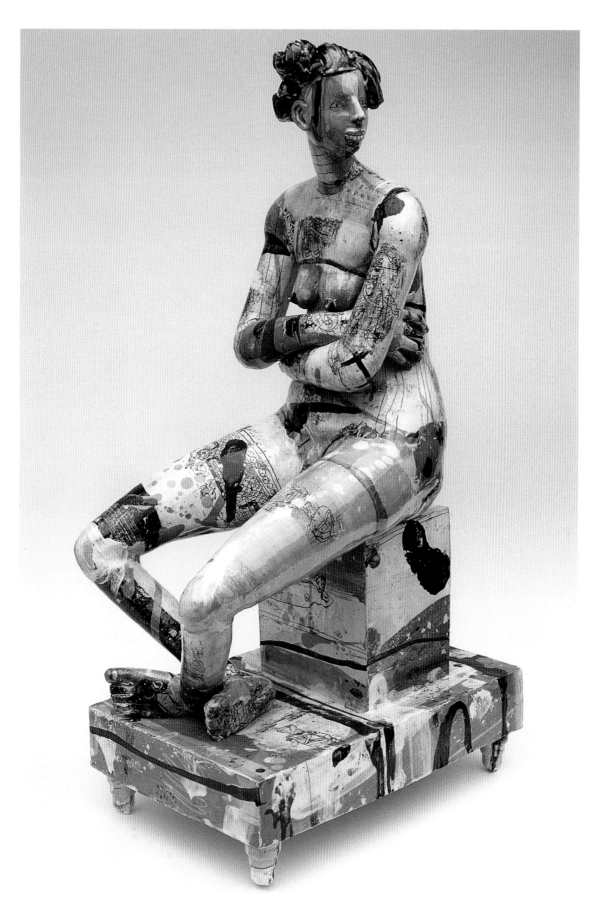

'*S*eated Nude' by
Phil Eglin. Lead glaze
over oxides and slips,
including monoprinted
tissue transfer images.

EXAMPLE CHROMIUM OXIDE RECIPES

Chrome Tin Pink 1200–1250°C Oxidation

Nepheline syenite	26
Wollastonite	40
China clay	21
Flint	8
Tin oxide	5
+	
Chromium oxide	0.1

Molecular formula

$$0.14KNaO. \quad 0.36\,Al_2O_3. \quad 2.23SiO_2$$
$$0.86CaO \qquad\qquad\qquad 0.10SnO_2$$

Aluminium:Silica = 1: 6

This produces a pleasant, glossy, soft pink at 1250°C, more opaque at the lower temperature.

Low Temperature Chrome Orange – 750°C Oxidation

Lead sesquisilicate	73
Lithium carbonate	27
+	
Red iron oxide	0.2
Chromium oxide	4

Molecular formula

0.38 PbO	–	0.59 SiO_2
0.62 Li_2O		

This produces a dry, bright orange/yellow, very sensitive to temperature and due to the absence of alumina will run if overfired. **Not suitable for food use.**

Cobalt Oxide (CoO)

This is the strongest of the colouring oxides and gives intense 'hard' blues in most glazes with a 0.5–1.5 per cent addition of cobalt. It also behaves as a flux, which helps it to dissolve in the glaze, although because it is used in such small quantities it has a limited, but sometimes noticable effect by increasing the 'gloss' of a glaze. Cobalt is a very stable oxide and will not

EXAMPLE COBALT OXIDE RECIPES

Midnight Blue 1250°C Oxidation

Nepheline syenite	41
Standard borax frit	10
Barium carbonate	21
Talc	5
China clay	10
Flint	13
+	
Cobalt oxide	4

Molecular formula

$$0.37KNaO. \quad 0.54Al_2O_3. \quad 2.99SiO_2$$
$$0.09CaO \quad 0.09B_2O_3$$
$$0.15MgO$$
$$0.39BaO$$

Aluminium:Silica = 1: 6

This gives a very intense crystalline blue.

Lithium/Cobalt Pink/Mauve 1250°C Oxidation

Lithium carbonate	8
Magnesium carbonate	10
Barium carbonate	18
China clay	36
Flint	28
+	
Cobalt	1

Molecular formula

$$0.35Li_2O. \quad 0.45Al_2O_3. \quad 2.41SiO_2$$
$$0.35MgO$$
$$0.30BaO$$

Aluminium:Silica = 1: 5

This gives a smooth, matt glaze with a subtle tinge of pink.

EXAMPLE COBALT OXIDE RECIPE

Pale Lilac – 1250°C Oxidation

Nepheline syenite	31
Dolomite	15
Talc	4
Barium carbonate	13
China clay	22
Flint	15
+	
Cobalt carbonate	1

Molecular formula

$$0.20KNaO. \quad 0.5Al_2O_3. \quad 2.35SiO_2$$
$$0.25CaO$$
$$0.35MgO$$
$$0.25BaO$$

Aluminium:Silica = 1: 5

This produces a very delicate soft, smooth matt glaze.

volatilize in firings and migrate onto other ware, but extreme care must be taken not to contaminate other glazes or ware, as a small trace on the hands may result in blue smudges or specks where they are not wanted, particularly in white glazes or on white ware. It is an expensive material to buy but this is mitigated by its use in very small quantities. When large amounts are used the glaze surface can become an unpleasant metallic black, although as much as 5 per cent can be absorbed in a few crystalline matt glazes. More delicacy and subtlety can be obtained from cobalt in alkaline glazes, particularly those that contain magnesium and barium (*see* example recipes), where soft pale lilac can be obtained, and pink in combination with lithium.

Cobalt is usually obtained as either the raw cobalt oxide, a relatively coarse form that can produce pronounced 'specking', or the cheaper and very slightly weaker form of cobalt carbonate ($CoCO_3$) that disperses slightly better in glazes with less risk of specking.

Copper Oxide (CuO)

This is a wonderfully versatile colouring oxide that is very widely used in studio ceramics. It is generally associated with the colour green, which it will produce in a wide variety of shades and tones, from the rich apple green in lead glazes to deep turquoise in alkaline glazes. Its sensitivity and reaction to the various fluxes and firing atmosphere allow it to produce a comparatively large range of colour, from pink in magnesium fluxed glazes to purplish-blue with lithium and barium. Copper will often also give variegated colour and surface quality, particularly in microcrystalline glazes, and above 3 per cent in such a glaze is likely to result in a smooth, stony charcoal grey-black.

At high temperature in a reducing atmosphere copper can produce strong blood red in an alkaline glaze if used in a very small quantity (0.5 per cent or less) in combination with about 3 per cent tin oxide, but sensitivity to reduction also makes it volatile and contamination of other wares can result. This can be particularly unpleasant on certain types of glazes and a flashing of hideous liverish pink can be deposited upon otherwise innocent pots.

At lower temperatures copper is still easily affected by reduction and reds and lustrous surfaces can be obtained, making copper a popular colourant for the raku process.

Like cobalt, copper is to be had in both the raw oxide form, or the slightly weaker but finer carbonate ($CuCO_3$).

EXAMPLE COPPER OXIDE RECIPES

Turquoise blue 1250°C Oxidation

Nepheline syenite	49
Barium carbonate	32
Lithium carbonate	3
China clay	10
Flint	5
+	
Copper carbonate	2

Molecular formula

$$0.34KNaO. \quad 0.52Al_2O_3. \quad 2.03SiO_2$$
$$0.13Li_2O$$
$$0.53BaO$$

Aluminium:Silica = 1 : 4

Gives a rich, smooth, opaque crystalline turquoise blue. When underfired this glaze also shows purple coloration (lower photograph).

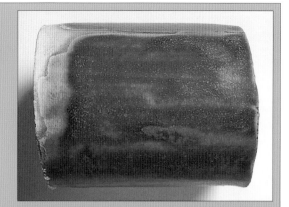

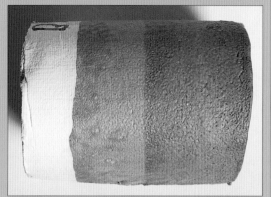

Copper Red Glaze 1280°C Reduction

Soda feldspar	43
Standard borax frit	14
Whiting	14
China clay	5
Flint	19
Tin oxide	5
+	
Copper carbonate	0.5

Molecular formula

$0.33KNaO$	$0.41Al_2O_3$	$3.66SiO_2$
$0.67CaO$	$0.13B_2O_3$	$0.13SnO_2$

Aluminium:Silica = 1 : 9

The test bowl shows the fugitive tendency of the red colour.

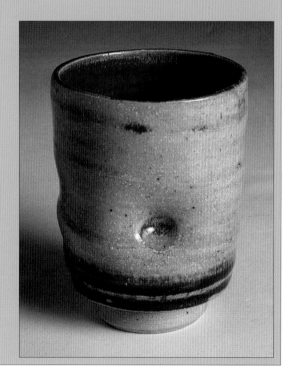

Iron Oxide (FeO)

Fe is short for the latin *ferric*, meaning iron. Iron oxide is used in a variety of forms, and is in some senses one of the most important ceramic oxides, not least because it is so common and is present in so many ceramic materials, either as a major component or as a significant impurity.

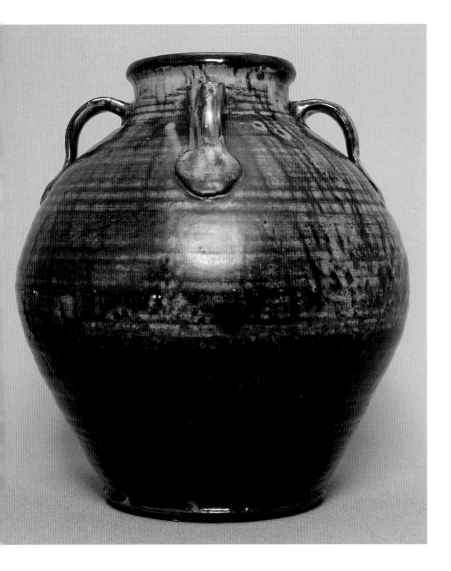

*J*ar with four handles by Michael Cardew. White slip over red earthenware, lead glaze streaked with iron oxide. The Potteries Museum, Stoke-on-Trent.

Red Iron Oxide (Fe₂O₃)

This is the most widely used form of iron oxide, and is a fine red coloured powder which produces shades of brown from pale honey to dark brown with additions of between 2 to 15 per cent. In a lithium glaze, red iron oxide can produce rich textured orange-rust colours. As the

EXAMPLE RED IRON OXIDE RECIPE

Kaki Glaze-Stoneware 1250°C Oxidation (SWMF 4)

Lithium carbonate	4
Dolomite	10
Barium carbonate	22
China clay	28
Flint	36
+	
Red iron oxide	10

Molecular formula

$0.2Li_2O$ $0.4Al_2O_3$ $3.0SiO_2$
$0.2CaO$
$0.2MgO$
$0.4BaO$

Aluminium:Silica = 1: 7.5

This is an oxidation version of the traditionally reduced kaki glaze.

EXAMPLE RED IRON OXIDE RECIPE

Orange-Rust Glaze 1260°C Oxidation

Petalite	53
Magnesium carbonate	9
Bone ash	13
Ball clay	13
Flint	12
+	
Red iron oxide	10

Molecular formula

$0.05KNaO.$ $0.38Al_2O_3.$ $3.32SiO_2$
$0.20Li_2O$
$0.42\ CaO$
$0.33MgO$

Aluminium:Silica = 1: 9

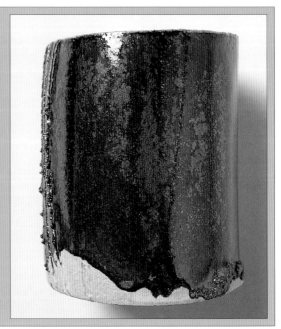

formula indicates, as a sesquioxide it behaves as a stabilizer, although only in oxidizing conditions. When it is reduced (at temperatures above 900°C) it begins to act like the other monoxides and becomes a flux. 'Synthetic' red iron oxide is also available, providing a purer and less variable form.

Black Iron Oxide (FeO)

This is the naturally reduced form of red iron oxide and will therefore have a fluxing effect at earthenware and stoneware temperatures in both oxidation and reduction atmospheres. In reduction firings, 1 to 3 per cent of iron can produce the pale green colour known as celadon; at 5 to 10 per cent the rich opaque black breaking to brown known as Tenmoku; and at 8 to 15 per cent the rich, rust-coloured Kaki glaze. In the typical chun, or 'jun' as it is sometimes known, glaze recipe (*see* Reduction Glazes, Chapter 12), 1 per cent of black iron is used.

Iron Spangles (Fe₃O₄)

Iron spangles, or magnetic iron, is a coarse form that looks like iron filings and produces 'spangled' effects in glazes.

Crocus Martis (FeSO₄)

This is a weak and soluble form that is sometimes calcined to make it only partially soluble. At high temperatures it can produce speckled honey-brown colours.

Iron Chromate (FeCrO₃, see chrome also)

Iron chromate contributes to opacity in glazes because of its chrome content. It is recommended for producing black in combination with cobalt or manganese. Iron is often a component of black glazes, although any three colouring oxides will usually produce a black (*see* Chapter 12).

Rutile (TiO₂) and Ilmenite (FeO.TiO₂)

These are both forms of titanium dioxide contaminated with iron, and therefore combine the crystallizing/opacifying qualities of titanium with the colouring properties of iron to produce mottled and sometimes almost 'glittery' effects which can at times be a little over-rich. Ilmenite has the higher iron content of the two. An interesting aside concerning rutile is that a glaze with over 15 per cent can become light-sensitive, darkening in bright light and paling in darkness. A further point to bear in mind about rutile is that it is a variable material which is often and annoyingly given the same formula as titanium dioxide (TiO₂), but nonetheless does contain iron and sometimes other impurities such as chrome and vanadium as well.

Manganese Dioxide (MnO₂)

This also produces brown colours, but with a touch more warmth than those from iron. In

EXAMPLE MANGANESE DIOXIDE RECIPE

Manganese Violet 1250°C

Nepheline syenite	24
Lithium carbonate	5
Dolomite	7
Talc	5
Barium carbonate	15
China clay	25
Flint	19
+	
Manganese dioxide	2
Cobalt carbonate	0.5

Molecular formula

0.16KNaO 0.5Al₂O₃. 2.5SiO₂
0.22Li₂O
0.12CaO
0.25MgO
0.25BaO

Aluminium:Silica = 1:5

Gives a matt opaque glaze with a soft, delicate violet colour.

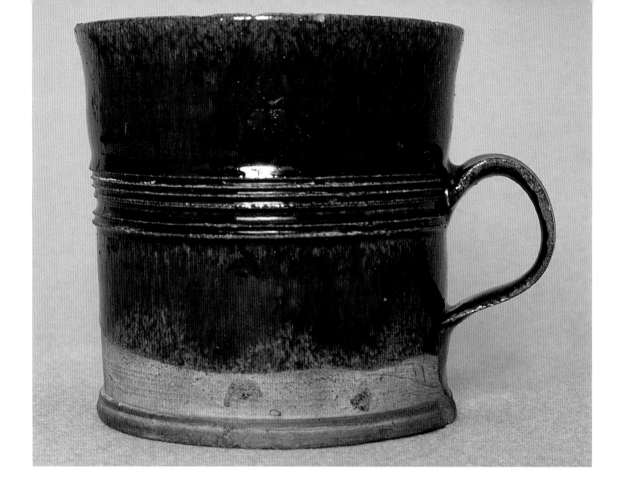

Eighteenth-century Staffordshire mug. Lead glazed with manganese stain. The Potteries Museum, Stoke-on-Trent.

high alkaline glazes, 1 to 3 per cent can give purple-brown, and in combination with a small amount of cobalt (0.5 per cent) a bright pale purple is possible in an alkaline glaze which is also low in alumina.

At earthenware temperatures some of the oxygen is liberated, and manganese dioxide becomes a monoxide (MnO) and a flux. If mixed with a small percentage of frit or clay (10 per cent) and painted thickly onto a clay and fired above 1150°C it can form a very metallic surface, bronze-like in quality. The freeing of the oxygen as a gas at about 1080°C can cause bubbling in glazes containing manganese that matures at this temperature, so it is best used in glazes fired 20–40°C above or

EXAMPLE MANGANESE DIOXIDE RECIPE

Manganese Bronze 1150–1200°C

Manganese dioxide	90
China clay	10
+	
Copper carbonate	2

This is more like an engobe than a glaze and is best applied by painting on.

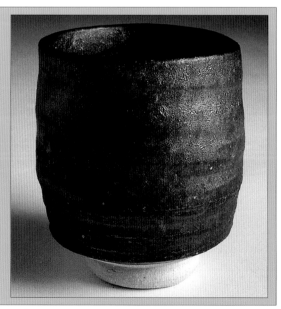

EXAMPLE NICKEL OXIDE RECIPE

Nickel Pink Glaze 1250°C

Nepheline syenite	29
Barium carbonate	35
Zinc	13
China clay	7
Flint	16
Nickel	3

Molecular formula

0.15KNaO	0.25Al$_2$O$_3$	1.49SiO$_2$
0.45BaO		
0.40ZnO		

Aluminium:Silica = 1: 6

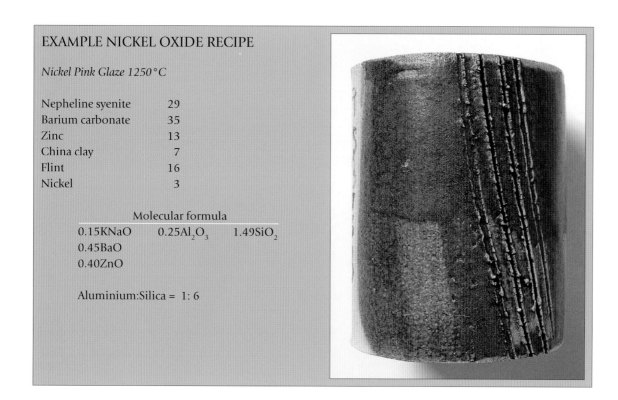

below 1080°C, unless a textured surface is wanted (*see* Chapter 12).

Manganese can also be obtained in the weaker and finer carbonate form (MnCO$_3$).

Nickel Oxide (NiO)

Nickel oxide is an underrated oxide that usually provides a greyish-green colour. It is more often used to modify subtly other oxide colours, and it can contribute to a black glaze in combination with other colouring oxides. In glazes with large amounts of barium and zinc it can produce a delicate shade of blue-purple to a strong, and depending upon your taste, bold, rather sickly pink, and yellow with titanium. It is also interesting in crystalline glazes where it can produce almost startling electric blue crystals (*see* Chapter 12) the normal range within which it is added to glazes is 2 to 5 per cent.

Vanadium Pentoxide (V$_2$O$_5$)

This exotic sounding but sometimes rather disappointing oxide gives fairly drab yellows with some mottling at up to 10 per cent strength. It

gives cleaner colours with lead glazes and in combination with tin and zirconia, and can produce interesting colour and surfaces in textured glazes (*see* Chapter 12).

EXAMPLE VANADIUM PENTOXIDE RECIPE

Tin/Vanadium Yellow 1060°C

Lead bisilicate	60
Standard borax frit	30
China clay	5
Flint	5
+	
Tin oxide	5
Vanadium pentoxide	5
Copper carbonate	1

Molecular formula

0.61PbO	0.19Al$_2$O$_3$	2.3SiO$_2$
0.14KNaO	0.24B$_2$O$_3$	
0.25CaO		

Aluminium:Silica = 1: 12

This glaze can also give good lustre results if reduced at 750°C on cooling (*see* Glaze Types).

*Large slip-cast,
underglaze painted
bowl, 'Venice', by
Angela Atkinson.
Collection of the
author. (Photograph by
Dick Brown.)*

Commercial Stains

Manufactured stains are available in a variety of forms: underglaze paints, pencils and pens for use on biscuitware; 'velvet' colours, similar to engobes in that they usually contain some flux material as well as clay to give semi-matt surfaces; and glaze and slip stains. What these all have in common is a delicate balance of ceramic oxides, carefully blended to give consistency of colour response across the pottery spectrum, including even oranges and reds, in a variety of glazes. They are also very finely ground to give evenly dispersed colour without the specking so often associated

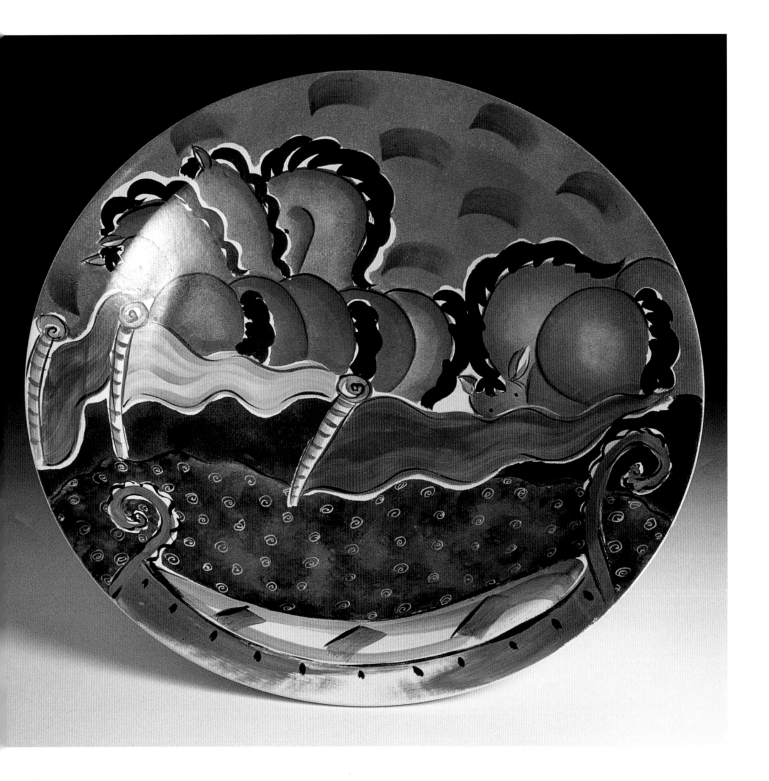

Large slip-cast, underglaze painted bowl, 'Venice', by Angela Atkinson. Collection of the author. (Photograph by Dick Brown.)

with the raw colouring oxides. This can give them a 'flat' manufactured appearance that many studio potters find unappealing, but I would say that when used well and appropriately they are a valuable addition to the ceramic palette.

Within any range of such stains, there may well be discrepancies in the temperatures that the different colours can survive, as these types of stains were generally developed for earthenware temperatures. However, their range and flexibility is gradually being improved all the time, although they are rarely stable in reducing conditions and are more reliable in low to medium temperature firings.

Underglaze Colours

These are mainly used for painting directly onto the raw clay or biscuit, and can be mixed with water or a painting medium to facilitate more reliably a trouble-free application of the glaze. When underglaze is mixed with only water, if applied thickly it may cause the glaze to crawl. 'Hardening on' with an extra firing is another way of avoiding this problem, although it is also expensive and time-consuming.

The advantage that underglaze colours have over the usual colouring oxides, apart from their range, is that they are intermixable, allowing subtle changes of tone and hue. If this is done with raw oxides such as chrome, copper, cobalt, iron, and so on, then only a dark brown or black ensues – although the use of the metal oxides in conjunction with underglazes can work very well, as in the examples by Bennet Cooper and Angela Atkinson. Bennet Cooper uses a transparent gloss earthenware glaze which hightens the intensity of the colour, while Angela Atkinson uses a semi-opaque glaze which softens the colour without losing the richness.

*T*wo *decorated bowls by Angela Atkinson.*

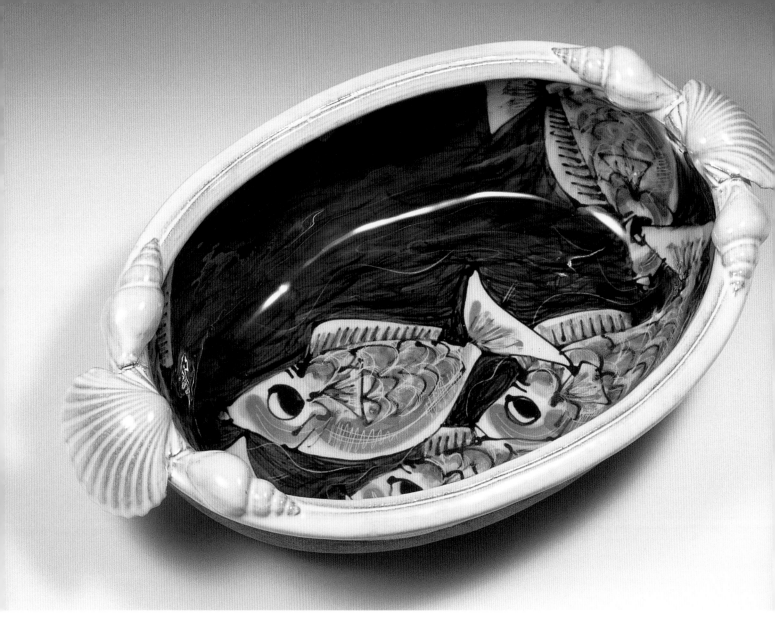

Oval dish decorated with slips, oxides and commercial stains by Bennett Cooper.

Underglaze colours can also be used along with the metal oxides in the majolica tin-glaze technique (*see* Chapter 12).

Glaze and Body Stains

These are stains which are formulated to disperse well into a glaze or slip; despite the name, body stains are more often used to colour a slip to coat the body, rather than the body itself. This is because the cost of these relatively expensive materials makes it more economical to do this rather than stain the clay itself, as the end appearance is the same in any case. Additions of 5 to 10 per cent in glazes and 10 to 15 per cent in slips are usually sufficient to achieve the desired colour, although smaller or greater amounts can be used for more subtlety or strength of colour as desired. After mixing with the colour, the glaze or slip should be sieved again, preferably through a 120's mesh to achieve thorough dispersal.

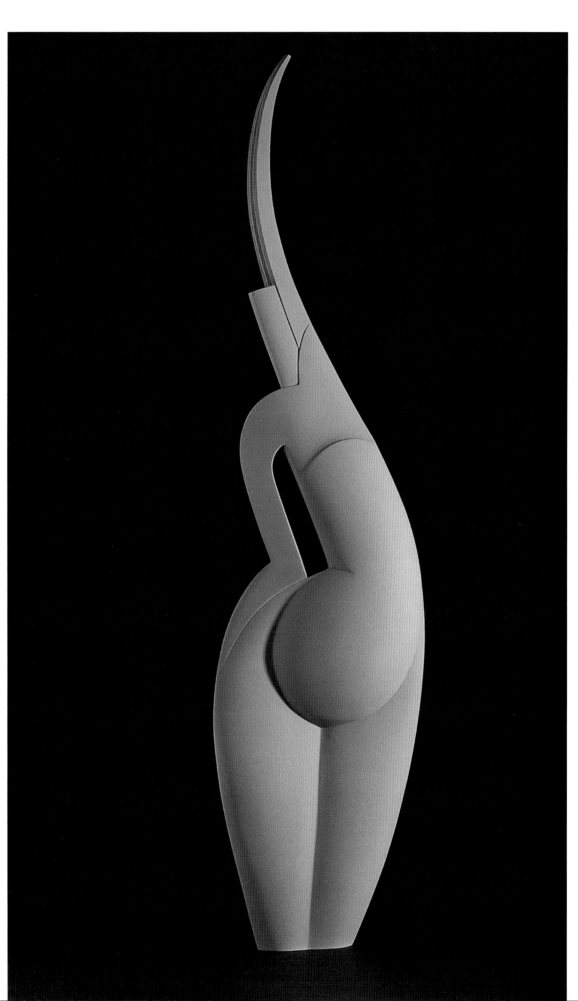

'Blue Jug' by Linda Gunn-Russell, 3ft (91cm) high.

12 Glaze Types

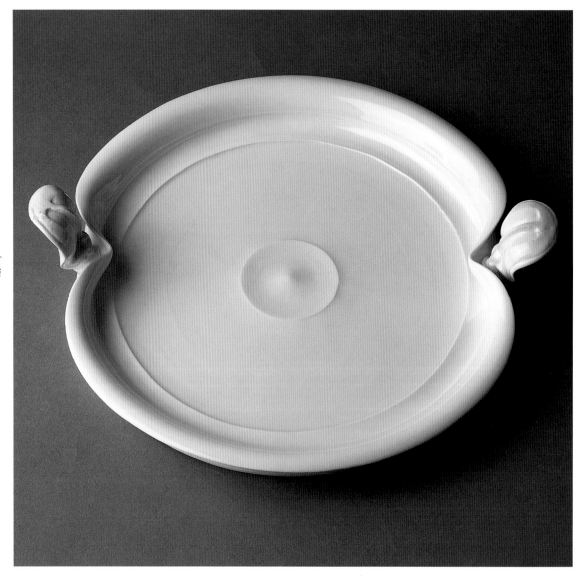

'*Creamware' platter with handles by Takeshi Yasuda. High temperature earthenware.*

Trying to break down into strict definitions the dauntingly huge variety of ceramic glazes that have already been created is an impossible task, but attempting to establish some broad categories and clarify existing and accepted definitions can be a useful exercise in creating a sense of the possibilities within the medium. Some definitions are self-explanatory, such as transparency, high and low temperature, and so on, and have not always been deemed

worthy of further attention. However, I believe that in working with glazes for studio ceramics, nothing should be taken for granted and that any glaze, no matter how ordinary, when used

well and appropriately can be as visually satisfying as some of the more exotic examples.

Many of the categories listed here inevitably overlap considerably with others. The headings are simply those terms that are in common use in ceramics and should not be considered as definitive or exclusive. Where possible, I have concentrated on the basic recipe of the glaze but where colour is intrinsic, suggested additions of oxide or stain have been included in the example recipes.

EXAMPLE BASIC TRANSPARENT GLAZE RECIPES

Earthenware 1060°C Oxidation

Borax frit	80
China clay	10
Flint	10

Molecular formula

$0.36KNaO. \quad 0.3Al_2O_3. \quad 2.71SiO_2$
$0.64CaO \quad 0.63B_2O_3$

Alumina:Silica = 1:9

Stoneware 1250°C Oxidation

Cornish stone	52
Dolomite	26
China clay	10
Flint	12

Molecular formula

$0.15KNaO. \quad 0.32Al_2O_3. \quad 2.56SiO_2$
$0.45CaO$
$0.40MgO$

Alumina:Silica = 1:8

Stoneware 1250°C (SWMF 4) oxidation

Lithium carbonate	4
Dolomite	10
Barium carbonate	22
China clay	28
Flint	36

Molecular formula

$0.2Li_2O \quad 0.4Al_2O_3 \quad 3.0SiO_2$
$0.2CaO$
$0.2MgO \qquad\qquad Al:Sil$
$0.4BaO \qquad\qquad 1:7.5$

Alumina:Silica = 1:7.5

Both the above stoneware glazes have very good craze resistance.

Transparent Glazes

Transparency is defined as the 'normal' state of a glaze, in that such a glaze is simply a complete fusion of alumina and silica with sufficient flux to dissolve these elements to form a clear, glassy coating which is stable on the ware and allows light to pass through unheeded. Any colour that such a glaze has is that which is seen by looking through it to the colour of the clay beneath, although they can also be tinted by moderate amounts of either colouring oxides or stains and still retain transparency.

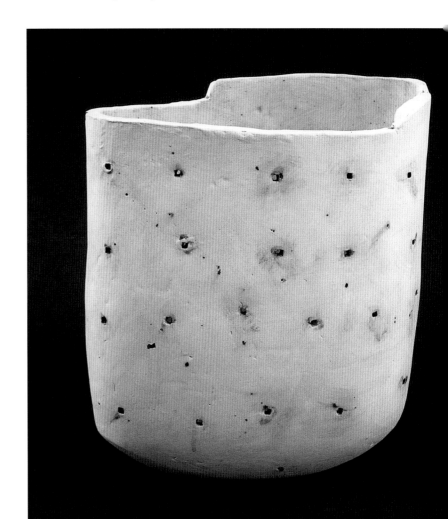

L̲arge bowl by Gordon Baldwin. Mid-temperature dry matt glaze with oxides. The Potteries Museum, Stoke-on-Trent.

For earthenware temperatures, a basic transparent glaze can be easily achieved by combining a commercial frit, lead, borax or alkaline with a small amount of china clay, in the ratio of eighty parts frit to twenty parts clay. This ratio might be slightly varied depending upon the exact temperature within the range, and made a little more sophisticated by small additions of extra silica in the form of flint, and one of the secondary fluxes, calcium or zinc perhaps.

For higher temperature or stoneware glazes, good transparency is less simply achieved. This is because feldspars, which are the natural equivalents of man-made frits, are not quite as well balanced for use in such a simple combination. Nevertheless, it is not so different in principle. A feldspar has more alumina in relation to the flux and silica it contains than a frit does, so this would need a little more balancing out with some secondary flux, and some extra silica. Again, the flux would most commonly be calcium (partly because it is a good general secondary flux, but probably also because of its relative cheapness).

The choice of frit type or feldspar might be dependent upon any other characteristics that may be desired of the glaze, such as its reaction to colouring oxide additions or its resistance to crazing, but lead frits will tend to give a yellowish tinge when seen over a white body.

Opaque Glazes

These are defined as having only a limited transparency, where the body or slip can be partially seen, but not with the clarity of a transparent glaze. They can, of course, be only slightly opaque, or completely opaque, thus creating whole new sub-categories. Perhaps the strictest definition of opacity would be when the alumina and silica are fully fused by the flux, in just the same way as in a transparent glaze, but leaving some material not fully dissolved within the glaze, thus preventing light from penetrating completely.

The two most commonly used materials for this purpose are tin and zirconia. Zirconia will not dissolve readily in a glaze even at high temperatures, and so can be used as an opacifier across the whole temperature range. Tin begins to dissolve progressively from about 1150°C upwards and is therefore less suited for high stoneware temperatures.

This kind of glaze will still be shiny, with the dispersed tin or zirconia creating whiteness as well as opacity. Titanium dioxide will also introduce opacity and whiteness, but will also progressively dull the surface of the glaze due to the fine crystalline surface it produces. In larger amounts of over 10 per cent it will give an increasingly matt as well as opaque surface.

More subtle qualities can be developed in opaque glazes by increasing the amount of secondary fluxes beyond the point of strict necessity, when they can also have a crystallizing effect on the glaze surface. Again, this is beginning to create mattness as well as opacity, but if a balance is achieved very pleasant qualities of softness and opacity can be created.

EXAMPLE OPAQUE GLAZE RECIPES

Basic Opaque White 1060°C Oxidation

Borax frit	80
China clay	10
Flint	10
+	
Tin oxide	12
or	
Zirconium silicate	12
or	
Titanium dioxide	10

Molecular formula

$0.36KNaO.$ $0.3Al_2O_3.$ $2.71SiO_2$
$0.64CaO$ $0.63B_2O_3$

Alumina:Silica = 1:9

Stoneware Opaque 1250°C Oxidation

Potash feldspar	60
Dolomite	20
China clay	20

Molecular formula

$0.33KNaO$ $0.57Al_2O_3$ $2.47SiO_2$
$0.33CaO$
$0.33MgO$

Alumina:Silica = 1:4

(*See also* Reduction Glazes.)

Matt Glazes

A matt glaze will necessarily also be opaque, in that whatever means are employed to dull the surface will prevent the penetration of light and reduce transparency at the same time.

True matt glazes can be narrowly defined as those that are created by crystallization on cooling. These crystal formations are called microcrystalline to denote the small size of the individual crystals that create the non-reflective surface.

Zinc oxide and titanium dioxide are the most effective agents for this purpose, although all the secondary fluxes – calcium, magnesium,

EXAMPLE MATT GLAZE RECIPES

Basic Matt White 1060°C Oxidation

Borax frit	70
China clay	7
Flint	8
Tin oxide	5
Zinc oxide	5
Titanium dioxide	5

Molecular formula

$0.29KNaO.$	$0.22Al_2O_3.$	$2.1SiO_2$
$0.52CaO$	$0.51B_2O_3$	$0.2TiO_2$
$0.19ZnO$		$0.1SnO_2$

Alumina:Silica = 1:9.5

Clay/Calcium Matt 1040°C–1060°C Oxidation

Lead bisilicate	45
Calcium borate frit	20
Whiting	15
China clay	20

Molecular formula

$0.35KNaO.$	$0.26Al_2O_3.$	$1.2\,SiO_2$
$0.65CaO$	$0.38B_2O_3$	

Alumina:Silica = 1:4.5

This gives a nice soft vellum matt white with a smooth surface. It has a pleasing open craze pattern when applied to low-fired stoneware biscuit.

Stoneware Clay Matt 1260°C Oxidation

	s
Nepheline syenite	10
Wollastonite	7
Whiting	35
China Clay	48

Molecular formula

$0.05KNaO.$	$0.5Al_2O_3.$	$1.21SiO_2$
$0.95CaO$		

Alumina:Silica = 1:2.5

This provides a very dry matt glaze, almost an engobe in composition, and like engobes can be painted onto dry or biscuitware, when it can give interesting colour variation, particularly with 2 per cent copper carbonate added (best with additions of colouring oxides).

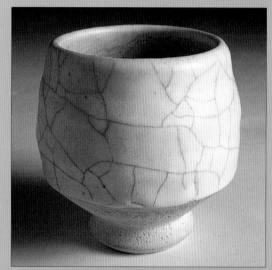

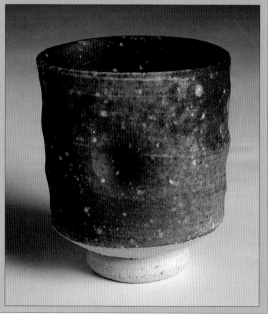

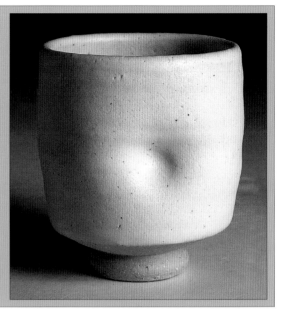

EXAMPLE MATT GLAZE RECIPE

Stoneware Matt White Dolomite Glaze 1250°C Oxidation

Cornish stone	46
Dolomite	24
China clay	22
Zirconium silicate	8

Molecular formula

$0.15KNaO.$ $0.47Al_2O_3.$ $2.3SiO_2$
$0.45CaO$ $0.2ZrO_2$
$0.40MgO$

Alumina:Silica = 1:5

This gives a thick, crystalline, sugary matt glaze with a slight texture.

barium, as well as zinc – will work in the same way if used in sufficient quantity and at the appropriate temperature.

Some matt glazes are often described as 'satin matts' or 'matt vellum' (meaning fine parchment made from calf skin). These terms are often used rather vaguely, but they do convey the wonderful tactile quality that some matt glazes can have. Other matt glazes are called 'sugar' glazes, because of the slightly glittery surface created by light reflecting off the tiny crystals.

Another very simple way of producing mattness is to increase the alumina content of the glaze. Alumina is the main glaze stabilizer and is a very refractory material. It is usually added in the form of china clay, as this has the highest alumina content of any clay, although any clay would add appreciable amounts of alumina, and the glaze surface becomes increasingly dull and rough. The drawback to these types of glaze is that they can simply look underfired, and in a sense that is exactly what they are. They are usually referred to as dry matt glazes, and in some cases could be described as vitreous engobes or slip glazes if the clay content is very high.

In one sense, the three categories of transparency, opacity and mattness shown in the examples, with the addition of colour, could be said to cover all the glazes that are created. In practice, however, different glazes are often characterized in different ways, by an ingredient, a firing process, or a specific quality. These following are a summary of some of the more commonly termed groupings.

Ash Glazes

Plant and wood ashes can be said to be feldspathic in composition, although wood ashes in particular are very low in alumina and silica, but their variety and availability have made them popular in studio ceramics where variable batch results are not necessarily considered a drawback. The ash from burnt wood or plants can easily be collected by burning in a brick stove so as to avoid iron contamination from gratings. It takes a large amount of wood or plant material to obtain a small amount of ash, and it is important to stir thoroughly the ash into plenty of water, leaving it to stand at least overnight before pouring the water away and repeating the exercise until the excess water becomes clean. This might need to be done two or three times, although not everyone agrees that this is absolutely necessary. The washing is intended to remove the majority of the soluble materials, mainly alkaline flux, but the remaining ash which is finally sieved and dried should still provide a useful material for mid to high temperature glazes, often with distinctive qualities, particularly that of 'stringing', a decorative variation on 'crawling'.

Ash can be substituted for feldspar in any recipe as a starting point for experimentation, and at stoneware temperatures some ashes will produce an attractive glaze with 80 per cent ash and 20 per cent clay.

EXAMPLE ASH GLAZE RECIPES

Basic Ash Glaze 1260°C Oxidation (molecular formula approximate because of variability of wood ash).

Wood ash	40
Any feldspar	40
Any clay	20

Molecular formula

$$0.3KNaO. \quad 0.4Al_2O_3. \quad 1.58SiO_2$$
$$0.6CaO \quad 0.02Fe_2O_3$$
$$0.1MgO$$

Alumina:Silica = 1:4

This glaze is smooth and transparent.

Dry Ash Glaze 1260°C Oxidation

Any ash	50
China clay	50

This gives a dry broken texture, good with colouring oxides.

Coal Ash Glaze 1260°C Oxidation

Coal ash	83
Locally dug clay	17

This displays typical ash glaze qualities, with its colour being due to iron impurities.

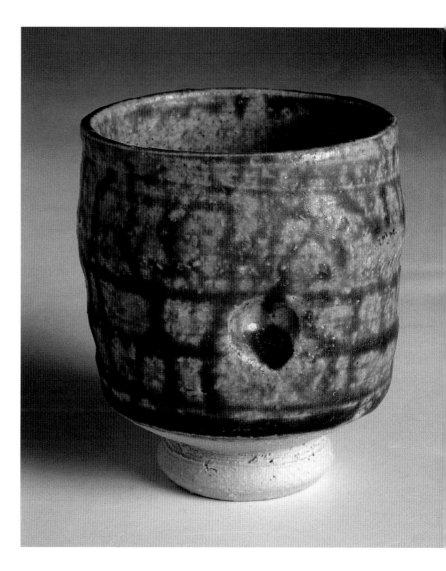

Crackle Glazes

These glazes exploit what might be considered a defect, that is, the crazing of the glaze due to the different expansion and contraction of body and glaze. Crazing will occur more often than not unless the body and glaze are carefully matched, so achieving crazing is really quite easy, but the effect most often aimed for is a decorative bold pattern of cracks.

Crazing most often begins after the ware has come out of the kiln, sometimes minutes, hours, days or even months afterwards. The crazing can therefore be monitored as it spreads and at the point where the pattern is judged to be at its best can be highlighted by rubbing an oxide, enamel or simply an ink into the cracks. Of course, the

Coal ash and local clay glaze showing typical ash 'stringing' (above).

Detail of broad, open crazing pattern.

Detail of dense crazing pattern.

Crystalline Glazes

Crystallization is not uncommon, and as we have seen is a factor in many matt glazes. These crystals are usually of the microcrystalline type, that is, so small they are hardly visible to the naked eye. The term crystalline applied to a glaze usually denotes a glaze in which the crystals are clearly visible and are called macrocrystalline. These types of crystal are more difficult to create, but when they occur can be quite spectacular and beautiful in themselves. The principal factor in creating large crystals is the creation of a fluid glaze, which necessitates as low an alumina content as possible, a relatively low silica content, and the inclusion of those materials which encourage crystal growth. These are primarily zinc oxide and titania (in the form of either titanium dioxide, rutile or ilmenite). The zinc content of a crystal glaze may be upwards of 25 per cent, but the quantity of titania required, although often crucial, may be as low as 1 to 3 per cent, up to about 8 per cent. These materials 'seed' the crystal growth which occurs during cooling, an event which should be very slow, over a period of several hours, particularly between 1100°C and 700°C. This can be achieved by 'firing down', that is, by turning the burners or elements on just low enough to still allow cooling but without causing an increase in temperature. The presence of a colouring oxide enables the crystals to stand out clearly against the background colour. If crystals fail to grow in a proven recipe through too rapid cooling, refiring to 1060°C may produce them, as they can grow during heating as well as cooling. Some ceramists effectively achieve the same end by allowing the kiln to cool to as low as 700°C and then switching on again to take the temperature back up to 1000°C or above before final cooling.

The elusive nature of crystal growth makes these glazes very popular, but their use can be highly problematic due to the problems of excessive fluidity which cause runniness and sticking to the kiln shelves during firing.

In my own view, these large crystal glazes can be novel and spectacular, but sometimes can be just too much and make the form almost irrelevant. Kate Malone is a ceramist whose crystalline glazes compete with the glaze to produce a sumptuous combination.

crazing may well continue to form, but the chosen network of crazing will stand out.

A glaze that does not craze can easily be encouraged to do so by the addition of those oxides with a high coefficient of expansion and contraction, particularly soda, but also potassium and to a lesser degree calcium. Excessive use of these ingredients, however, can produce a pattern of crazing which is so dense that it becomes almost a texture. Of prime importance is the amount of silica in both the body and the glaze – bodies low in silica will cause the glaze to craze more easily, while decreasing the silica in the glaze will also encourage crazing (*see* Chapters 3 and 16).

EXAMPLE CRACKLE GLAZE RECIPE

Opaque Crackle Glaze 1250°C Oxidation

Cornish stone	49
Dolomite	25
China clay	18
Flint	8

Molecular formula

$$0.15KNaO. \quad 0.42Al_2O_3. \quad 2.55SiO_2$$
$$0.45CaO$$
$$0.40MgO$$

Alumina:Silica = 1:6

It must be remembered that the amount of crazing will be dependent upon the particular clay body to which the glaze is applied.

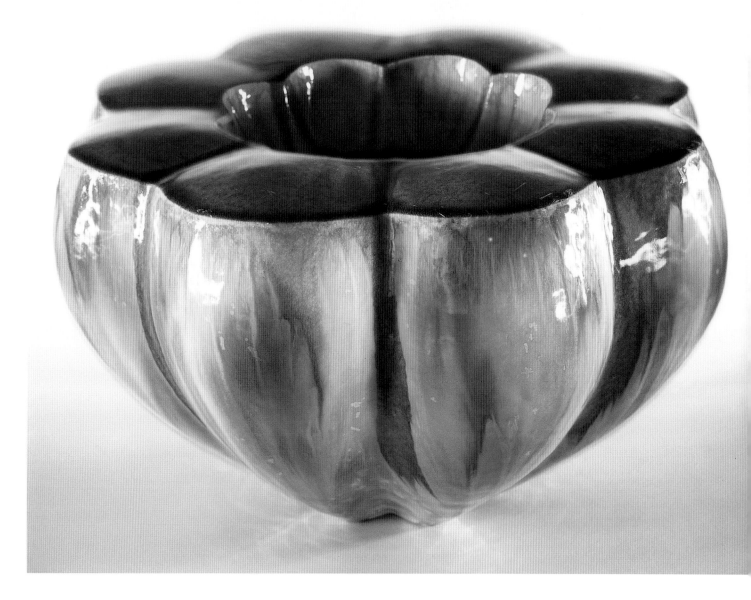

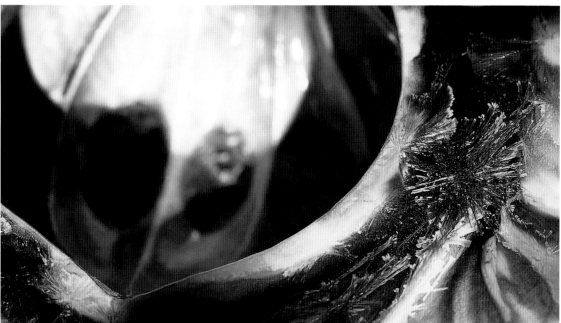

'Sliced Fruit of Your Dreams' by Kate Malone (above).

Detail of glaze surface by Kate Malone.

EXAMPLE CRYSTALLINE GLAZE RECIPES

	CRYSTAL 1	CRYSTAL 2
Calcium borate frit	14	14
High alkaline frit	24	–
Alkaline frit	–	25
Barium carbonate	8	8
Zinc oxide	33	33
China clay	1	–
Flint	17	17
Rutile	–	3
Titanium dioxide	3	–
+		
Copper carbonate	2	–
Nickel oxide	–	1.5

Crystal 1 = ochre crystals on a pale green background at 1260°C oxidation (upper photograph).

Crystal 2 = blue-grey crystals on an amber background at 1260°C oxidation (lower photograph).

Molecular formula

0.17KNaO.	0.04Al_2O_3.	0.83SiO_2
0.15 CaO	0.18B_2O_3	0.06TiO_2
0.06 BaO		Al:Sil
0.62 ZnO		1:22

Alumina:Silica = 1: 22

Like all crystal glazes these are runny and shelves should be suitably protected. The tests illustrated were conventionally fired in an electric kiln, but cooled slowly and evenly from 1150°C to 900°C.

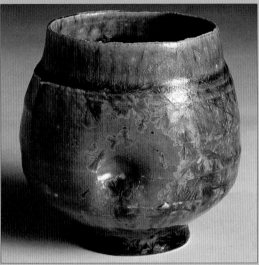

Nineteenth-century Royal Doulton vase with crystalline glaze. The Potteries Museum, Stoke-on-Trent.

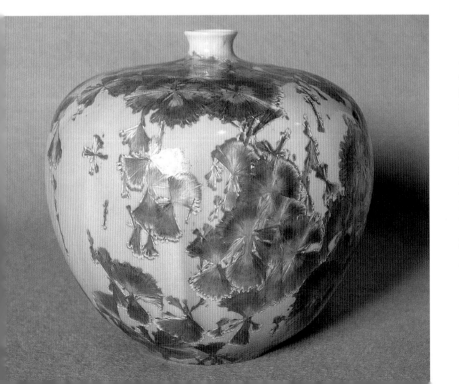

Reduction Glazes

Most glazes can be fired in either an oxidized or a reduction atmosphere. This term is applied to glazes that work best under high temperature-reducing conditions (*see* Chapter 15), and can only practically be achieved in fuel-burning kilns; electric kilns are not really suitable. The most notable effects of reduction firing occur from the reactions of iron and copper. Iron, in particular, is strongly affected, and because it is present in relatively large amounts in most clays, and as an impurity in the other clays and glaze materials we use, its influence is strong. There are many well known 'traditional' glazes that originated in the Far East such as celadon, chun (sometimes called jun), tenmoku and

EXAMPLE REDUCTION GLAZE RECIPES

Blue Celadon 1280°C reduction

Cornish stone	27
Whiting	27
China clay	23
Flint	23
+	
Red iron oxide	0.75

Molecular formula

0.1KNaO	$0.42Al_2O_3$	$2.89SiO_2$
0.9CaO		

Alumina:Silica = 1:7

Chun Glaze 1280°C Reduction

Calcium borate frit	5
Potash feldspar	40
Talc	4
Bone ash	6
Whiting	15
Flint	30
+	
Black iron oxide	1

Molecular formula

0.21KNaO	$0.22Al_2O_3$	$2.94SiO_2$
0.69CaO	$0.11B_2O_3$	$0.06P_2O_5$
0.10MgO		

Alumina:Silica = 1:13

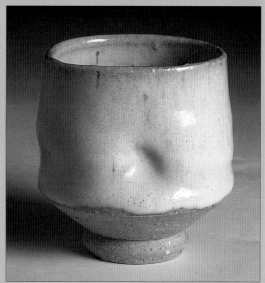

Tenmoku Glaze 1280°C Reduction

Potash feldspar	47
Whiting	18
China clay	12
Flint	23
+	
Red iron oxide	12

Molecular formula

0.32KNaO	$0.5Al_2O_3$	$3.72SiO_2$
0.68CaO		

Alumina:Silica = 1:8

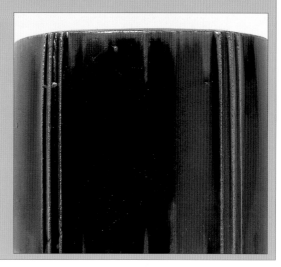

EXAMPLE REDUCTION GLAZE RECIPES

Copper-Red Glaze II 1280°C Reduction

Potash feldspar	48
Calcium borate frit	6
Whiting	11
Zinc	4
Tin	3
Flint	28
+	
Copper carbonate	0.5

Molecular formula

$0.32KNaO$	$0.35Al_2O_3$	$4.0SiO_2$
$0.50CaO$	$0.15B_2O_3$	$0.05SnO_2$
$0.18ZnO$		

Alumina:Silica = 1:11

This is a much softer, 'peach bloom' type copper-red glaze than the one in Chapter 11. The copper-red glaze porcelain pot illustrated is by Ben Brierley.

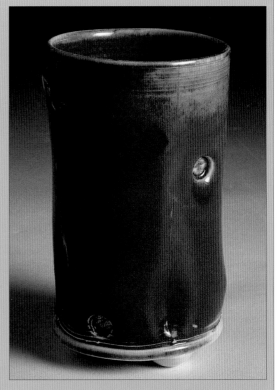

Opaque White 'Shino' 1280°C Reduction

AT ball clay	33
Potash feldspar	33
Nepheline syenite	34

Molecular formula

$0.97KNaO$	$1.6Al_2O_3.$	$6.4SiO_2$
$0.03MgO$	$0.04Fe_2O_3$	

Alumina:Silica = 1:4

This glaze is a popular type derived from the traditional Japanese 'shino' glaze that typically breaks to orange, particularly at the edges.

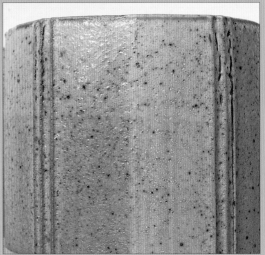

kaki that illustrate the different colour and surface qualities that iron can give. However, iron also contributes to glaze qualities through its effect on the clay body itself, and the way its fluxing effect at high temperature fuses body and glaze together and 'blurs' the distinction between the two.

Copper is more straightforward, although like iron it is easily reduced and in reduction can give very strong blood reds, such as the famous Chinese ox-blood glaze.

I think the popularity of reduction glazes for many lies in their clearly non-industrial appearance and those finished qualities that in a sense illustrate the craft processes that the object has undergone. For others, this obvious craft quality is seen to be limiting, and does not allow the object to address a wider contemporary audience.

Lustre Glazes

Metallic and iridescent colours can be produced on low temperature glaze surfaces in two ways (*see* photographs overleaf). In-glaze lustres can be achieved through the heavy reduction of copper and other metals in an alkaline glaze (*see* Chapter 11) that has been to its maturing temperature. The temperature is then allowed to drop down to about 750°C, and at this point it is reduced heavily for twenty to thirty minutes, before final cooling with the kiln well sealed to prevent reoxidation. More variety can be achieved by adding other oxides, carbonates and sulphates of gold, silver, bismuth and others. These types of lustre can be difficult to control,

as the reduction needs to be surprisingly heavy and is easily lost on cooling, but the results are sometimes dramatic.

On-glaze lustres can be created by mixing copper with a calcined red clay or yellow ochre, and again other metals may also be used. The proportions are between 10 to 50 parts metal to 100 parts clay or ochre, mixed into a paste. An addition of a binder such as gum arabic will help application and adhesion before and during firing. This mixture is painted onto an already fired glaze, with low temperature tin glazes said to be the most suitable, and then refired and reduced at around 700°C.

Commercially produced lustres are also available that are reliable and simple to fire.

EXAMPLE LUSTRE GLAZE RECIPES

In-glaze Lustre Recipes 1000°C and Low Temperature Reduction

Alkaline frit	57	57
Standard borax frit	30	30
China clay	5	5
Flint	5	5
Tin oxide	3	3
+		
Copper carbonate	1	1
Cobalt carbonate	2	
Manganese carbonate	3	
Vanadium pentoxide	3	

Molecular formula

$$0.69KNaO \quad 0.16Al_2O_3. \quad 1.88SiO_2$$
$$0.31CaO \quad 0.23B_2O_3 \quad 0.05SnO_2$$

Alumina:Silica = 1:11

These glazes are fired in an oxidizing atmosphere to 1000°C, allowed to cool to approximately 750°C, and reduced fairly heavily for about thirty minutes. The kiln should then be well sealed to prevent reoxidation. If the kiln is of a type that is difficult to seal properly, these glazes can be fired raku style. In order to do this, remove the ware from the kiln after 1000°C has been reached and the kiln has cooled a little, and place the ware on a thin bed of sawdust. Immediately cover it with an upturned saggar or any airtight and heat-resistant container and leave it to reduce and then cool. Copper seems to be

crucial in these glazes, as it forms lustres readily in any low temperature reduction, as will tin also when reduced quickly and heavily. Titanium is said to help in stabilizing the lustres produced.

Tin Glaze for On-glaze Lustres 1060°C

Lead bisilicate	28
Borax frit	46
Zinc oxide	6
China clay	4
Flint	4
Tin oxide	10
Titanium dioxide	2

Molecular formula

$$0.25PbO \quad 0.16Al_2O_3. \quad 1.75SiO_2$$
$$0.19KNaO \quad 0.33B_2O_3 \quad 0.2SnO_2$$
$$0.33CaO \quad \quad 0.08TiO_2$$
$$0.23Zinc$$

Alumina:Silica = 1:11

Lustre Pastes

Copper carbonate	34
Yellow ochre	66
+	
Gum arabic	2
Silver nitrate	34
Yellow ochre	66
+	
Gum arabic	2

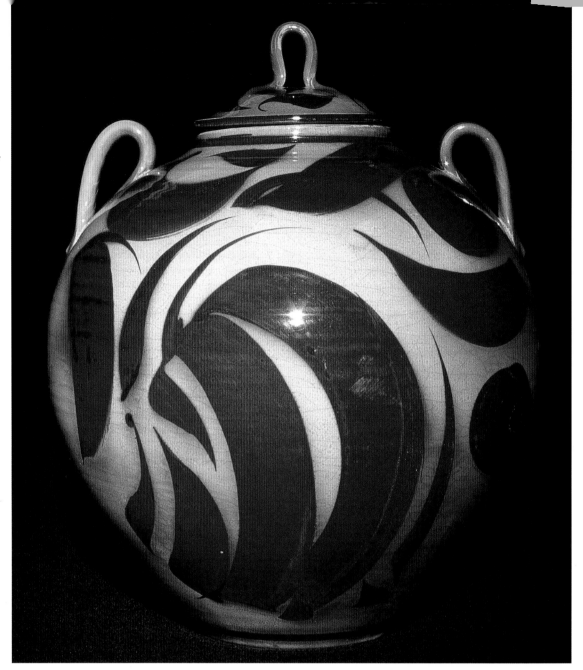

Lidded jar with silver/copper low temperature reduction lustres by Alan Caiger-Smith. The Potteries Museum, Stoke-on-Trent.

Large ruby lustre charger by William de Morgan, circa 1890. The Potteries Museum, Stoke-on-Trent.

Texture Glazes

These glazes are sometimes called lava or crater glazes, and describe the typical effects of gases escaping through the glaze layer during melting, either from the glaze itself, or from a slip or glaze applied beneath. This is another glaze effect that could be equally described as a defect. Textured glazes are, of course, not suitable for functional wares because they are unhygienic, and so are used for purely decorative effect, varying from subtle texture to large bubbles and craters. The material that is most commonly added to glazes is fine silicon carbide, normally used as an abrasive powder, but which gives off carbon gas over quite a wide temperature range, between 900°C and 1230°C – an addition of 1 to 5 per cent is generally sufficient to produce a pronounced effect. The important thing to note is that this is a one-way process, and the firing needs to be stopped at the point where the glaze surface is molten enough to allow the gas to percolate through, but before all the gas has escaped and the glaze has settled back down again. Fast cooling usually helps to 'freeze' the surface effect.

The technique works best on viscous matt glazes, both visually and practically. Fluid glazes tend to settle back down too readily and suit the process less well.

There are probably many such materials that could be tried for the same purpose, but of course it is important to be sure that any gases given off during firing are not harmful, either to the kiln lining, and, more importantly, to anyone breathing the fumes.

Other materials that have been used to create texture include cryolite, fluorspar and lepidolite. These all give off fluorine gas, but are also used as fluxes and so must be allowed for in the glaze recipe. Yet another material is plaster of Paris or potter's plaster, as used in the making of moulds. Plaster is calcium sulphate and it is the sulphate which is given off to create texture, but an obvious drawback is that the plaster can cause the glaze slop to set hard!

Martin Lewis uses layers of glazes which sometimes include deliberately untreated and unsieved materials such as wood ash that release their residual carbon to create texture.

The detail from a work by the author shows a matt stoneware glaze (*see* Chapter 11) applied over a vanadium slip containing silicon carbide; as the gases escape the slip is brought to the surface to give startling surface variation.

'Square, Circle, Triangle' by Martin Lewis. Large coil-built vessel with textured glazes.

*C*oil-built vessel by
Martin Lewis.

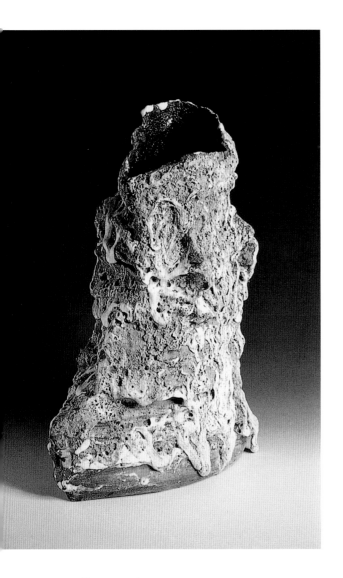

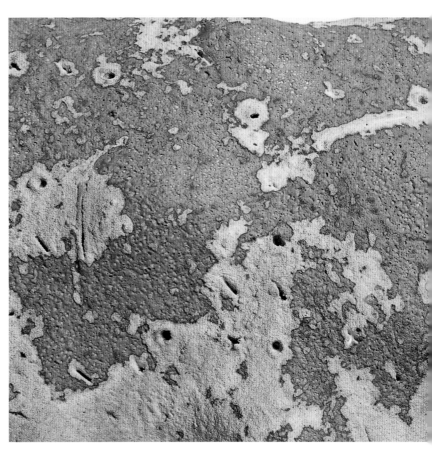

Raku Glazes

Like salt-firing, raku is more a process than a category of glaze types. The technique probably originated in Japan in the sixteenth century and in essence involves placing the pots into an already hot kiln and removing them as soon as the glaze has melted. The pots then cool very rapidly in the open air. The modern addition to this process is to take the red hot ware straight from the kiln, allowing only a few moments for the glaze surface to cool sufficiently to seal over, and to put it into a combustible material like sawdust. The intention here is to swamp the ware completely so that the combustion is deprived of air, with only smoke produced and as little flame as possible. The resulting incomplete combustion traps carbon in the unglazed areas and prevents the glaze from oxidizing, thus creating reduction effects.

The process suits low temperature glazes for several fairly obvious practical reasons, and is usually carried out at glaze temperatures around 950°C and 1000°C. The clay body needs to withstand the severe thermal shocks involved (*see* Chapter 3) and so should not have a high biscuit firing, and this leads to a characteristic crazed or 'crackle' finish.

The reduction in the sawdust allows surface lustres to be formed, particularly from copper, and other metal salts may be added to produce a variety of lustre effects. These can be added along similar guidelines to those given in lustre glazes, but due care should be taken in relation to preparation, handling and ventilation during firing.

Lustres can also be created on the unglazed body by a mix of 90 per cent copper carbonate with 10 per cent of a borax frit painted onto biscuit and fired in the Raku kiln to about 960°C. On removal, it is placed on a layer of sawdust and covered for ten minutes or so by an airtight container (an upturned metal bucket is ideal). The effects can be spectacular, especially when the process is enhanced by a propane or butane flame gun, but like all the lustre effects the results can be elusive and inconsistent at first.

*V*essel (left) with heavily textured glaze surface by Aki Moriuchi. (Photograph by Michael Harvey.)

*B*arium/copper glaze over a vanadium/silicon carbide slip (above).

Raku ware is not really suitable for food use of any sort, particularly when it has been reduced, although it is said that traditionally oxidized raku was soaked in strong tea to penetrate the crazing and seal the body. This might make it capable of retaining liquids, but is probably more useful as a way of emphasizing the crazing for decorative effect (*see* Crackle Glazes, page 111).

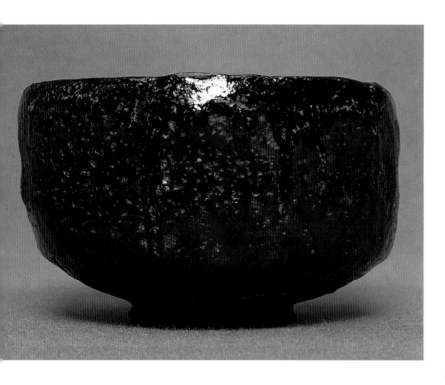

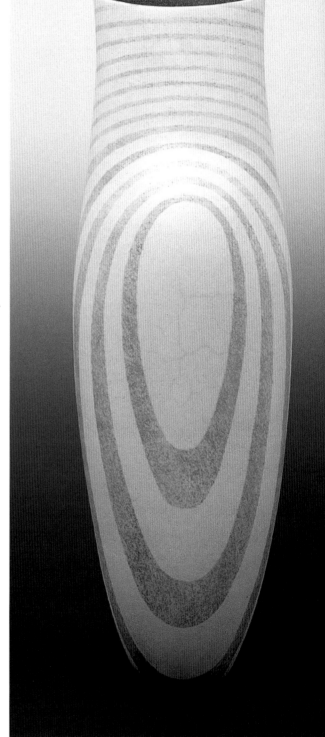

*J*apanese Tea Ceremony wares, raku bowl and tea jar with ivory lid, circa 1700. The Potteries Museum, Stoke-on-Trent (above and right).

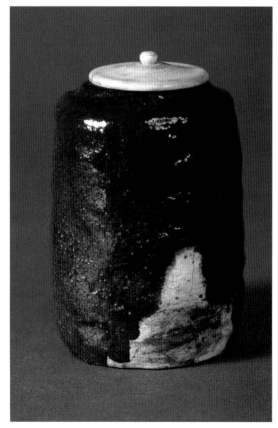

'*T*all Vessel' by David Roberts. Raku-fired with very light controlled fine sawdust reduction (far right).

EXAMPLE RAKU GLAZE RECIPES

White Tin Opaque 1000°C Oxidation

Alkaline frit	65
Standard borax frit	25
Tin Oxide	10
+	
Bentonite	4

Molecular formula

$$0.71\,KNaO \quad 0.13Al_2O_3 \quad 1.66SiO_2$$
$$0.29CaO \quad 0.21B_2O_3 \quad 0.14SnO_2$$

Alumina:Silica = 1:13

Alkaline Turquoise 1000°C Oxidation

Alkaline frit	65
Standard borax frit	25
Bentonite	4
Tin oxide	4
Copper carbonate	2

Molecular formula
Similar to above

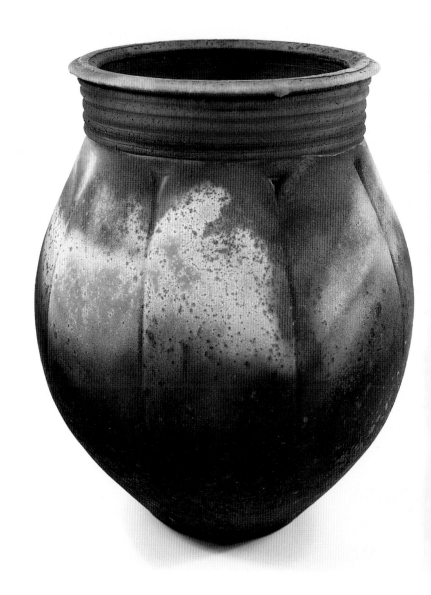

Thrown vessel by John Wheeldon, with smoke-fumed copper reduction lustre.

Salt/Soda Vapour Glazing

As much a firing process as a glaze type, salt and soda can produce distinctive and useful glaze surfaces. Common salt, the type which is used universally in cooking, is sodium chloride. Sodium is also, of course, one of the stronger fluxes used in ceramics, and the principle of salt glazing is very simple. Ware is placed in the kiln, heated to about 1200°C to 1280°C and then damp salt is introduced into the chamber, usually dropped into the hot part of the firebox of a wood, oil or gas kiln, in small quantities at ten to fifteen-minute intervals, allowing the fumes from one salting to clear before the next one. The salt immediately vapourizes, and helped by the rapidly expanding steam, is carried around the kiln chamber and is deposited on all exposed surfaces. The salt simply fluxes the vitrifying clay, which in turn provides the alumina and silica that combine with the sodium to create the three essential components necessary to form a glaze. The kiln atmosphere can be oxidation or reduction. A small 20–30cu.ft (5.66–8.49cu.m) kiln will require about 3–4kg (6.6–8.8lb) of salt for a good salting, although the amount needed may be more for the first few firings until the interior gets well coated.

There are drawbacks inherent in this process. Firstly, the kiln needs to be built of dense high alumina bricks; these are low in thermal efficiency but are needed to withstand the corrosive nature of the salt, as conventional kiln bricks would be severely eroded by salting. Secondly, the fumes are not particularly pleasant and constitute a pollutant (basically a salt kiln will give off a very dilute, weak hydrochloric acid vapour), and therefore the operation needs to be well ventilated and the kiln sited away from people and sensitive environments.

Soda-glazed ginger jar by Ruthanne Tudball. Coated with a blue-black slip, brushed over with a titanium wash, fired in a light reduction atmosphere.

Because of the greater awareness of environmental issues, soda firing has been investigated as an alternative to salt firing, although the pollution aspect of small-scale salt glazing should be kept in perspective – a short journey in the car creates a similar amount of atmospheric pollution to a single salt firing. Essentially, soda glazing is the same process as salt glazing, but the sodium carbonates that are used as a substitute for salt do not volatilize as readily and an uneven coating often results, which sometimes can mean ware being glazed on one side, but not the other. To overcome this, means have to be found to ensure even distribution of the soda around the wares. One of the simplest ways of doing this is to dissolve washing soda crystals in water and spray the solution into the kiln by the use of a garden-type pressure sprayer, of the type normally used for weed killers. This allows good control and the spray can be accurately directed onto the ware. Because conventional salt kilns already have ports for the introduction of the salt, these can be used to 'aim' through, as can the bung holes in the door. Ideally, the kiln should be designed specifically with the use of soda in mind to provide sufficient openings to

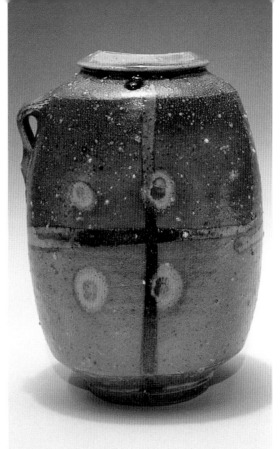

Thrown and altered jug by Walter Keeler. Salt-glazed with cobalt slip (far left). (Photograph by Colin Somerset.)

Bottle by Phil Rogers. Salt-glazed with high alumina porcelain/ china clay slip. This piece was fired on its side, resting on cockle shells for decorative effect (left).

Lidded salt-glazed jar by Jane Hamlyn. Heavily salted cobalt and titanium slips in a 1280°C reduction fire.

EXAMPLE SALT/SODA VAPOUR RECIPE

Salt/Soda Slips for 1280°C Reduction

TAN/ORANGE		MOTTLED CREAM/ YELLOW	
AT ball clay	20	AT ball clay	46
China clay	80	Nepheline syenite	46
		Titanium dioxide	8
GREEN		BLUE	
SMD ball clay	33	SMD ball clay	64
Nepheline syenite	67	China clay	22
+		Flint	14
Cobalt carbonate	0.5	+	
Chrome oxide	1	Cobalt carbonate	2
		Red iron	2

The photograph shows a soda-fired test bowl with tan/orange slip. Interior and rim are glazed with tenmoku glaze; salt and soda can have a noticeable 'bleaching' effect on iron glazes.

allow the spray to be evenly applied to all the ware. For these reasons, soda firing is perhaps more fiddly and contrived than salting which has a more 'natural' feel to the process, but one advantage is that soda can often produce brighter and livelier surface qualities.

Other problems with vapour glazing are that it shortens the working life of kiln furniture and shelves, even when protected by a bat wash. The ware also needs a conventional glaze on those parts that will not be exposed to the salt or soda vapour, such as the insides of lidded pots and tall, enclosed forms that the salt will not penetrate fully. The ware also needs setting on small pads or 'pips' called wadding (*see* below) to prevent pots sticking to shelves, lids to rims, and so on. The salt kiln cannot really also be used for conventional firings because the salt builds up on the interior and volatilizes of its own accord on each firing, so that even when no further salt is added, at least a fine coating will be deposited on any ware placed in the kiln. However, despite any drawbacks, salt or soda firings can produce wonderfully rich and varied surfaces,

*S*etting ware in the salt kiln using 'pips' of wadding to raise the ware off the kiln shelf and to prevent the lid from being stuck to the body. The pips should be evenly spaced: three to five are sufficient for most ware depending on size and weight. They should be neatly placed and positioned as they leave a slight mark when removed after firing.

WADDING

Alumina	6
Flour	6
China clay	1

The flour is included so that the wadding can be easily formed into small round balls ('pips') and attached to the bases of the ware. The flour burns out in the firing and the pips are then soft and crumbly, detaching without difficulty.

Staffordshire salt-glazed tankard, eighteenth century. The Potteries Museum, Stoke-on-Trent.

from the particularly distinctive orange-peel effect to the leathery tan quality derived from china clay slips.

Most of the interest and variation of colour and surface in vapour glaze firing is created through the application of slips to the ware before the salt or soda-glaze firing. Without these, the vapour would give a fairly anonymous transparent surface taking on the character of the clay beneath. Salt/soda slips are devised to react well with the salt. They are sometimes based around clays with a comparatively low alumina content to produce brighter, glossier results, and high alumina clays such as china clay for matt effects. The slips below can be painted, sprayed or dipped and can be applied before or after biscuit firing, but care should be taken not to apply them too thickly on biscuitware, particularly the high clay tan/orange recipe.

Soda-firing in progress. Washing soda is being sprayed into the kiln with a garden pressure sprayer.

Slip Glazes

These are glazes which are made up largely of clay, usually a low grade red clay. These can sometimes melt sufficiently at 1250°C to form a rich glossy glaze without any additional flux. If a lower melting point is required the flux content can be increased, but one of the advantages of a glaze with a very high clay content is that it can be applied at the 'raw' or leather-hard stage without flaking off during drying as would happen with most other glazes. This allows the ware to be fired only once and avoids the expense and necessity of a biscuit firing – for this reason, they are also sometimes called raw glazes.

Majolica

This is as much a technique as a kind of glaze, although this name is now generally understood to denote any decorated tin-glazed earthenware. The name originates from the island of Majorca, although this sort of ware was made throughout the Mediterranean region and spread to Holland, where it became known as Delft ware, and England where it was made most famously in Lambeth, Liverpool and Bristol. The technique involves painting directly onto the unfired glaze surface with oxides and stains, and when the glaze is fired they melt into the surface to give lovely soft fresh colours. Tin is traditionally used as the opacifier because of its particular qualities of softness, although zirconium silicate will produce a similar opacity. It is a matter of subjective judgment as to which is superior, but many potters prefer tin, perhaps partly as it maintains a tradition of more than 500 years.

The application of the colour is traditionally bold and spontaneous, in large part due to the fact that mistakes cannot be removed without damaging the glaze surface underneath, although now the unfired glaze may be made to be less easily damaged by the addition of binders or gums. The oxides or commercial colours may be painted on raw, mixed only with water, although the stronger oxides in particular benefit from dilution with some of the liquid glaze itself, or some other flux material such as a frit. Painting mediums are also available from suppliers which allow easier flow with the brush.

Example of a locally dug red clay, melted at 1250°C and suitable as a basis for a slip glaze.

'Basketwork' teapot by Andrew and Joanna Young. This ware is raw glazed with a chromium stained 1280°C reduction glaze.

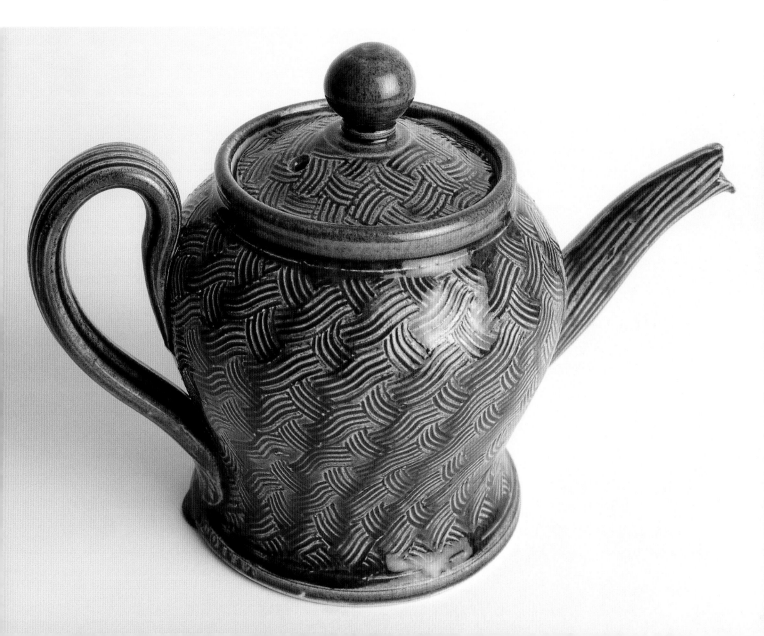

Tin-glazed 'Adam and Eve' charger. Lambeth 1680. The Potteries Museum, Stoke-on-Trent.

EXAMPLE MAJOLICA GLAZE RECIPE

Majolica Glaze 1060°C Oxidation

Lead bisilicate	70
Potash feldspar	10
China clay	6
Flint	4
Tin oxide	10

Molecular formula

$0.92PbO$	$0.26Al_2O_3$	$2.71SiO_2$
$0.08KNaO$		$0.3SnO_2$

Alumina:Silica = 1:10

Egyptian Paste

This is a self-glazing body technique which is really very limited, but nevertheless interesting. It is probably the earliest form of glazing and is achieved by adding soluble salts in the form of soda ash and/or sodium carbonate to a glaze body mix typically consisting of feldspar, flint and clay.

As the mixture dries out the soluble salts are carried to the surface where they form a glaze layer when fired to a low earthenware temperature, 950°C–1000°C.

Egyptian Paste is most often used for making small objects such as jewellery and beads, but a drawback is that the salts coat the whole surface so the kiln shelves need protection. Alumina powder is suitable, and whiting is sometimes recommended (although it is a high temperature flux and on its own at low temperature it will remain a powder); beads can be threaded on to kanthal wire.

*L*arge platter, after
*Bernard Palissy, 'La
Fecondite', Lambeth,
circa 1680. The
Potteries Museum,
Stoke-on-Trent.*

EXAMPLE EGYPTIAN PASTE RECIPE

Egyptian Paste 1000°C Oxidation

Nepheline syenite	40
Soda ash	12
Ball clay	10
Flint	36
Bentonite	2
+	
Copper carbonate	2

Molecular formula

$1.0KNaO \qquad 0.64Al_2O_3 \qquad 5.5SiO_2$
$0.19KNaO$

Alumina:Silica = 1:9

This is an excellent recipe with good fired strength
and good colour response with other oxides.

Glaze Development & Testing

There are basically two methods of creating your own glazes: a) empirical methods involving trial and error; and b) the application of glaze chemistry and theory. There are many people who seem to have an instinctive understanding and ability with the ceramic materials, and have great success with 'try it and see' methods, much in the same way as some people possess a natural gift for cooking. Others may prefer a more systematic approach. However, it should be remembered that glaze chemistry as a science is comparatively recent and that much wonderful ceramic work was created through empirical investigations alone.

Of course, there is a third option, to use unquestioningly the recipes that are widely available in books or magazines that fit our requirements, without any attempt at understanding how their qualities are attained. However, I believe that anyone who has a desire to use materials and processes creatively will inevitably develop at least some need to understand them and reveal to themselves more of their potential.

Most of us aim at a mixture of the first two approaches, and the basis for success in developing glaze recipes is familiarity with the materials that go into them. The chapters in this book on Basic Chemistry, the Main Glaze Oxides and the Raw Materials are important for reference as well as providing an introduction to the relevant properties of ceramic oxides and materials.

Equipment

The apparatus that is needed for carrying out glaze tests need not be elaborate nor necessarily different from that used for making up larger batches. It is useful to keep a broad stock of raw materials – suppliers will sell all the materials in small amounts for those you may not use very often – and to keep sample quantities of all your materials in small, sealed (to keep the powders dry) plastic containers for convenience when making up tests. An accurate set of scales is a necessity. Most tests are made up in 100g batches, and as percentage additions of some colouring oxides can be as low as 0.1%, a good lever or triple beam balance set of scales and weights is essential. Electronic scales can also be very accurate, but if they do become faulty it is not always as easy to notice as with balances. A jug marked in millilitres and a 100ml measuring cylinder is useful for measuring specific amounts of water when the consistency of the glaze slop is important or when measuring specific amounts of liquid glaze for line blending (*see* below). For sieving small test quantities a cup sieve is ideal, and sieving is made much easier if the cup sieve is supported by a flanged cup that the sieve will fit into. These are easy to make by either throwing or casting. A mortar and pestle is also very useful for grinding coarse materials before sieving.

Test pieces should be large enough to give sufficient information and to incorporate a vertical surface so that the fluidity of the glaze can be observed. It can prove very useful to write clearly

on the test tiles with iron oxide at least a clear number corresponding to the recipe in your glaze notebook, or better still, the entire recipe. If the clay is a dark iron clay, then a coat of clay and alumina bat wash over the area to be written on will make the lettering stand out.

Tests ideally are fired in the same kiln as the ware normally will be so that firing conditions are the same. A small test kiln will fire much more quickly than a large kiln and produce more information in a shorter time, but it is worth remembering that the length of firing cycle can sometimes make a noticeable difference to a glaze. This factor accounts for the inconsistent results often obtained when mixing up other people's recipes, and for this reason it is better to put a temperature cone in with a test firing, as this gives a much better indication of heat work done. It also provides a useful and clear visual record of the temperature to which the test has been fired.

Finally, calculators are very useful for converting batch recipes to percentage recipes and more advanced molecular calculations are also done for you by computer glaze calculation programmes.

Triple beam balance scale capable of weighing down to 0.1g with measuring cylinders, mortar and pestle and small sieve with flanged container (above).

Cross-section of flanged container showing fitting for small cup-sieve.

Recipe written on the side of a test piece avoids confusion later.

Practical Starting Points

Glazes can be created from a very small number of ingredients; indeed, frits or feldspars will form a glaze on their own at the appropriate temperature because they already contain the three essential categories of ingredients: flux, alumina and silica. A very useful and instructive exercise in seeing how simply glazes can be created is to blend a flux material with a clay or feldspar. For example, this can be done with a frit and a clay at low to medium temperatures, or with a feldspathic material and a secondary flux (calcium, magnesium, and so on) for stoneware. Wood ashes are particularly good materials to blend with clay at higher temperatures because they usually contain enough strong fluxes to give a successful melt and can be obtained and processed quite easily. Similarly, it is often interesting to use a locally dug clay as the quantities required are feasible to obtain, and even a small amount of plastic clay will provide a useful quantity as a glaze ingredient. A local clay will also be much more readily fusible than, say, a china clay (unless you happen to live next door to a china clay mine) because it will certainly contain some fluxes among its other impurities and its alumina content will be appreciably lower than that of china clay. The difference in the effect on fusion between china clay and low temperature secondary clays should not be underestimated, and a local clay will also colour the glaze through its iron content.

Mixtures of two materials like this are often carried out in the form of line blends.

Line Blends

A line blend is a very easy method of exploring the effect of one material on another. This can be two simple raw materials as in the example that follows, or it can be two more complex compounds consisting of several raw materials, such as two different glazes, for instance.

The first example is illustrative of the action of a flux material, a frit (*see* Chapter 9), on a refractory material, clay. The basic method is to make a sequence of combinations starting with 100 per cent of material A and 0 per cent of material B, and ending at 0 per cent of A and 100 per cent of B.

The gradations here are every 10%, and this gives a good indication of how the materials increasingly fuse together across the range as the clay decreases. In the example below, the best mix is ninety parts frit to ten parts clay, and in fact experience will soon tell us that this ratio of frit to clay is typical if a glassy surface is desired.

It can be sufficient when line blending to go in steps of 20, that is, 80–20, 60–40, and so on initially, especially when experimenting with two glazes, and then doing a further set of blends around the most promising mix, for example if 60–40 looks the best, to do a further set in steps of 5: 70–30, 65–35, 55–45, and 50–50.

The following exercise involves a deliberately unplanned investigation, starting with a blend of a commercial frit with a clay I took from the base of a cliff in Dorset, and progressively adding new materials to develop and alter the character, texture and, finally, the colour of the glaze.

Example of a Line Blend

The photograph above right shows the progressive fluxing action of the lead bisilicate upon the clay, or, put another way, the matting effect of the clay on the lead bisilicate. Tests like this can be

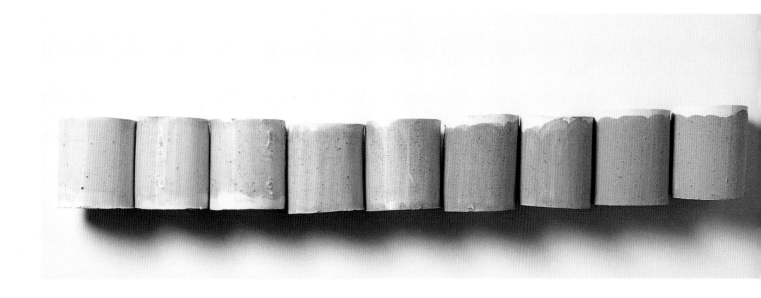

Example 1: Line Blend for a Glossy Melt at 1060°C Using a Frit and a Local Clay		
STAGE 1		
	Material A (lead bisilicate)	Material B (local clay)
Test 1	100% A*	0% B
2.	90	10
3.	80	20
4.	70	30
5.	60	40
6.	50	50
7.	40	60
8.	30	70
9.	20	80
10.	10	90
11.	0% A	100% B*

*Note: These can be omitted when the characteristics of the materials at the desired temperature are already known.

a glassy material, or, conversely, how a clay becomes more glassy with the addition of a powerful flux material.

Such a straightforward line blend can be made more sophisticated by further development. Other materials may be blended into the recipe through progressive additions in multiples of five or ten. The size and number of the multiples can be varied to suit the material to be added, for example five or ten might suit additions of most materials, but those whose recommended maximum in a glaze is less than 15 per cent might be added in multiples of only one, two or three.

In the next stage of this exercise, the choices might be flint (silica), for hardness, durability and craze resistance, or another primary flux material to alter colour response, perhaps an alkaline or borax frit, a secondary flux material or an opacifier, and so on. It is worth remembering, however, that complexity and number of ingredients do not necessarily lead to a recipe for a better glaze.

STAGE 2

	Test 1a	Test 1b	Test 1c	Test 1d
Lead bisilicate	90	90	90	90
Clay	10	10	10	10
+				
Flint	10	20	30	40 parts

Note that here the tests are carefully numbered – this is crucial and also the test pieces themselves must be clearly marked for future reference. I use red iron oxide and a small brush to write on test pieces.

done by weighing out the parts dry and mixing each test separately, which is accurate but time-consuming, or by wet blending (*see* below), which can be quicker but is also less precise, although accurate enough for general testing.

From this set of tests the 90/10 mix appears to work quite well and this may prove to be sufficient for a simple earthenware pottery glaze. This first exercise illustrates the very basics of an approach to empirical glaze research and reveals the dulling effect of larger amounts of clay on

Test 1a here was chosen and the recipe is recalculated to 100 per cent by the formula:

$$\frac{\text{Batch item}}{\text{Batch total}} \times 100$$

If desired, further materials may be tried. Here another flux material, calcium borate frit, is added:

STAGE 3

	Test 2a	Test 2b	Test 2c	Test 2d
Lead bisilicate	82	82	82	82
Clay	9	9	9	9
Flint	9	9	9	9
+				
Calcium borate frit	10	20	30	40 parts

This time 2c is chosen, the calcium borate has reduced the yellowness from the lead and its low expansion characteristics should further help to reduce crazing. The recipe is once again recalculated to 100 per cent for the purpose and ease of comparison with other recipes:

TEST 2C

Lead bisilicate	63
Calcium borate frit	23
Clay	7
Flint	7

Now we have a fairly straightforward earthenware transparent glaze, so to make it more interesting another blend might be executed with a material that would affect the opacity and texture of the glaze. A secondary flux material like calcium perhaps at this temperature would achieve opacity in sufficient quantity, or tin or titanium could be used. Finally, the colour response of the glaze will be explored with colouring oxide additions along the lines suggested in Chapter 11, page 87.

In this following blend I have chosen titanium in multiples of five, up to twenty parts for a final base glaze, which I hope will have a more matt surface and some texture when colour is added.

	Test 3a	Test 3b	Test 3c	Test 3d
Lead bisilicate	63	63	63	63
Calcium borate frit	23	23	23	23
Clay	7	7	7	7
Flint	7	7	7	7
+				
Titanium dioxide	5	10	15	20 parts

In this case, five parts of titanium had little effect on the surface, while ten parts had surprisingly too much and made it duller than I wished. Rather than doing yet another blend between 5 and 10 parts of titanium, a straightforward compromise can be reached and an addition of 7.5 parts of titanium was decided upon and tested, giving a final percentage recipe of :

Lead bisilicate	59
Calcium borate frit	21
Clay	6.5
Flint	6.5
Titanium dioxide	7
+	
Copper carbonate	2
Cobalt carbonate	0.5

Molecular formula		
$0.62PbO$	$0.16Al_2O_3$	$1.97SiO_2$
$0.01KnaO$	$0.55B_2O_3$	$0.32TiO_2$
$0.37CaO$		

Lastly, some colour has been added, in this case copper and cobalt in combination (*see* Chapter 11). I often choose copper as a general test of a glaze's colour response because it is so sensitive to the fluxes used, while the cobalt was included to indicate the subtlety that colouring oxides in combination can produce. I usually prefer to express colouring oxides as addition to the percentage recipe, whereas some prefer to recalculate them back into the overall percentage recipe. The reason is that I like to consider the colour as an add-on to the 100 per cent recipe that constitutes the 'essential' recipe ingredients and give the glaze its basic character. This method also makes it easier to compare one percentage recipe with another. I use this rule with most recipes, except where the colouring oxide is intrinsic to the nature of the glaze.

The photographs opposite show the final glaze and also with the colour added, and illustrate the typical mottled and variegated surface effect caused by the titanium.

Line Blending Two Known Glazes

In the previous example, line blending was used to investigate a succession of raw materials in a deliberately experimental manner without any very particular end result in mind. Another very valuable variation on the technique is to take

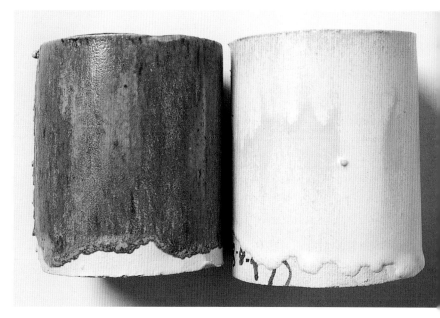

Wet Blending

This avoids some of the dust hazards involved in dry-mixing glazes and can also be much quicker. The technique is to ensure that both glazes are mixed up in equal weight and added to exactly the same amounts of water: 100g (3.5oz) of glaze to 100ml (6cu.in; or 100cc – the same thing) of water is a useful quantity and has the advantage of keeping the numbers conveniently rounded. The glazes are then blended carefully together; 8ml (0.5cu.in) of A to 2ml (0.12cu.in) of B is equivalent to eight parts to two parts by weight, and so on. I find that a

The final line blended glaze on a test bowl (left).

The final blend of the glaze with and without colouring oxide showing the variegation typical of titanium (above).

two known glazes and produce systematic variations between them.

This can be carried out by weighing out and dry-mixing thoroughly each set of ingredients of the two glazes separately and making sure that all the ingredients are completely interdispersed. If the tests were mixed up in 100g (3.5oz) batches, a total of 200g (7.06oz) dry weight of each glaze would be needed to make up the four intermediate 100g blends. This method will work even when the two recipes are very different, as Example 2 demonstrates (*see* table).

A pleasingly neat feature of this type of blend is how the maths work out in equal steps. Once the first calculation for test 1 has been done (80 per cent of each glaze A ingredient + 20 per cent of each glaze B ingredient), the amounts for tests 2, 3 and 4 can be easily extrapolated. The photograph overleaf shows test 2 with an added 2 per cent copper carbonate producing an extremely rich and variegated surface.

Example 2

GLAZE A							GLAZE B	
Barium carbonate	35						Wood ash	60
Nepheline syenite	50						Nepheline syenite	30
China clay	15						Whiting	10

		Test 1	Test 2	Test 3	Test 4		
A (%)	100	80	60	40	20	0	
B (%)	0	20	40	60	80	100	

GLAZE A							GLAZE B
Barium carb.	35	28	21	14	7	0	Barium carb.
Whiting	0	2	4	6	8	10	Whiting
Nepheline syenite	50	46	42	38	34	30	Nepheline syen.
Wood ash	0	12	24	36	48	60	Wood ash
China clay	15	12	9	6	3	0	China clay

Test 2 from the blend of two glazes, with copper oxide added to give pink and green coloration.

SUGGESTIONS FOR LINE BLENDS

1000°C – 1200°C

Any frit	–	any clay
Any frit	–	flint
Any frit	–	any feldspar or wood ash
Any frit	–	any secondary flux material, whiting, zinc, talc, and so on
Any frit	–	any other frit
Any clay	–	any primary flux, lead oxide, pearl ash, soda ash, borax,* lithium, colemanite or Gerstley borate
Feldspar	–	any raw primary flux, lead, soda, borax, lithium, colemanite or Gerstley borate.

1200°C – 1300°C

Wood ash	–	any clay
Wood ash	–	any feldspar**
Wood ash	–	any secondary flux material
Any feldspar	–	any secondary flux material
Any clay	–	any primary flux material

Notes: * All these fluxes in pure form are soluble and create practical problems in use, lead is also a health hazard and should only be considered for use where adequate health and safety conditions apply.

** In this context, any feldspar includes cornish stone, nepheline syenite, petalite, and so on.

100ml measuring cylinder is useful for this, although a plastic syringe can also be very accurate. The glazes should be added a few drops at a time and also be well stirred at every addition to ensure that all the ingredients are in suspension. The larger the quantity in which the glazes are mixed the greater the accuracy, but this has to be balanced against wastage of materials in the process.

Wet blending can also be employed in other more complex mixes such as triaxial and quadraxial blends.

Triaxial Blending

This is a method that, as the name suggests, allows three materials to be logically and systematically mixed. Like line blending, it can be used to investigate raw materials, known glazes, or a mixture of the two.

Most people find the concept of line blending easy to understand, but some find triaxials less easy. Perhaps their most confusing aspect is the diagrams which are used to illustrate them, which, although initially confusing are simply a graphic solution to the problem of laying out a three-way mix of materials.

The diagram below shows a typical triaxial diagram similar to the one in Chapter 3, in which each point of the triangle is given a letter, A, B and C, each signifying a different material. A is at the top or apex of the triangle and this point represents 100 per cent of material A, and anywhere along the line B–C at the base represents 0 per cent of material A. Each line parallel to B–C represents an increase of 20 per cent up to 100 per cent at point A.

Point B represents 100 per cent of that material and the lines parallel to and including A–C represent the diminishing amounts of B down to 0 per cent. The same is true for C and the lines parallel to A–B.

Separating the diagram into its three components and viewing each individually as in the figure overleaf, reveals the simple basis of the triaxial grid.

When the diagram is put back together again as overleaf the intersections created (in this case twenty-one) show the points at which the proportions of each material can easily be calculated. For example, at point 5 the mixture would be A – 60 per cent, B – 20 per cent and C – 20 per cent. At point 9 the mixture would be A – 40 per cent, B – 20 per cent and C – 40 cent. The mixture at each point is calculated by counting the number of lines from each point towards the opposite side of the triangle.

Although triaxial blends look complicated and time-consuming, they offer a large amount of information and are also, especially when blending raw materials, very useful as a means of

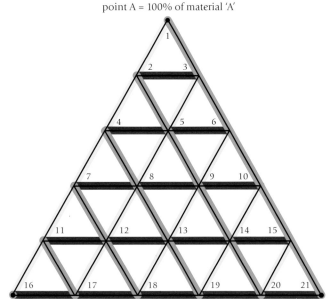

point A = 100% of material 'A'

point B = 100% of material 'B' point C = 100% of material 'C'

A 21-point triaxial diagram.

*B*reakdown of triaxial diagram. Separating the diagram into its three components and viewing each individually as here reveals the simple basis of the triaxial grid.

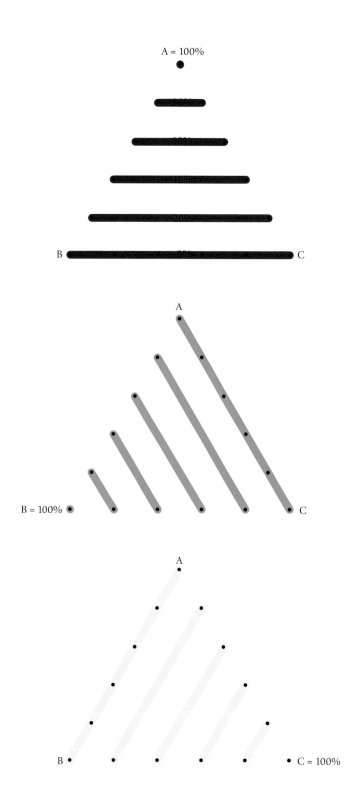

developing an understanding of the nature and behaviour of the raw materials. However, it is not always necessary to mix every blend on the diagram because, as can be seen from the figure above opposite, all the points on the outer edge combine only one or two of the materials, and it is only at points 5, 8, 9, 12, 13 and 14 that all three materials are mixed.

A 21-point triaxial grid is really the minimum for usefulness in glaze development, yielding

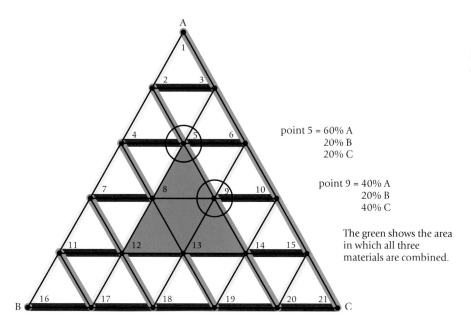

Triaxial diagram with examples of blends at point 5 and point 9.

point 5 = 60% A
 20% B
 20% C

point 9 = 40% A
 20% B
 40% C

The green shows the area in which all three materials are combined.

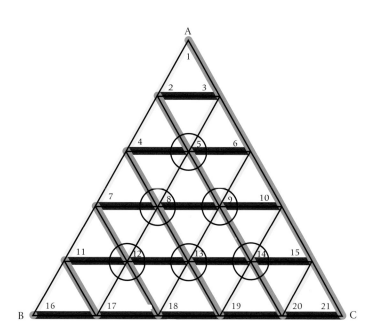

Triaxial diagram showing all the points (circled) where all three materials are blended.

six three-way blends, but they can explore very subtle variations by extending them to 28, 36, 45, 55, 66 points, and so on. A 66-point diagram would yield a total of thirty-six blends that included all three materials. This also has the advantage of breaking down the variations at each point into convenient percentage units of ten.

A Triaxial Blend with More than Three Materials

The next example is a triaxial blend of three materials, but illustrates the extra variation that can be introduced by making one of the points represent more than one material:

A = 50% local clay and 50% china clay
B = wood ash
C = talc

The full number of possible blends is listed below. Those in bold type are the points at which all three materials are involved.

1.	A – 100%		
2.	A – 80	B – 20	–
3.	A – 80	C – 20	–
4.	A – 60	B – 40	–
5.	**A – 60**	**B – 20**	**C – 20**
6.	A – 60	C – 40	–
7.	A – 40	B – 60	–
8.	**A – 40**	**B – 40**	**C – 20**
9.	**A – 40**	**B – 20**	**C – 40**
10.	A – 40	C – 60	–
11.	A – 20	B – 80	–
12.	**A – 20**	**B – 60**	**C – 20**
13.	**A – 20**	**B – 40**	**C – 20**
14.	**A – 20,**	**B – 20**	**C – 60**
15.	A – 20	C – 80	–
16.	B – 100	–	–
17.	B – 80,	C – 80	–
18.	B – 60,	C – 40	–
19.	B – 40,	C – 60	–
20.	B – 20,	C – 80	–
21.	C – 100	–	–

Numbers 5, 8, 9, 12, 13 and 14 in bold are the tests that are made up this time. Of course, a fuller picture would be gained by mixing up all twenty-one blends, but whether or not this is done every time is a matter of judgment.

Because A represents two clays (50 per cent local clay and 50 per cent china clay) the amount that A represents at each point is halved between the local clay and china clay, and the tests are therefore mixed up as follows:

	A		B	C
	local clay	*china clay*	*ash*	*talc*
Test 5	30	30	20	20
Test 8	20	20	40	20
Test 9	20	20	20	40
Test 12	10	10	60	20
Test 13	10	10	40	40
Test 14	10	10	20	60

The picture right shows a test bowl glazed with test 5. Its comparatively high clay content makes it less fluid than the low clay blends, but it still retains a characteristic ash-glaze quality.

As with line blending, the raw materials for triaxial blends should be considered in terms of their suitability for the temperature to which they will be fired. If all three materials chosen are relatively refractory, such as clays, feldspars and secondary fluxes, there will be little hope of them melting at earthenware temperatures. Similarly, frits and pure primary fluxes in excess would be impractical for higher stoneware temperatures. However, it is worth saying that in studio ceramics where the technical performance, strength and durability of the glaze is sometimes less important than purely visual considerations, that so long as the three materials chosen contain between them in some reasonable measure the three essential glaze oxides, flux, alumina and silica, then the likelihood of achieving successful ceramic fusions is high.

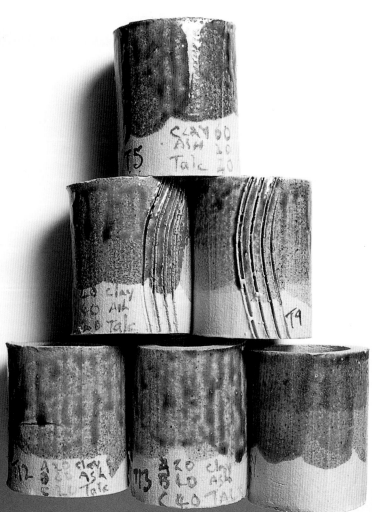

*T*riaxial tests, 5, 8, 9, 12, 13, and 14 showing blends of all three materials, A (local clay and china clay), B (ash) and C (talc).

As with all glaze trials it is worth also testing the colour response of the more promising blends by adding some colouring oxide to them or applying over a coloured slip.

A Triaxial Blend with a Glaze and Two Raw Materials

As with line blends, triaxials can also be used to blend a known glaze with up to two other glazes or raw materials. A known glaze could be blended with clay and a secondary flux perhaps as a useful means of investigating their effects on the glaze surface.

With two known glazes and just one raw material, the choice this time might be clay or flint, but could also be a secondary flux or a feldspar, and so on. It is worth sometimes taking a 'risk' if only for the sake of increasing your experience and knowledge of the materials.

In the next example using a 21-point triaxial diagram, a basic ash glaze recipe of feldspar, wood ash and clay is the starting point. This is a fluid, glassy melt at 1260°C and this blend will explore the effects that a secondary flux, magnesium, and flint will incur.

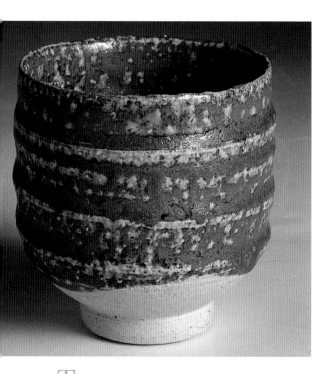

*T*est bowl with blend number 5 over a white stoneware body. Slower cooling in a full-size kiln has given the glaze a slightly crystalline texture.

Materials = A – basic B – barium C – flint
ash glaze carbonate

Wood ash	40
Potash feldspar	40
China clay	20

From the previous example, we know that in a 21-point grid there are six intersections where all three ingredients are combined and these are 5, 8, 9, 12, 13, and 14. The mixture amounts are given below.

test 5	A = 60	test 8	A = 40	test 9	A = 40
	B = 20		B = 40		B = 20
	C = 20		C = 20		C = 40

test 12	A = 20	test 13	A = 20	test 14	A = 20
	B = 60		B = 40		B = 20
	C = 20		C = 40		C = 60

As material A is in itself a complex material made up of three ingredients, the amount of each of its ingredients to be included in the triaxial blend is calculated by dividing the quantity of each recipe ingredient of the glaze by 100 and multiplying by the amount of A at that point in the graph.

EXAMPLE, TEST 5

Material A (basic ash glaze)
Wood ash	$40/100 \times 60 = 24$	
Potash feldspar	$40/100 \times 60 = 24$	60
China clay	$20/100 \times 60 = 12$	

Material B (barium carbonate) 20

Material C (flint) 20

Total 100

The tests can be written out in the following manner:

TEST	5	8	9	12	13	14
Wood ash	24	16	16	8	8	8
Potash feldspar	24	16	16	8	8	8
China clay	12	8	8	4	4	4
Barium	20	40	20	60	40	20
Flint	20	20	40	20	40	60

Triaxial blends can in this way produce highly complex variations when up to three different

glaze recipes are used, yet the calculations for each blend recipe are essentially very simple. Moreover, if the blend is done wet, with each glaze mixed with exactly the same amount of water (*see* Wet Blending, page 138), then the process can be relatively quick also.

Quadraxial Blends

A further extension of these empirical investigations is the quadraxial blend. These work in the same way as triaxial blends, but have an extra side which allows four materials to be systematically blended. A feature of these is that the mathematics restrict each material represented at each corner to 50 per cent.

In the example below, a 36-point grid will yield 16 points, at which all four materials or glazes are involved.

A = feldspar 50%
B = whiting 50
C = clay 50
D = flint 50

The following examples illustrate how the grid works:

point
1	= 50% A (feldspar), 50% B (whiting)
6	= 50% A (feldspar), 50% D (flint)
8	= 40% A (feldspar), 40% B (whiting), 10% C (clay), 10% D (flint)
22	= 20% A (feldspar), 20% B (whiting), 30% C (clay), 30% D (flint)
31	= 50% B (whiting), 50% C (clay)
33	= 30% B (whiting), 50% C (clay), 20% D (flint)
36	= 50% C (clay), 50% D (flint)

A 36-point quadraxial blend produces sixteen points, at which all four materials are included at points 8, 9, 10, 11, 14, 15, 16, 17, 20, 21, 22, 23, 26, 27, 28 and 29. The four corner points will include two materials only, and the rest around the outside, three. Again, it is not necessary to mix all 36 blends.

Quadraxial blends are very useful for investigating the raw materials and, like triaxials, they can convey how the oxides interact on a practical level and develop your working knowledge. They can be used to investigate four single materials, or, like triaxials, the letters A, B, C and D can be used to represent more than one material each or indeed a separate glaze recipe. If a quadraxial blend of four known glazes was to be undertaken, although time-consuming it would give lots of new possible glaze compositions.

3 6-point quadraxial diagram. The four corners represent blends of only two materials. All points (excluding the four corners) situated on the blue line represent blends of three of the materials. All points on and within the red square represent blends of all four materials.

The Development of Glazes through Molecular Equivalent Formulae

In Chapter 10 the relationship between the molecular weights of compounds and their recipe quantities was investigated, and how glazes could be considered in terms of the numbers of molecules of each of the individual main glaze oxides, through the use of the limit formula was discussed.

The number of molecules of any oxide, for example $0.4Al_2O_3$, is correctly referred to as an equivalent number, because of course in the glaze itself we do not find fractions of molecules. The numbers given to each oxide in the formulae are theoretical equivalent numbers

that express the relationships between the overall amounts of the oxides.

Molecular formulae may seem very daunting to the beginner, and I have to admit that the very people who are interested in creative arts are often those most likely to shrink from anything remotely connected to maths or science. This, of course, is a blatant generalization, but, luckily, for those who are wary of theoretical formulae and small decimal numbers, calculators and computers can now make the process of using these formulae less painful. There are several computer software programs available (*see* Useful Addresses, Appendix) that overcome most of the difficulties encountered in such calculations, and as time goes on these will become more and more sophisticated. They can also be programmed to include particular materials wherever the percentage analysis is available, can provide cost estimates and indicate expansion characteristics, as well as containing many other features. So, if the basic principles can be grasped, and a good empirical understanding of how the raw materials behave in ceramic fusions can be attained, the use of molecular formulae can be a very useful tool in developing ones' own glazes.

At this point, a thorough reading and working through of the examples given in Chapter 10 should be done before going on to attempt more complex formula.

Construction and Development of a Glaze From the Limit Formulae

Below is the limit formula guide for stoneware glazes (*see* Limit Formulae, Appendix), followed by a possible glaze formula assembled from within the parameters it sets out.

High Temperature Alkaline Dominated 1225– 1300 °C

MOLECULAR EQUIVALENT LIMITS

KNaO 0.2–0.4	Al_2O_3 0.3–0.5	SiO_2 3.0–5.0
CaO 0.4–0.7	B_2O_3 0.1–0.3	
MgO 0.0–0.35		
BaO 0.0–0.3		
ZnO 0.0–0.3		

The oxides are chosen from within the amounts allowed for each oxide. Any normal glaze really must contain at least one of the fluxes, some alumina and, of course, some silica. The golden rule of such unity formulae is to be sure that the choice of fluxes adds up to a total of 1.

Possible Glaze Formula

K_2O	0.2	Al_2O_3 0.4	SiO_2 4.5
CaO	0.4		
MgO	0.2		
ZnO	0.2		

The first requirement is to find materials that supply only those oxides required in the formula. This is where knowledge of the materials and familiarity with their symbols are required. Looking through the list of raw materials reveals that there are several alternatives, but a useful rule to follow is to find first the materials that supply the fluxes, then to include some clay and flint (or quartz) to make up the alumina and silica if necessary.

Looking at our possible glaze formula, the only flux which is not available in a convenient singular form is potassium (K_2O), but we have seen that potash feldspar is a useful source of potassium for stoneware glazes because it also contains the essential oxides of alumina and silica, making it a common first choice. The other fluxes in the formula are all available as simple oxides or as carbonates. A reminder should be made here that with materials such as whiting (calcium carbonate) and magnesium carbonate, the carbon in the formula can be ignored for purposes of glaze calculation because it burns out at low temperature and plays no significant part in the fusion process.

Here then is a selection of materials that can supply the oxides in the formula:

Potash feldspar	$K_2O.Al_2O_3.6SiO_2$
Whiting	CaO
Magnesium carbonate	MgO
Zinc oxide	ZnO
China clay	$Al_2O_3.2SiO_2$
Flint or quartz	SiO_2

The next step is to write out the oxides required from left to right, starting with the stronger alkaline fluxes followed by the secondary fluxes, then the sesquioxides (usually alumina), and finally the glass formers (usually silica). Below this line, underneath the symbol for each oxide the amount required by the formula is written:

Oxides required	KNaO	CaO	MgO	ZnO	Al$_2$O$_3$	SiO$_2$
Equivalent required	0.2	0.4	0.2	0.2	0.4	4.5

Note that the symbol used for potassium oxide has been changed from K$_2$O to KNaO, the combined symbol for either potassium and/or sodium (*see* Chapters 9 and 10).

Now, look at the list of selected materials and still working from left to right, choose the material that supplies K$_2$O (potassium oxide). This is potash feldspar, whose formula is K$_2$O.Al$_2$O$_3$.6SiO$_2$. This formula tells us that for every molecule or part of potassium (K$_2$O), potash feldspar will also provide one molecule or part of alumina (Al$_2$O$_3$) and six molecules or parts of silica (SiO$_2$). Here, where 0.2 molecules of K$_2$O are required by the formula, the amounts of the other oxides it contains will be in those proportions, that is, also 0.2 parts of alumina and 1.2 parts of silica (6 × 0.2). The oxides supplied are then subtracted from the oxides required to show the remaining oxide amounts to be supplied by other materials. The equivalent number of molecules of K$_2$O required by the formula to be supplied ('sup.' in the following tables) by potash feldspar – 0.2, is entered in brackets under the heading ME. This indicates that 0.2 is the molecular equivalent amount required of potash feldspar to also provide 0.2 molecules of alumina and 1.2 molecules of silica, and is the number by which the molecular weight of potash feldspar will be multiplied to give us the actual batch quantity.

Oxides required	KNaO	CaO	MgO	ZnO	Al$_2$O$_3$	SiO$_2$
(ME) Equivalent required	0.2	0.4	0.2	0.2	0.4	4.5
Potash feldspar sup. **(0.2)**	0.2	**	**	**	0.2	1.2
Ox. rem.	–	0.4	0.2	0.2	0.2	3.3

This last line showing the oxides remaining (Ox. rem.) reveals that 0.2 molecular equivalents of potash feldspar supply all the potassium, half the alumina and just over a quarter of the silica.

The next oxide required is calcium, followed by magnesium and zinc. These are the secondary fluxes and in this case they are used in their pure oxide forms as whiting (calcium carbonate), magnesium carbonate and zinc oxide. This means that where the formula calls for 0.4 molecules of CaO, 0.4 molecules of whiting will supply 0.4 molecules of CaO and nothing else. The same is true for the magnesium carbonate and zinc oxide.

Oxides required	KNaO	CaO	MgO	ZnO	Al$_2$O$_3$	SiO$_2$
Equivalent required **(ME)**	0.2	0.4	0.2	0.2	0.4	4.5
Potassium feldspar sup. **(0.2)**	0.2	**	**	**	0.2	1.2
Ox. rem.	–	0.4	0.2	0.2	0.2	3.3
Whiting sup. **(0.4)**	**	0.4	**	**	**	**
Ox. rem.	–	–	0.2	0.2	0.2	3.3
Magnesium carbonate sup. **(0.2)**	**	**	0.2	**	**	**
Ox. rem.	–	–	–	0.2	0.2	3.3
Zinc oxide sup. **(0.2)**	**	**	**	0.2	**	**
Ox. rem.	–	–	–	–	0.2	3.3

By now, all that remains are 0.2 molecules of alumina and 3.3 molecules of silica. In the initial selection of materials intended to supply this formula, china clay was chosen for its alumina and clay content. As with many of the oxides, different choices can be made; here, alumina could have been supplied by calcined alumina, a pure source of alumina which is widely used for its refractory properties for protecting kiln furniture or for setting fragile ware. In this case, china clay will also add some of the outstanding silica, killing two birds with one stone as it were, but it also incorporates into the recipe some of the plastic properties of clay. This improves the unfired strength of the glaze on the ware and makes handling easier, and also helps to prevent rapid settling of the ingredients in the bucket. For these reasons, clay is incorporated into recipes wherever possible.

Oxides required	KNaO	CaO	MgO	ZnO	Al$_2$O$_3$	SiO$_2$
Equivalent required **(ME)**	0.2	0.4	0.2	0.2	0.4	4.5
Potassium feldspar sup. **(0.2)**	0.2	**	**	**	0.2	1.2
Ox. rem.	–	0.4	0.2	0.2	0.2	3.3

	KNaO	CaO	MgO	ZnO	Al₂O₃	SiO₂
Whiting sup. (0.4)	**	0.4	**	**	**	**
Ox. rem.	–	–	0.2	0.2	0.2	3.3
Magnesium carbonate sup. (0.2)	**	**	0.2	**	**	**
Ox. rem.	–	–	–	0.2	0.2	3.3
Zinc oxide sup. (0.2)	**	**	**	0.2	**	**
Ox. rem.	–	–	–	–	0.2	3.3
China clay sup. (0.2)	**	**	**	**	0.2	0.4
Ox. rem.	–	–	–	–	–	2.9

Lastly, the final remaining 2.9 molecules of silica are provided by either flint or quartz, both of which are pure forms of silica and are interchangeable in glazes, and so the formula is completed.

Oxides required	KNaO	CaO	MgO	ZnO	Al₂O₃	SiO₂
Equivalent required (ME)	0.2	0.4	0.2	0.2	0.4	4.5
Potassium feldspar sup. (0.2)	0.2	**	**	**	0.2	1.2
Ox. rem.	–	0.4	0.2	0.2	0.2	3.3
Whiting sup. (0.4)	**	0.4	**	**	**	**
Ox. rem.	–	–	0.2	0.2	0.2	3.3
Magnesium carbonate sup. (0.2)	**	**	0.2	**	**	**
Ox. rem.	–	–	–	0.2	0.2	3.3
Zinc oxide sup. (0.2)	**	**	**	0.2	**	**
Ox. rem.	–	–	–	–	0.2	3.3
China clay sup. (0.2)	**	**	**	**	0.2	0.4
Ox. rem.	–	–	–	–	–	2.9
Flint sup. (2.9)	**	**	**	**	**	2.9
Oxides remaining	–	–	–	–	–	–

The batch recipe amounts are calculated by multiplying the molecular equivalent number of each material by the molecular weight of that material:

0.2 ME potash feldspar	×	MW 556.8	=	111.4
0.4 ME whiting	×	MW 100.1	=	40.0
0.2 ME magnesium carbonate	×	MW 84.3	=	16.9
0.2 ME zinc oxide	×	MW 81.4	=	16.3
0.2 ME china clay	×	MW 258.2	=	51.6
2.9 ME flint	×	MW 60.1	=	174.3
		Batch Total	=	**410.5**

And finally the percentage recipe can be obtained by the formula:

$$\frac{\text{Batch item}}{\text{Batch total}} \times 100 =$$

Potash feldspar	27
Whiting	10
Magnesium carbonate	4
Zinc oxide	4
China clay	13
Flint	42
	100%

Unsurprisingly, given that it conformed to known parameters, this recipe turned out to be acceptable as a semi-opaque glaze, but also rather dull and unexceptional. However, it is always worthwhile testing a glaze recipe with a colouring oxide to see what colour responses are possible. Copper is often a good choice for this purpose because of its sensitivity to the different flux materials, but in this case an addition of 10 per cent red iron oxide was chosen (for no particular reason other than variety). This produced a more interesting, slightly mottled rich brown, but still with a rather harsh surface quality.

First version of the glaze developed from ME formula with 10 per cent added red iron oxide, oxidation-fired in an electric kiln to 1260°C.

Making Changes

The investigation and development through the molecular formula of such a recipe as the one above can be done in two ways. Firstly, the formula can be kept the same but supplied by different materials. This can sometimes produce quite noticeable changes because many of the raw materials, even when chemically identical, can behave differently in the glaze fusion and produce different characteristics. Secondly, the fluxes can be changed so that the overall balance of the glaze is left unaltered, but the glaze characteristics are changed accordingly.

In the next example, the glaze formula is unchanged, but some of the materials chosen to supply the oxides are changed.

Oxides required	KNaO	CaO	MgO	ZnO	Al_2O_3	SiO_2
Equivalent required	0.2	0.4	0.2	0.2	0.4	4.5

Materials chosen to supply the oxides required

Cornish stone	0.72KNaO 0.28CaO	$1.02Al_2O_3$	$8.43SiO_2$
Dolomite	CaO.MgO		
Whiting	CaO		
Zinc oxide	ZnO		
China clay		Al_2O_3.	$2SiO_2$
Flint or quartz			SiO_2

Calculation of a Feldspathic Material Containing More Than One Flux

For this recipe, the potash feldspar is substituted by cornish stone. Cornish stone will supply the same oxides as potash feldspar supplied, but in different amounts, and also some calcium, another oxide required in the glaze formula.

This creates a new problem – how to determine how many molecules of a material will be required to supply the correct amount of a flux, when the material chosen to supply that flux contains more than one.

This example calculation shows how to determine how many molecular equivalents of Cornish stone will provide the correct amount of KNaO while taking into account the calcium. The answer is arrived at by dividing the amount of KNaO required in the glaze formula by the amount of KNaO in cornish stone (0.72), and multiplying the rest of the cornish stone formula through by this number to see the relative amounts of calcium, alumina and silica it also supplies. In this case, 0.28 molecules of cornish stone are required for every 0.2 molecules of KNaO it provides:

$$\frac{\text{amount of KNaO required in glaze}}{\text{amount of KNaO in cornish stone}} \quad \frac{0.2}{0.72} = 0.28$$

0.28 = the molecular equivalent amount of cornish stone required to supply 0.2 molecules of KNaO.

KNaO	$0.72 \times 0.28 = 0.20$
CaO	$0.28 \times 0.28 = 0.08$
Al_2O_3	$1.02 \times 0.28 = 0.29$
SiO_2	$8.43 \times 0.28 = 2.36$

The rest of the calculation is similar to the previous example. Dolomite is the other new material which supplies equal amounts of magnesium and calcium in sufficient quantity as to dispose of the need to use magnesium carbonate.

Oxides required	KnaO	CaO	MgO	ZnO	Al_2O_3	SiO_2
Equivalent required	0.2	0.4	0.2	0.2	0.4	4.5
ME						
Cornish stone sup. **(0.28)**	0.2	0.08	**	**	0.29	2.36
Ox. rem.	–	0.32	0.2	0.2	0.11	2.14
Dolomite sup. **(0.2)**	**	0.2	0.2	**	**	**
Ox. rem.	–	0.12	–	0.2	0.11	2.14
Whiting sup. **(0.12)**	**	0.12	**	**	**	**
Ox. rem.	–	–	–	0.2	0.11	2.14
Zinc oxide sup. **(0.2)**	**	**	**	0.2	**	**
Ox. rem.	–	–	–	–	0.11	2.14
China clay sup. **(0.11)**	**	**	**	**	0.11	0.22
Ox. rem.	–	–	–	–	–	1.92
Flint sup. **(1.92)**	**	**	**	**	**	1.92

percentage recipe

Cornish stone	0.28	×	MW 694.7	=	194.5	48
Dolomite	0.2	×	MW 184.4	=	36.9	9
Whiting	0.12	×	MW 100.1	=	12.0	3
Zinc	0.2	×	MW 81.4	=	16.3	4
China clay	0.11	×	MW 258.2	=	28.4	7
Flint	1.92	×	MW 60.1	=	115.4	29
			Total	=	403.5	100

The result here was a softer, smoother, more opaque glaze and with the extra 10 per cent of red iron it gave a more subtle brown-black but still with a mottled 'oil spot' texture.

Changing the Formula – Different Fluxes, and Altering the Silica

In this final development, adjustments are made to the original formula, changing the fluxes and altering the balance of alumina and silica. Instead of potassium or sodium (KNaO, the two most commonly used strong alkaline fluxes),

lithium, the other strong alkali, is used, and barium replaces the zinc and some of the calcium. Lithium and barium will produce different colour responses with many of the colouring oxides, and a possible benefit might be a lesser tendency to craze due to the lower expansion/contraction characteristics of lithium. Reducing the silica to 3.0 molecular equivalents, the lowest amount recommended in the limit formulae, significantly alters the ratio of alumina to silica from 1:11, to 1:7.5, and should stiffen the glaze to an extent.

NEW GLAZE MOLECULAR FORMULA (GMF)						
Oxides required	Li_2O	CaO	MgO	**BaO**	Al_2O_3	SiO_2
Equivalent required **(ME)**	0.2	0.2	0.2	**0.4**	0.4	**3.0**
Lithium carbonate sup. **(0.2)**	0.2	**	**	**	**	**
Ox. rem.	–	0.2	0.2	0.4	0.4	3.0
Dolomite sup. **(0.2)**	**	0.2	0.2	**	**	**
Ox. rem.	–	–	–	0.4	0.4	3.0
Barium carbonate sup. **(0.4)**	**	**	**	0.4	**	**
Ox. rem.	–	–	–	–	0.4	3.0
China clay sup. **(0.4)**	**	**	**	**	0.4	0.8
Ox. rem.	–	–	–	–	–	2.2
Flint sup. **(2.2)**	**	**	**	**	**	2.2

Note: The changes to the formula are in **bold** type.

percentage recipe

Lithium carbonate	0.2	×	MW 73.8	=	14.8	4
Dolomite	0.2	×	MW 184.4	=	36.9	10
Barium carbonate	0.4	×	MW 197.3	=	78.9	22
China clay	0.4	×	MW 258.2	=	103.3	28
Flint	2.2	×	MW 60.1	=	132.2	36
			Total	=	366.1	100

This final recipe gave a very good smooth transparent glaze with no crazing, despite the reduced silica content. Also with the added 10 per cent synthetic iron oxide, a pleasant rich iron kaki effect was achieved (*see* photograph, left).

Final version of the formula showing kaki rust effect from the iron. Oxidized fired to 1260°C (left).

The resulting glaze in this case is incidental, as the point of the above is to illustrate how glazes can be originated and developed using a variety of methods, from systematic trial and error to the molecular formula. Computer glaze calculation programmes can now be bought very cheaply, removing the necessity to do the calculations in long-hand, but their use will be enhanced by an understanding of the methodology they employ.

There are an infinite number of variations of glaze surface possible from the forty to fifty or so mineral oxide compounds used in ceramic glazes, and I believe that this is one of the reasons why ceramics has been and still is such a rich and important part of our visual culture, and why the pursuit of the craft so popular and compelling. It is always exciting to discover for oneself new and unique combinations, although equally it should be remembered that a glaze surface should be appropriate to the object to which it is applied – an attractive glaze surface will not rescue a bad piece of work.

14 Glaze Mixing & Application

The application of glaze to ware is in itself a simple and straightforward task which is usually enabled by the ware having already undergone a first or 'biscuit' firing. Of course, glaze can be applied to unfired clay, (*see* Chapter 12) and this was common practice in the past, but the advent of electric kilns made it much easier to do a biscuit firing and so avoid the difficulties involved in glazing, in particular the problems of cracking or deformation of the ware through taking up some of the glaze water. The purpose of biscuit firing is to turn the clay into ceramic, making it strong enough to survive firm handling, yet porous enough to absorb water readily.

In most cases, the biscuit temperature is in turn determined by the temperature to which the glaze will be fired. Ware that will have a glaze that fires to stoneware temperatures needs only a 'low biscuit' fire to give sufficient strength for handling and absorbency; however, too low a temperature and there is a risk that the ware may not be sufficiently sintered or fused. A commonly used temperature for 'low biscuit' is 960°C, and this is a good compromise between ensuring the right properties and incurring the least expenditure on energy costs. When the glaze is subsequently fired to a high temperature, the clay body will of course then develop its full density and strength.

Ware which will have an earthenware or low temperature glaze is by contrast often fired to 'high biscuit'. This is because most clay bodies are not so strong if only fired to earthenware temperatures and will still have a good deal of porosity. This would mean that if crazing of the glaze were to occur (and it usually would) then the ware would be permeable by liquids. This is an obvious drawback in the making of functional pottery, which would leak and become unhygienic. Even for non-functional

work there is still the greater risk of crazing, and an already relatively weak bond between clay and glaze can be weakened further if subjected to damp.

A high biscuit firing achieves three important objectives: it increases the strength of the finished ware; it reduces permeability; and, perhaps most importantly, it reduces the tendency of the glaze to craze. This is accomplished through the conversion of any free silica, particularly in the form of flint, to cristobalite which increases the expansion/contraction coefficient of the body. This, in turn causes the body to shrink more on cooling after the glaze firing and to maintain the glaze under compression. (*See* Chapters 3, 6 and 16.)

High biscuit temperature is usually between 1150°C–1200°C, but more refractory clays tend to need a higher temperature (and a 'soak' is usually helpful), and clay bodies such as bone china are biscuit fired to 1250°C which allows them to develop their unique strength and density.

Of course, when a ware has been high-biscuited the body has begun to fuse and vitrify and this makes it more dense and less porous. To counteract the reduced porosity the glaze can simply be mixed more thickly, or an additive may be used to thicken the glaze. The same would also be true for very thin ware that would not be able to take up enough water from the glaze 'slop'.

Mixing

A liquid glaze slop is normally a suspension of materials in liquid, not a solution. Soluble materials are avoided if possible because they

When weighing out ingredients it is essential to be systematic, as it is very easy to miss a material out or add one twice. It is better to copy the recipe and keep the original clean and safe, and to cross out or tick each ingredient as it is added – there are few things more frustrating than to lose track halfway through mixing up a recipe. If this does happen, it is better to start again rather than risk the uncertainty and potential further waste of time, materials and energy in testing and correcting the original mistake.

Usually, two containers of the required size are needed, the first to mix the ingredients with water, and the second to sieve the slop into. As a general guide, most glazes require between an 80's to a 120's mesh sieve, although this is not an absolute rule. I prefer to add the weighed ingredients to the water and allow them to slake for a few minutes. As a general guide, 100cc (6cu.in) of water to 100g (3.5oz) of dry ingredients (or a litre (1.76 pints) of water for every kilo (2.2lb)) is about the right amount of water, although this may vary a little, as glazes with a lot of clay will take up more water than those without. The glaze can be pushed through the sieve with a stiff-bristled 'lawn' brush. It is sometimes easier to use more water than necessary because it makes mixing, and particularly sieving, much easier, although of course this results in a very thin slop which should then be allowed to settle, at least overnight, before the excess water can be poured or siphoned off.

Each time a glaze is used it always needs a thorough stir, and sometimes it may need resieving. In the studio, this can often be done easily by hand, but for any quantity more than a large bucket, a power mixer, usually called a glaze blunger, is useful, though I have to say that it is still always best to check for lumps and grit in the glaze by hand (after removing the blunger!) before using the glaze.

For many glazes this is sufficient preparation, but certain types of glazes work better if the particles are ground to a finer consistency, which helps certain interactions and fusions. This is usually achieved in a 'ball mill', a device that rotates a container filled with very hard porcelain 'balls' or pebbles into which the glaze slop is added. The mill is left rotating for several hours and the action of the pebbles on the glaze can give a significantly finer particle size. A glaze that has been milled may well melt at a slightly lower temperature than it would otherwise.

may be absorbed into the clay body itself, altering its firing properties and depleting the glaze at the same time. There are also health and safety hazards associated with some of the common soluble materials used in ceramics, such as raw lead compounds.

The glaze ingredients are invariably mixed with water to make the glaze slop, and all that happens when this slop is applied to the ware is that the water is absorbed by the biscuit, leaving a thin coat of glaze on the surface of the ware. In practice, different glazes require different thicknesses and this is easily adjusted by adding or removing water.

Glaze Additives

It is worth remembering at this point that clay is a useful ingredient to work into many recipes if possible as it helps the suspension of the glaze in the water, and also gives some handling strength and resistance to finger printing and damage when dry. Some materials settle very quickly and the slop may need almost constant agitation to prevent this, which is simultaneously time-wasting and irritating. If the recipe does not allow for clay to be included then other 'additives' may be used, as shown below.

Bentonite ($Al_2O_3.4SiO_2.H_2O$)

Bentonite is the most common additive used in glazes to prevent settling. It is a highly plastic clay which helps the glaze to stay in suspension. It can be used at a strength of 1 to 3 per cent, and in combination with calcium chloride (*see* below) can also increase the thickness of the glaze coating. This combination will help to prevent the dense settling to the bottom of the glaze tub that is characteristic of glazes with a high proportion of fritted and calcined materials, and even when the glaze does eventually settle out, it is much easier to remix. The required amount of bentonite is best dry-mixed with some or all of the other ingredients so that it disperses more easily in the water. If it is added on its own it floats on the surface of the water in globules that are very difficult to break down (*see also* Chapter 3).

Calcium Chloride ($CaCl_2$)

This is a soluble form of calcium which is used to flocculate (increase the viscosity) a glaze slop. When dissolved in hot water and added to a glaze in very small quantities, a few drops of the solution per litre, it can reduce settling of the ingredients. In larger quantities it can thicken the glaze and help it to adhere to ware of low porosity.

Magnesium Sulphate ($MgSO_4$)

This is more commonly known as Epsom salts. Magnesium sulphate has the same properties as calcium chloride and is used in much the same way.

Gum Arabic

This is a glaze binder which gives strength to the unfired glaze, and is also useful as an addition to colouring oxides and stains to give better brushing characteristics. It must be stored in dry conditions.

SCMC (Sodium Carboxymethylcellulose)

This is similar to gum arabic, and while more expensive, it has a longer shelf life.

There are many other materials that can be used to thicken and reduce settling of glazes, such as various gums, seaweed extracts, sugar, borax crystals, Calgon, even wallpaper pastes. It is always worth remembering that some may also have side effects like making the glaze go very hard in the bucket when dried out or forming a crust on the surface. Sometimes it is less bother to put up with the irritation of stirring frequently, or to seal the glaze container so that the glaze does not dry out rather than using some of the more exotic tricks of the trade.

Pouring and Dipping

These two methods often go together in that most vessel forms are usually coated by the glaze being poured inside, and then back out again while turning the form to ensure coating the whole of the interior. The piece is then immediately dipped before the inside is dry to avoid an extra thick coat of glaze on the rim. This is usually done upside down when glazing vessels, as air pressure prevents the glaze from going up inside, provided that the ware is immersed vertically and the rim does not enter the glaze at an angle.

There is a neat little trick for doing the operation in one move, which really only works well with small, easily gripped containers like footed bowls, mugs and so on. It is one of those many small skills in the making of ceramics that is

*A*ir trapped on the
inside of a ware
preventing the glaze
from rising up the
inside of the ware.

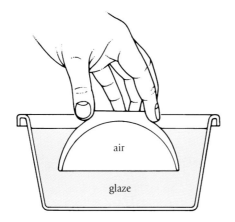

enjoyable to acquire. The diagram below shows a pot being partly immersed before being jerked upwards sharply, then pushed back into the glaze to the required depth. The trick is not to break surface when making the sharp upward jerk, which causes the glaze to splash up the inside of the pot; if the rim of the pot does break the surface then the suction is lost and the glaze is not drawn up inside. This technique is best practised with a glass so that the action can be observed.

It is possible sometimes to dip the entire piece, inside and out, in one operation and then only remove the glaze from those areas as necessary, such as the base for example. The rule to remember here is that the form needs to be relatively simple and manageable to avoid holding the piece for too long while immersed in the glaze, and without trapping air which would result in unglazed patches.

*D*ouble dipping in a
single action without
coating the base of the
ware.

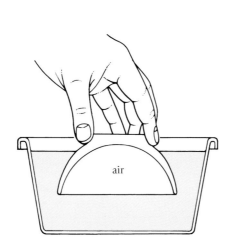
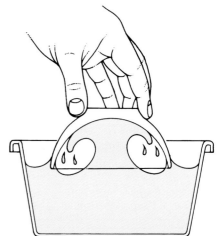

*D*ipping ware all
over in one action.

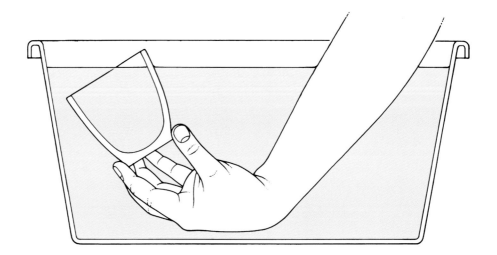

Pouring glaze over the outside of a piece is done when it is too big or too heavy to be dipped. The work can be supported on slats over a suitable container and the glaze is simply poured over the area to be glazed. The drawback here is that ware with overhangs in the form of attachments such as handles are not really suitable for this method.

Dipping, where practical and appropriate, is by far the easiest and simplest way of achieving an even, all-over coating of glaze on ceramic. It is ideal for small items that can be handled and gripped easily; there also needs to be sufficient glaze in a large enough container to avoid overflow when the ware is immersed. This technique is ideally suited to low biscuit-fired ware of a reasonable and fairly even thickness. This, in turn, ensures an even thickness of glaze covering which will, because it has been quickly 'sucked' onto the surface, be less prone to damage in handling when dry.

The main problem encountered in dipping is that of fingermarks where the piece has been gripped. This can sometimes be avoided by 'designing' into the making of the piece an unglazed area. When this is not possible, the fingermarks are easily touched up once the glaze has lost just enough moisture to be handled (most glazes are usually less easily damaged when they are still slightly damp than when they are completely dry and powdery) by dabbing on a small amount of glaze with a finger or soft brush.

Metal tongs can be used to hold the ware so as to avoid fingermarks. These make only very small marks that can easily be lightly rubbed over when dry, but they can be more trouble than they are worth unless carefully designed for the work being dipped and when many identical items have to be dipped.

Spraying

This method is in some ways the easiest form of glazing, provided that a good spray gun, compressor and glazing booth with extraction and ventilation are available. It has the principal advantage of requiring only a small quantity of glaze to be mixed, even for large pieces of work.

In practice, however, I have seen more student and beginners' work spoiled by poor spraying than by any other glazing technique. The problem is that pouring and dipping are perceived to be difficult because of the dexterity and judgment required in these processes, which by necessity have to be executed quickly, while spraying looks like an easy option. The reality is that when spraying it is difficult to know when a sufficient thickness has been applied and whether it has been applied evenly. A common mistake is to underspray areas which are angled away from the spray gun.

It is very important to be systematic in spray glazing, and it is best done on a banding wheel so that the work can be rotated. It is often useful when spraying uniform pieces (a round bowl, for example) to make some sort of reference, a dab of paint on the banding wheel for instance, so as to know when a full circumference of the piece has been completed.

Two coats are the minimum needed (depending on the thickness of the glaze slop), and care should be taken not to over/under spray areas; most importantly, the spray should always hit the surface at right angles. I always prefer to spray the 'difficult' inaccessible areas first (details, under and inside handles for instance), turning pieces upside down to get better access to some surfaces, and it is worthwhile checking the glaze thickness at various points around the piece by piercing with a sharp needle or scalpel blade.

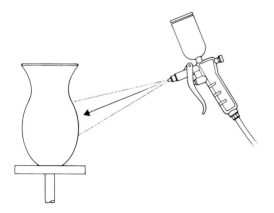

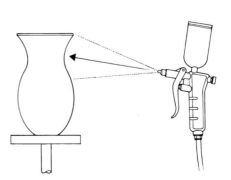

Glaze spraying at the correct angle.

Glaze can be applied in a variety of other ways, such as painting, sponging, trailing and so on, although these are perhaps best thought of as secondary means of application, often used for smaller areas for specific or decorative effects.

General Points in Glaze Application

Successful glazing requires good organization and preparation, making sure that the glaze is the right thickness for the porosity of the work itself and the application method chosen, and, most importantly, thinking through the advantages and disadvantages of the method to be used before you do it. Correct glaze thickness varies depending on what type of glaze is be applied. Some are better applied more thickly than others, but a coating of about a thumbnail thickness is a reasonable general guide.

A clean, damp sponge can be used to remove glaze from where it is not wanted, such as surfaces which are in contact with the placing shelf, or lid fittings which are to be fired in place. When it is known beforehand that glaze is to be removed from certain areas of a piece, this can

be facilitated by rendering them very smooth during making (it is sometimes difficult to remove all traces of a glaze from a textured or grainy surface), and/or by damping that specific area prior to applying the glaze. For example, a sponge on a stick can be used to wet the strainer holes inside a teapot to prevent the glaze from clogging them. If unglazed areas are to be in contact in a high temperature firing, such as is the custom when firing lids in place in stoneware firings to prevent warping, care must be taken to clean the glaze back carefully, and the application of a bat wash consisting of two parts alumina to one part china clay to the contact area will ensure easy separation after firing. Industrial-type white earthenwares are sometimes glazed all over and fired on stilts to 'seal' the body and prevent absorption of water and subsequent crazing and discoloration.

Resists may be used for the purpose of preventing the glaze adhering to certain areas of the ware, and also for decoration. The traditional type is melted candle wax diluted with some paraffin, but there are many proprietary brands available from suppliers, and other materials like latex glues can also be used. With all of these, there can be the frustration of accidentally getting the resist where you do not want it, which can mean that the piece has to be thoroughly washed or even refired to remove the resist completely.

Setting ware on stilts.

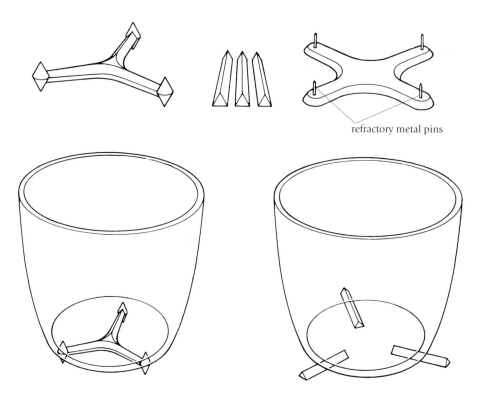

refractory metal pins

15 Firing Glazes

The opening of the kiln after a glaze firing is almost always an exciting prospect that provokes either intense pleasure or disappointment, rarely indifference. There are many pitfalls on the way to producing finished and glazed ceramic work, such as cracks in drying, breakages, warping and cracking, and even the risk of the ware exploding in the biscuit fire. There are also the dangers of incorrect glaze application, and so on. The list of opportunities for failure could be very long indeed. It is therefore very important to get the final glaze firing right in order not to waste the huge investment of time and effort in getting the work to that stage, and to avoid the disappointment of ruining a good piece of work at the final hurdle.

Still, glaze firing itself is not so difficult or complex and can often be done at a faster rate than first biscuit firings. Freshly glazed ware will have absorbed and will contain some of the glaze slop water and this will emerge as steam as a temperature of 100°C is reached. This is not as hazardous as when water is released from raw clay as the biscuit is more open and porous and releases the steam more easily. Even so, there is still a risk of loosening the glaze layer by driving the steam off too quickly, and at the extreme in fast raku firing where the ware may be placed directly into a hot chamber, the immense and sudden expansion of any residual water in the biscuit can cause it to explode quite violently. It is best therefore to make sure that the glazed ware has fully dried out before starting the firing. A good method is to have the kiln warm when placing the ware, and allow it to dry out with the doors and bungs open for the vapour to escape.

In a biscuit firing the kiln needs good ventilation right up to 600°C to allow the pore water and chemically combined water to escape from the raw clay, but this is not the case on second or subsequent firings once the ware has been heated beyond 100°C.

Care should still be taken at the points of cristobalite inversion and quartz inversion, 220°C–300°C and 573°C respectively (*see* Chapter 6), as these changes in crystalline structure take place each time the ware is heated or cooled to these temperatures. It is particularly important to allow slow and even cooling down through this range, because by this time the ware has a solid coating of glaze which creates its own additional stresses on the body and increases its vulnerability at these crucial stages.

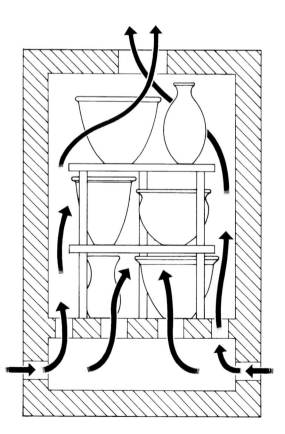

*F*lame direction in an up-draught kiln.

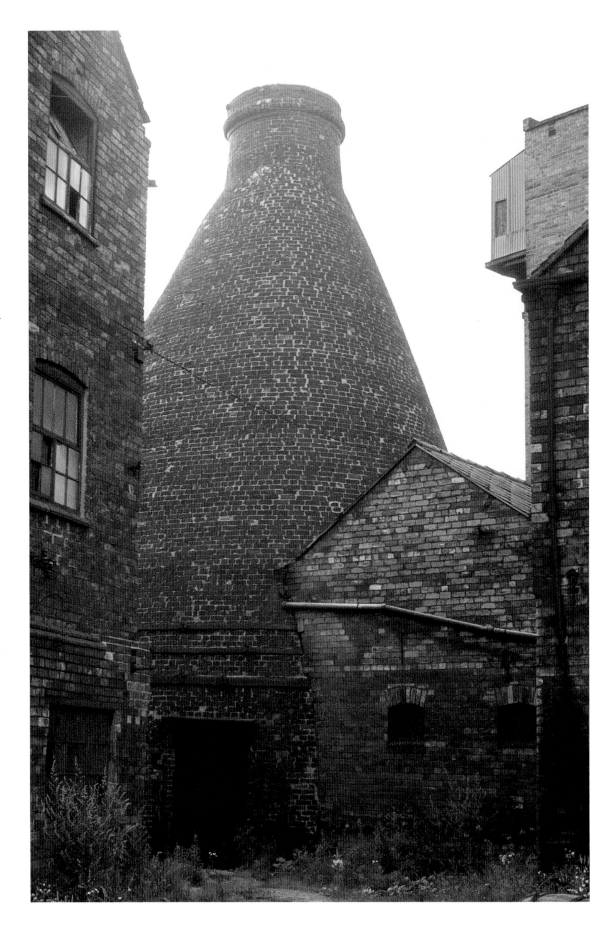

*D*erelict bottle
kiln. The Potteries
Museum, Stoke-on-
Trent.

The stronger fluxes, lead, borax, lithium, potassium and soda, begin to fuse the glaze from 600°C progressively onwards and by 950°C most earthenware glazes are becoming molten and glassy. Similarly, a glossy stoneware glaze will start to melt at about 100–50°C below its maturing temperature. Glazes vary, of course, and some mature over a wide range and are more tolerant of under- or over-firing than others, but the general aim is for an accuracy to within plus or minus 10°C.

As the glaze begins to melt, bubbles are formed as gases are released from the glaze constituents. This process is called decomposition, and added to those gases given off from the glaze can be those from the body itself when the glaze firing is above the temperature of the first biscuit firing, as further decomposition takes place in the body. It is therefore common practice to hold the kiln at the desired glaze temperature for a short period of time to ensure that any bubbles that have formed have time to settle out and that the heat fully penetrates the ware and matures the glaze on both the inside and outside of the ware. Kiln size is obviously a factor in determining the length of soak, but twenty minutes to an hour is within the common boundaries. Soaking is sometimes also carried out at the end of biscuit firings, although for different reasons, in both cases, the procedure ensures that sufficient and even heat work is achieved (*see* Chapter 6).

Cooling, like heating, is dependent upon the type of construction and quality of insulation of the kiln, and can vary from a few hours down to room temperature for a small, low-thermal mass type, to two or three days for a large kiln made from heavy firebrick. Gradual and progressive cooling is the crucial factor, particularly below 600°C, with no sudden changes in temperature or draughts catching the ware. Cooling from the point at which the firing is finished may be dependent upon the glaze type. Fluid, clear glazes or 'lava' glazes can be better with rapid cooling, while opaque and crystalline matt glazes can benefit from slow cooling which encourages devitrification to take place.

Rapid cooling is sometimes carried out from stoneware temperatures down to as low as 1000°C to inhibit the formation of cristobalite in the body. Although cristobalite can be useful in an earthenware body by increasing its expansion/contraction coefficient and thus helping to keep the glaze under compression and reducing crazing where undesirable, it has the drawback

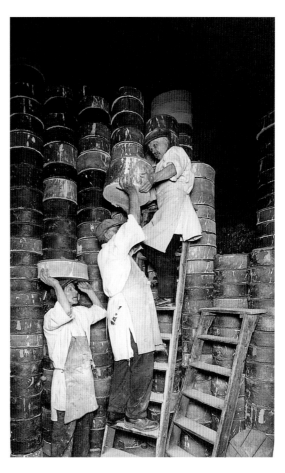

of making the body prone to dunting. With stoneware glazes the problem of crazing is more cosmetic than practical as the body is mature and relatively non-porous. The formation of cristobalite is therefore not required and by inhibiting its formation in the body the risk of dunting in cooling or in use is lowered.

Oxidation and Reduction

Many glazes are characterized specifically as either for oxidized or reduction firing. What these terms tell us in a practical sense is that glazes can be fired with or without a plentiful supply of air which can affect their chemistry and their appearance. An oxidizing firing is one in which there is a sufficient supply of air for complete combustion to take place. In fuel-burning kilns (oil, gas, wood) this means that enough air needs to be mixed with the fuel in

the burners or firebox to allow a good, clean flame without smoke, and unrestricted ventilation through the exit flue and chimney to allow air to flow through the ware chamber. Electric kilns naturally oxidize because the heat is generated by electric current passed through kanthal wire elements rather than by burning carbon-based fuels, and so oxygen is therefore not 'consumed' in the same way. It is possible to create a reduction atmosphere in an electric kiln by introducing a combustible material through the 'spy holes', but this is not advisable because it damages the elements and with certain fuels can be positively dangerous.

In fuel-burning kilns, maintaining sufficient air supply to the fuel and adequate ventilation has to be worked at. It is very easy when trying to raise the temperature to put in more fuel than can be consumed efficiently and so create the imbalance of fuel to air which causes the reduction of oxygen to occur. This is no doubt how the technique of reduction firing developed, as a natural consequence of the process and kiln fuels used and perhaps should not be seen as a special effect or artificial firing method. Another way of looking at it is that reduction firing is simply the product of inefficient combustion.

What happens when the air supply is restricted is that carbon is produced from the incomplete combustion of the fuel and combines at first with what remaining oxygen is readily available in the kiln to form carbon

*F*lame direction in a down-draught kiln.

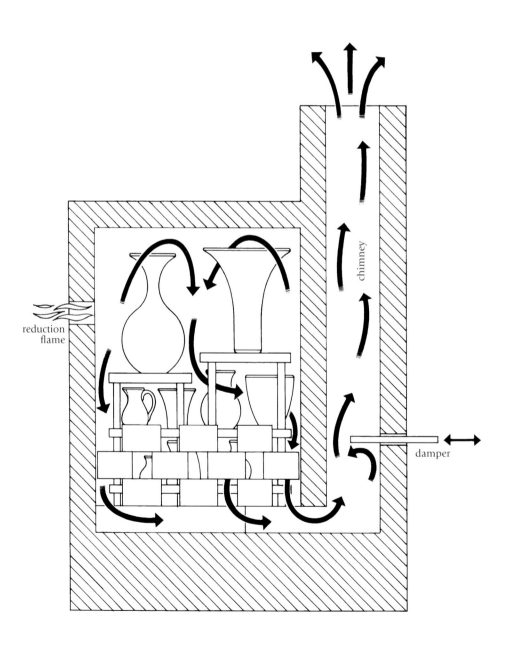

monoxide, which then attempts to 'steal' oxygen from those oxides present in the ware. Not all the ceramic oxides are affected, but some are relatively easily reduced. Some of the particular effects available from reduction are detailed in Chapter 12.

The term reduction firing is usually assumed to apply to ware fired to high stoneware temperature, 1260°C–1300°C. The reduction is begun at around 1000°C and may continue right up to the maximum temperature. Sometimes it is necessary to alternate the reduction with periods of oxidation, so as to compensate for the fact that the inefficient combustion inherent in reduction slows down the rate of temperature climb.

The amount of reduction is controlled by a combination of adjustment of fuel to air at the burner or firebox, and use of a damper in the flue or chimney to regulate and restrict the air flow through the chamber. As can be seen from the diagram, fuel-burning kilns are normally of the down-draught variety where the exit flue is at the bottom of the kiln, forcing the heat that first rises to the top of the kiln to be pulled back down through the ware by the 'pull' or draught from the chimney. This has the advantage of cre-

ating turbulence within the chamber, and more even heat distribution than if the exit is in the roof of the kiln. The strength of reduction is judged by the length and colour of the flame that protrudes when a bung is temporarily removed from a spy hole in the door and the amount of smoke coming from the chimney. These factors will vary from kiln to kiln and two or three firings may be needed to achieve the desired level consistently.

Reduction firing became widely popular in this century due to the work of Bernard Leach, who was one of the first to introduce oriental glazes and techniques from Japan into Britain in the early and middle part of the twentieth century. He inspired generations of potters in Britain and America, and this influence and style has subsequently spread all over the world.

Key to the character of reduction-fired ware is the behaviour of iron (*see* Chapter 8). This ubiquitous oxide is present in most clays and many of the glaze oxides. It is the oxide most affected by reducing conditions and contributes significantly in determining those physical and visual qualities of body/glaze integration that have proved enduringly popular in studio ceramics.

 # Glaze Defects & Problems

Crazing

This is probably the most commonly encountered problem in ceramics and it has been impossible to write this book without mentioning it in several contexts. It is a problem that has dogged potters for centuries, and although the causes are by now generally well understood, it still occurs frequently. The nineteenth century potter John Riley wrote in his recipe journal:

crazed ware is certainly a monster in potting that devours and eats up the resources of the potter: it is frightful to the dealer, and an injury to the community at large.

(*Journal of Ceramic History*, Volume 13. City Museum & Art Gallery, Stoke-on-Trent)

While this may not always be the case, it is easy to sympathize with his feelings when trying to adjust and fit a glaze to a clay body. Mr Riley's feelings notwithstanding, crazing is not necessarily always considered a fault, and can be

*B*ody/glaze
compression diagram.

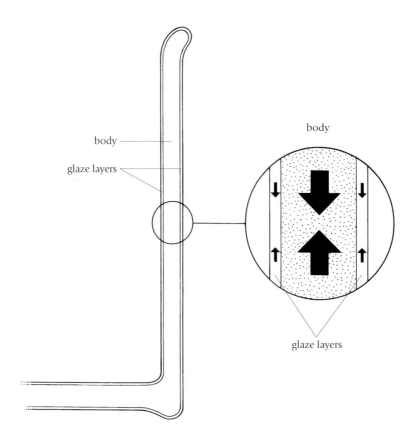

deliberately encouraged as a decorative surface quality. Crazing is a practical flaw when it occurs in a glaze which is over a porous body that needs to be impervious to liquids. Tableware is the most obvious example, but low-temperature-glazed sculpture or gardenware can also be damaged by weathering, particularly by freezing which expands any absorbed moisture and can cause the glaze layer to loosen and fall off.

The fundamental cause of crazing is the tension on the glaze created by the body having a lower coefficient of expansion and contraction. In theory, body and glaze should have the same coefficient of expansion and contraction, but this is not easily achieved in a studio environment. Instead, adjustments can be made to the body, or more easily to the glaze to give it the lower coefficient of the two so that the body puts the glaze under compression.

The principal method of combating crazing is to add more silica to the body, preferably in the form of flint to increase the coefficient of expansion and contraction of the body (*see* Chapter 3). Paradoxically, additions of silica will reduce the expansion and contraction of the glaze, because when silica is fluxed and dissolved in a glaze it behaves very differently and develops lower expansion and contraction properties.

The other main factors are to do with the expansion and contraction coefficients of the glaze fluxes. Soda has by far the highest expansion, followed by potassium and then calcium and barium. Boric oxide is the very lowest expansion flux material used in glazes, and those others that are also considered to be beneficial in reducing crazing are magnesium, then zinc, lithium and lead.

Finally, glazing a porous body all over will help to reduce the absorption of water by the body in everyday use and thus prevent the subsequent slight but sufficient swelling of the body which pushes the glaze apart and again causes crazing. Bathroom sinks are a classic example of this. Sanitary wares are manufactured to a high standard and the body and glazes are carefully matched, but sooner or later the water finds a way into the body and crazing begins. Ware that is glazed all over must be fired on stilts. The fine points on the stilt become fused to the ware by the glaze, but are easily knocked off with a 'sorting' tool and smoothed with an abrasive block.

Shivering

Shivering (sometimes called shelling or peeling) is simply the opposite of crazing and all of the above remedies taken to the extreme would compress the glaze so much that it would shatter and be forced off the body.

Shivering is a far less common problem than crazing because glazes are about ten times stronger under compression than under tension, so the imbalance has to be quite extreme to cause enough stress for peeling to occur. The picture below shows an earthenware high lithium glaze that has shivered, typically on tight corners such as rims, handles, lips, and so on. When it happens at high temperatures where the body and glaze have become well fused together it can take flakes of the body with it. The remedies are the reverse of those for crazing.

A very low expansion lithium glaze shelling away from a high expansion body, the opposite of crazing.

Crazing Remedies

1. Add more silica in the form of flint to the body.
2. Incorporate some talc into *earthenware* body recipes.
3. Increase the biscuit temperature and soak at full temperature.
4. Substitute all or part of the soda or potash feldspar in the glaze recipe with a lithium feldspar.
5. Substitute alkaline frits with borax or lead frits.
6. Add more silica to the glaze.
7. Incorporate other low expansion oxides into the glaze, or a special low expansion frit when needed (*see* Appendix; Table of Expansion).

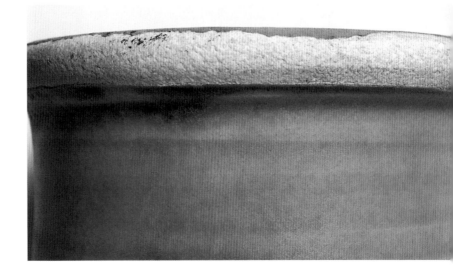

Crawling

This is another so-called fault which is sometimes deliberately encouraged for surface effect. The most common causes are dust on the biscuit, oxide or stain heavily applied to the biscuit before glazing, excessive shrinkage of the glaze after application, and too great a thickness of the glaze. Biscuitware should therefore be glazed as soon as possible after being taken from the kiln, or lightly wiped with a damp sponge prior to glazing.

Underglaze painting sometimes causes the glaze to pull away from it in much the same way as emulsion paint will from a grease spot. It happens with the more inert colouring oxides, with chrome the worst offender, and many commercial underglaze powders may also encourage crawling if applied thickly. Sometimes this can be avoided by adding a small amount of flux (for example a spot of borax frit) to the colour, or 'hardening on' the colour in an extra firing, before applying the glaze coat, although this is expensive and time-consuming. A small amount of gum binder mixed with the colour is a better and cheaper option.

Excess shrinkage of the glaze coating can result in cracks in the unfired glaze surface which loosens its grip on the body and encourages crawling. This can be caused by having too much raw clay in the recipe, or too much bentonite or other binders such as gum arabic.

Less common but more fundamental is crawling due to excessive viscosity of the glaze. Some oxides have a higher surface tension, and those that tend to be added in significant amounts are the secondary fluxes magnesium and calcium, and the opacifiers zirconium and tin. Zinc, in particular, is often singled out as a problem with regard to crawling, and where large quantities are used it may be calcined to reduce its shrinkage. Opaque and matt glazes are therefore most prone to crawling because they are likely to incorporate some of these oxides in combination.

Careful application of the glaze will reduce the risk of most of the above occurring. When spraying, make sure that the gun is at just the right distance for the glaze to go on sufficiently wet to compact closely to the surface and yet avoid runs. Above all, make sure that the glaze has not been applied too thickly as this will exacerbate all of the above and can create other problems such as running.

Crawling Remedies

1. Make sure the ware is free of dust and grease.
2. If necessary, add a binder or flux to the oxide or underglaze colour and avoid excessive thickness in underglaze painting.
3. Reduce the amount of glaze binders.
4. Reduce the thickness of the glaze application.
5. Reduce the amounts of calcium, magnesium, zinc, tin and zirconium where appropriate.
6. Substitute clay and zinc with calcined forms.

Dunting

Dunting is a traditional potter's term for cracking. Specifically, it is used to describe a crack through both the glaze and body which occurs through too rapid heating or cooling, either while still in the kiln or as it is being removed. Cooling dunts are much more common and can be identified by their sharp edges because the glaze has melted and become solid again when they occur. A heating dunt will have a softer edge where the glaze has melted and pulled slightly away from the edge after the crack was formed.

Quartz and cristobalite inversions take place at $573\,°C$ and approximately $226\,°C$ respectively when some of the silica in the body undergoes a sharp increase or decrease in crystal size. These are known as 'dunting points' because of the sometimes fatal stress they cause in the body. It is therefore vital to both heat and cool the kiln slowly and carefully below $600\,°C$ and avoid cold draughts on the ware from opening the door too early at the end of the firing. It must be remembered that although the temperature indicator may give a $100\,°C$ reading, this is the air temperature. Thick kiln shelves (and sometimes thick pots) will have a high thermal mass which can make the base of the pot in contact with the shelf retain a much higher temperature than the air inside the kiln, and even cause quite a differential between the top and bottom of the pot itself. All these result in severe stress on the ware and it is sensible to allow the kiln to cool 'en masse' naturally. I always advise not to unload a kiln until the ware can be touched with bare hands (although I have not always followed it myself, often with the predictable result).

Glazed ware is more prone to dunting, due again to the conversion of silica in the body to

A dunted bowl.

cristobalite. While being a good thing in increasing resistance to crazing, cristobalite can be a bad thing in excess with regard to causing dunting. Each time ceramic is fired above 1150°C more cristobalite can be formed and the vulnerability to dunting increased.

Other factors contributing to dunting are uneven thicknesses within the form, glaze left inside the base when pouring or dipping, or fluid glazes pooling thickly in the bottom (often causing a neat horizontal crack right around the base, detaching it from the rest of the piece).

Dunting Remedies

1. Above all, slow cooling below 600°C and especially from 300°C to room temperature.
2. Avoid sudden and pronounced changes in the wall thickness of the ware.
3. Shorter firing cycle above 1000°C to reduce cristobalite formation.
4. Avoid unnecessary refires for same reason as 3.
5. Use a different clay more suited to the ware or alter the recipe to reduce cristobalite formation.
6. Add talc to a *stoneware* body to improve its thermal shock resistance. (The opposite can be true when talc is added to an earthenware body, *see* Crazing Remedies above.)
7. Add a stoneware grog and/or fireclay.

Bubbling

Many glaze oxides and materials contain volatile elements that will be released during firing. The more obvious ones are carbon, nitrogen and sulphur, which need to be allowed to escape in the process of decomposition and must exit through the glaze surface. Ideally, the glaze will have settled back down by the end of the firing, as a pan of boiling liquid will after it is removed from the stove. If the gases are still being released at the end of the firing, or if the firing is stopped and cooled quickly, or if the glaze is viscous (*see* Chapter 12), then the bubbles can be 'frozen' in place. Allowing a soak for 20–30 minutes at the maturing temperature of the glaze is a useful remedy for this problem.

Some transparent glazes if applied too thickly may be smooth on the surface, but can be seen to have hundreds of tiny bubbles under the surface. This can also happen with opaque or matt glazes, but is less obvious. Such a glaze, if seen in cross-section through a microscope, would be aerated like foam and be impractical for use with food or liquid. In these cases, the extra thickness has trapped some of the gases below the surface after the glaze has settled and can be a very unpleasant looking effect indeed.

Bubbling and even severe blistering can be caused by over-firing the glaze. Some of the glaze oxides themselves become volatile, notably lead, soda, borax and zinc, which all become increasingly unstable above 1150°C. If present in large quantities in a glaze fired much higher than this temperature the glaze can look as if it has boiled, and is sometimes referred to as such. The cure is adjustment of the recipe with more stable fluxes or simply firing at a lower temperature.

Bubbling Remedies

1. Soak at full temperature, and do not cool rapidly.
2. Thinner glaze application.
3. Lower firing temperature.
4. Reduce volatile fluxes.

Pinholing

Sometimes, small bubbles in the surface of the ware are referred to as pinholes and these are often flaws in the surface of the body, rather than the glaze. This is mainly a problem in slip-cast ware and is often caused by air in the casting slip. These bubbles can be very small and may not be noticed until the glaze has accentuated them. Less vigorous mixing of the casting slip and passing it through a sieve before pouring into the mould should help. The first cast from a mould is also prone to this and other faults, and may be best discarded or treated as a test; old, dirty and dusty moulds may suffer as well.

When pinholes do occur in a glaze surface it is often in opaque/matt glazes with large quantities of high viscosity materials, in particular alumina, zirconia and tin. Here again, the pinholes are the result of decomposition of gases within the glaze, but in a glaze of high viscosity the holes do not always seal up so easily. Soaking at full temperature will help reduce pinholing, as will introducing or increasing the low viscosity oxides of soda, potash or lithium.

Pinholing Remedies

1. Take care not to introduce air into casting slip and/or sieve before use.
2. Check moulds for dust and wear.
3. Decrease clay content of glaze/increase strong alkaline fluxes.
4. Soak the glaze at full temperature.

Lime Spit-out

Spit-out is a term that is confusingly used to describe two very different firing defects. The first is spit-out from the body caused by foreign material that is more porous than the surrounding fired clay. The most common culprits are limestone impurities in the clay at source (limestone is the source of all the calcium compounds that, for most of the time, are so useful in ceramics), or plaster that has found its way into the clay from a mould or plaster wedging bench perhaps. It may not show up at first, then slowly but surely it absorbs moisture from the atmosphere or from use and expands just enough to force a small flake away, revealing a tell-tale speck of white. This may occur weeks or months after the firing, and is a nightmare if not detected early, although there is little that can be done other than slaking the whole batch down and sieving it, or referring back to the supplier.

Glaze Spit-out

This is fundamentally the same fault as bubbling, but here refers specifically to the burst bubbles or blisters that appear on previously good glazed surfaces that have been refired to enamelling temperatures. It is a common problem with porous earthenware pottery that has been out of the kiln for some time before having ceramic enamels, transfers or lustres applied. It is caused by water absorbed into the ware through unglazed areas or flaws in the glaze surface. When the firing to 750–800°C takes place the water turns to steam and escapes through the surface of the glaze which at this temperature has softened enough to allow the steam to bubble through, but is not sufficiently fluid to settle back down again. This can be avoided by refiring the ware to its full glaze temperature to expel the moisture and allow it to settle over properly, but it is better still to do enamel firings as soon as possible after the glaze firing so as to avoid things like dust and grease which can also cause problems.

This type of spit-out does not occur with bone china or other vitreous bodies because their lack of porosity prevents absorption of moisture in the first place.

Glaze Spit-out Remedies

1. Fire on enamels, transfers and lustres as soon as possible.
2. Refire porous earthenware to full glaze temperature before enamelling.

The above are some of the more serious and common faults in firing glazes onto ceramic. There are many other hazards, of course, such as contamination of the glaze (keep a lid on it), damage to the surface during application and packing into the kiln, over- and under-firing, and so on. To avoid as many as possible it is important to observe good workshop practice and be methodical and keep clear notes on all materials, processes and tests. If problems persist and cannot be traced, most suppliers will often offer help and advice.

On-glaze Materials & Techniques

'*Acid Toby*' *by Richard Slee. Painted and sprayed enamels over earthenware glaze. (Photograph by Zul Mukhida.)*

The term on-glaze is used to refer to enamels and lustres that are applied to an already fired and glazed surface. They have been in use for centuries, but more recently there has been a tendency to see them as an industrial process of limited use to the studio craftsperson. Historically, they have often been used to hide glaze defects or to improve dull and uninteresting glaze surfaces, but of course they have their own qualities and provide an extension to the ceramist's palette.

Enamels

Enamels are not greatly different from low temperature glazes. They employ those fluxes that operate at the lower end of the temperature scale, in particular boric oxide, which also provides a readily fusible glass former, but also potassium, soda and lead. Even the so-called high temperature fluxes, calcium, barium, magnesium and zinc may also be involved in small quantities. They also contain alumina and silica as all glazes do, and are opacified and coloured with the usual oxides.

It is perfectly possible to prepare your own enamels, but the process is difficult and time-consuming due to the need for fritting the materials (which is also a hazardous process, *see* Chapter 9) and fine grinding. The availability of good quality, reliable enamels from craft suppliers makes it unworthwhile for most ceramicists.

Enamels are normally fired onto otherwise finished ware to a temperature of between 730°C and 850°C. Conventionally, they are applied to a good smooth gloss glaze to achieve their full colour and brightness, but they can be applied to other surfaces, even unglazed ones,

*E*namel-decorated
*salt glaze teapot
commemorating
Frederick the Great of
Prussia, 1757. The
Potteries Museum,
Stoke-on-Trent.*

but with less predictable results – for instance, they may crawl and have a dull, undeveloped colour and surface.

They are most often used on low temperature (earthenware) glazes, which has the advantage of achieving a 'softening' of the glaze surface and allowing the enamels to 'sink' in, thus becoming more integrated with the glaze and also more durable. A high temperature (stoneware) glaze does not soften enough at enamel temperatures to allow this to happen. For this reason, most enamel-decorated industrial ware is either earthenware or bone china which both share the high biscuit – low glaze process. Porcelain is made by the low biscuit – high gloss process, making it less suitable for enamel decoration.

Enamels should be applied to newly fired earthenware, because most earthenware bodies have some porosity and will inevitably eventually absorb some moisture through tiny imperfections in the glaze or unglazed areas, and when fired again this moisture escapes through the slightly softened glaze surface to cause 'glaze spit-out' (*see* Chapter 16). Though soft enough to allow the vapour through, the glaze is not sufficiently fluid at enamel temperature to allow the glaze to seal over again on cooling.

It is possible to refire older earthenware to full glaze temperature to remove the absorbed moisture, because at the higher temperature the glaze can reseal itself after the vapour has been expelled. This is not necessary for bone china because it has a high flux content and the high biscuit temperature of 1250°C used for china makes it a fully vitreous body with negligible porosity.

Preparation

Enamels can be bought as dry powders or ready mixed with a suitable medium for use straight from the container. These tend to be more expensive but are useful when only small amounts are required. Otherwise, enamels need thorough mixing with an oil- or PVA-based medium, which is done on a smooth, hard surface such as a glazed slab or glass sheet with a broad, firm palette knife until the enamel is of a good consistency but will run smoothly off the end of the palette knife.

Enamels can also be made to take on a matt appearance by the addition of a small amount of underglaze in the same colour.

'The Potters', commemorative plate with enamel photo transfer. Collection of author. (Photograph by Dick Brown.)

Application

Enamels can be applied in a variety of ways, by painting, spraying, sponging, and so on, ground laying where the dry powder is dusted onto ware which has been coated with gum, or by printing techniques such as silk screen or lithographic transfer. Turpentine and fat oil can be used to achieve the ideal consistency and flow for the painting on of enamels, while PVA medium is also used sometimes to avoid the use of oil-based materials. Some of the media available are general purpose and can be used for both painting and silk-screen purposes.

When spraying on enamels, an effective medium is to mix the dry enamel powder with milk. This allows good flow through the gun, and hardens the colour onto the ware effectively; skimmed milk or dry milk powder are equally effective.

Silk-screen is very popular in studio ceramics because it allows the reproduction of artwork and photographic images onto pottery or sculpture in the form of ceramic transfers, or decals as they are also known. The equipment is the same as used in other art activities and is more commonly available; lithography offers finer detail but is more complex and less commonly available. The silk-screens are made up by hand or photographic means and are printed onto special transfer paper. When dry, the print is covered with a gum coating known as 'cover-coat' and left to dry again. When immersed in water the paper loosens but the enamel and covercoat remain bonded and are slid onto the glaze surface and are carefully smoothed on to avoid any air being trapped between the transfer and glazes which can cause the transfer to blister and peel away.

There are many small companies that will make up small batches of ceramic transfers to order, and there are also industrial sources of what are known as 'open stock' transfers, that is non-copyright designs which are available to anyone. Many artists have used these both seriously and ironically to good effect.

Firing

Enamel firings are relatively straightforward, although, as always, care should be taken through the cristobalite and quartz inversions, but the main requirement is a good, clean oxidizing firing. Enamel firings can be performed in fuel-burning kilns, but care must be taken to make sure that no more fuel goes in than is absolutely necessary to maintain temperature rise and that there is plenty of oxygen available to the burners or fireboxes. Electric kilns are much more suitable, but in these also the kiln should be well ventilated and the bungs and vents left open to 500°C to allow the fumes from the oil and medium to evaporate.

The temperature that enamels will survive to without losing their colours varies considerably. I have fired blue and black enamels to stoneware temperatures, and many will go to earthenware without significant colour loss, allowing a good deal of scope for 'unconventional' enamel treatment, but the standard temperatures to get the manufacturer's intended finish is 730–850°C.

Lustres

Here we are concerned with commercial lustres that are supplied ready for use, rather than raku, in-glaze and other reduction glazes. Commercial metallic lustres are available in a variety of forms, such as gold, silver, platinum, copper, bronze and bismuth, which is used to

Vase, 'Cutting Edge', by Grayson Perry. Perry uses slips, underglaze colours, oxides, glaze, enamels, lustres and open stock transfers.

create a range of lustrous colours including mother of pearl. They are made by producing a chloride from the metal by dissolving it in acid and combining it with a resin and an oil-based medium. During firing the resin burns off, leaving a very thin coat of metal bonded to the surface of the glaze.

Beautiful effects can be gained with the non-metallic lustres over a variety of coloured glazes because they are transparent, although the glaze surface needs to be glossy as with enamels to get the best out of them. Lustres can also be modified with lustre thinners or turpentine to produce less conventional finishes.

Application

These types of lustre are already prepared and can be applied straight from the bottle. Painting is the preferred method of application as lustres only require a single thin coat and do not show up the brushstrokes in the same way enamels do, and they are too expensive for other more wasteful methods such as screening or spraying.

Firing

Like enamels, they are easy to fire and also need good ventilation. The colours are more fugitive than enamels, so careful watch of the temperature is needed. The normal recommended temperature is 750°C, making it possible to fire lustres in the same kiln, or even on the same pot as enamels, but often they are fired on separately.

Lustre bowl by John Wheeldon. The body is stained with oxides and commercial lustres are painted on the fired glaze.

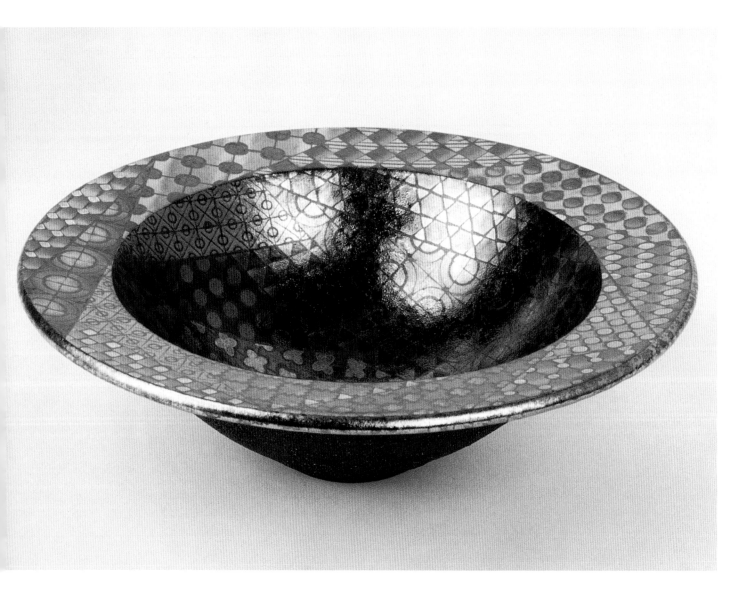

Appendices

Table of Elements

ELEMENT	SYMBOL	ATOMIC WEIGHT	ELEMENT	SYMBOL	ATOMIC WEIGHT
Aluminium	Al	27.0	Magnesium	Mg	24.3
Antimony	Sb	121.8	Manganese	Mn	54.9
Arsenic	As	74.9	Nickel	Ni	58.7
Barium	Ba	137.3	Nitrogen	N	14.0
Beryllium	Be	9.0	Oxygen	O	16.0
Bismuth	Bi	209.0	Phosphorous	P	31.0
Boron	B	10.8	Platinum	Pt	195.1
Cadmium	Cd	112.4	Potassium	K	39.1
Calcium	Ca	40.1	Praseodymium	Pr	140.9
Carbon	C	12.0	Selenium	Se	79.0
Cerium	Ce	140.1	Silicon	Si	28.1
Chlorine	Cl	35.5	Silver	Ag	107.9
Chromium	Cr	52.0	Sodium	Na	23.0
Cobalt	Co	58.9	Strontium	Sr	87.6
Copper	Cu	63.5	Sulphur	S	32.1
Fluorine	F	19.0	Tin	Sn	118.7
Germanium	Ge	72.6	Titanium	Ti	47.9
Gold	Au	197.0	Uranium	U	238.0
Hydrogen	**H**	**1.0**	Vanadium	V	50.9
Iron	Fe	55.8	Zinc	Zn	65.4
Lead	Pb	207.2	Zirconium	Zr	91.2
Lithium	Li	6.9			

Table of Thermal Expansion and Contraction

This table indicates those important main ceramic oxides that when fired have a high coefficient of thermal expansion (and contraction). High thermal expansion materials in clay bodies and low expansion materials in glazes are important factors in reducing glaze crazing.

High Expansion
 Na_2O Sodium
 K_2O Potassium
 SiO_2 Silica (in clay bodies)*
 CaO Calcium
 BaO Barium
 PbO Lead
 Li_2O Lithium
 ZnO Zinc
 MgO Magnesium
 Al_2O_3 Alumina
 SiO_2 Silica (in glazes)*
 B_2O_3 Boric
Low Expansion

Note: Silica appears twice as its expansion characteristics are very different in clay bodies where it is not fully fused, and in glazes where it is dissolved in the melt.

Tables of Surface Tension and Viscosity

Surface tension can be related to the fluidity and viscosity of glazes, although the two tables do not match exactly. One that has large quantities of high surface tension oxides may tend to 'crawl', while one that has more oxides with low surface tension will have more fluidity.

High Surface Tension	High Viscosity
Al_2O_3 Alumina	Al_2O_3 Alumina
MgO Magnesium	ZrO Zirconia
ZrO Zirconium	SnO_2 Tin
CaO Calcium	BaO Barium
SnO_2 Tin	TiO_2 Titanium
ZnO Zinc	SiO_2 Silica
BaO Barium	MgO Magnesium
SiO_2 Silica	CaO Calcium
TiO_2 Titanium	ZnO Zinc
B_2O_3 Boric	B_2O_3 Boric
Li_2O Lithium	PbO Lead
PbO Lead	Li_2O Lithium
Na_2O Sodium	Na_2O Sodium
K_2O Potassium	K_2O Potassium
Low Surface Tension	**Low Viscosity**

Shrinkage and Porosity Test Chart

A chart like this one can be used to document a test for a clay body for these two important properties, as well as giving a good visual reminder as to the appearance of the clay body at different temperatures. A minimum of 400g of plastic clay necessary for this exercise, sufficient to make four 100g test tiles which should be marked with the name of the body, the weight (100g) and the temperature it is to be fired to. In the example, the four firing temperatures chosen are commonly used ones and can be altered to suit individual requirements.

Weigh out 100g of plastic clay, roll it out into a flat strip about 120mm long. Draw a line down the centre exactly 100mm long:

During the drying-out period, at the leather-hard stage and the white dry stage, weigh and measure the test to record the weight loss and shrinkage.

Fire the first test to 960°C. Weigh and measure for shrinkage and weight loss and enter these in the appropriate columns. Then soak the test in boiling water for a few minutes, allow to cool, then remove surplus water by dabbing dry with a slightly damp sponge. Weigh accurately again and record the result under the 'wet weight' column.

This should be repeated for each of the tests at the different temperatures to give a picture of how temperature increase affects shrinkage and porosity.

Percentage shrinkage and porosity can be calculated by the following equations:

$$\frac{\text{plastic length} - \text{dry length*}}{\text{plastic length}} \times 100 = \text{percentage linear shrinkage}$$

$$\frac{\text{saturated weight} - \text{dry weight}}{\text{dry weight}} \times 100 = \text{percentage porosity*}$$

These calculations may seem superfluous when dealing with quantities based on 100; however, they are necessary when dealing with odd numbers above or below 100 (*see also* Useful Formulae).

Shrinkage and Porosity Chart (different temperatures can be substituted to suit particular firing cycles).

	Length (mm)	Shrinkage (%)	Weight (g)	Saturated Weight (g)	Porosity (%)
Plastic	100mm		100gm	xxxxxxxxxxxxxxx	xxxxxxxxxxxxxx
Leather				xxxxxxxxxxxxxxx	xxxxxxxxxxxxxx
Dry				xxxxxxxxxxxxxxx	xxxxxxxxxxxxxx
960°C					
1060°C					
1150°C					
1250°C					

Useful Formulae

Batch to Percentage Recipe

Conversion of a batch recipe (that is, one that adds up to more or less than 100) to a percentage recipe:

$$\frac{\text{Batch Item}}{\text{Batch total}} \times 100 = \text{per cent}$$

Brongniart's Formula

This formula is used to determine accurately the dry content of a clay slip or glaze slop. It is useful when accurate additions of dry colour and so on have to be made to an already mixed slip or glaze:

$$\text{dry weight} = (P{-}20) \times \frac{G}{G-1}$$

Where: P = the weight of a pint of slip in ounces; 20 = the weight of a pint of water; G = the Specific Gravity of the dry material.

For metric quantities, weigh 100cc of slip (do not include the weight of the container) and calculate:

$$(\text{wt of 100cc of slip} - 100) \times \frac{SG^*}{SG-1} = \text{dry weight}$$

Example:

$$140 - 100 \times \frac{2.5^*}{2.5-1} = 66.7\text{g dry weight}$$

*Note: Specific gravities for rough calculation purposes have been calculated and are given below:

Slips and stoneware glazes = SG 2.5
Lead and borax/alkaline glazes = SG 3.0
Lead glazes = SG 4.0

Percentage Shrinkage and Porosity

Percentage shrinkage and water absorption (porosity) can be calculated by the following equations:

$$\frac{\text{plastic length} - \text{dry length}}{\text{plastic length}} \times 100 = \text{percentage linear shrinkage}$$

Example:

$$\frac{80\text{cm} - 73\text{cm}}{80\text{cm}} \times 100 = 8.75\% \text{ linear shrinkage}$$

$$\frac{\text{saturated weight} - \text{dry weight}}{\text{dry weight}} \times 100 = \text{porosity}$$

Example:

$$\frac{172\text{g} - 164\text{g}}{164\text{g}} \times 100 = 4.87\% \text{ water absorption}$$

The above porosity calculation gives a relative indication which is adequate for most studio purposes.

The Limit Formulae

RO		R_2O_3		RO_2	

Raku (low temperature) – Lead dominated 840–950°C

PbO	0.70–1.0	Al_2O_3	0.05–0.20	SiO_2	0.1–1.5
KNaO*	0.0–0.3				
CaO	0.0–0.2				
ZnO	0.0–0.1				

Earthenware – lead dominated 950–1100°C

PbO	0.70–1.0	Al_2O_3	0.10–0.25	SiO_2	1.5–2.5
KNaO	0.0–0.3				
CaO	0.0–0.2				
ZnO	0.0–0.2				

Earthenware – alkaline dominated 950–1050°C

PbO	0.0–0.5	Al_2O_3	0.05–0.25	SiO_2	1.5–2.5
KNaO	0.4–0.8				
CaO	0.0–0.3				
ZnO	0.0–0.2				

Earthenware – lead, calcium, boric oxide dominated 950–1050°C

PbO	0.3–0.6	Al_2O_3	0.15–0.20	SiO_2	1.5–2.5
KNaO	0.1–0.25	B_2O_3	0.15–0.60		
CaO	0.3–0.6				
BaO	0.0–0.15				
ZnO	0.1–0.2				

Mid temperature – lead, calcium, alkaline dominated 1140–1180°

PbO	0.3–0.6	Al_2O_3	0.2–0.28	SiO_2	2.0–3.0
KNaO	0.1–0.25				
CaO	0.1–0.4				
ZnO	0.0–0.25				

Mid temperature – calcium, boric oxide, alkaline dominated 1140–1180°C

KNaO	0.1–0.25	Al_2O_3	0.2–0.28	SiO_2	2.0–3.0
CaO	0.2–0.5	B_2O_3	0.3–0.6		
BaO	0.0–0.25				
ZnO	0.0–0.25				

Mid temperature – calcium, boric oxide, lead dominated 1140–1180°C

PbO	0.2–0.3	Al_2O_3	0.25–0.25	SiO_2	2.5–3.5
KNaO	0.2–0.3	B_2O_3	0.2–0.6		
CaO	0.35–0.5				
ZnO	0.0–0.1				

High temperature – alkaline dominated 1225–1300°C

KNaO	0.2–0.4	Al_2O_3	0.3–0.5	SiO_2	3.0–5.0
CaO	0.4–0.7	B_2O_3	0.1–0.3		
MgO	0.0–0.35				
BaO	0.0–0.3				
ZnO	0.0–0.3				

Formula to Recipe Proforma

Enter glaze molecular formula here:

	RO	R₂O₃	RO₂

$$\frac{RO}{R_2O_3 \quad RO_2}$$

Material	MW × ME	= batch weight	% recipe
TOTAL			

$$\frac{\text{batch item}}{\text{batch total}} \times 100 = \%$$

Glaze Oxides		RO — Fluxes (monoxides)					R₂O₃ — Sesquioxides		RO₂ — Glass formers	
Material		PbO	KNaO	CaO	MgO	BaO	ZnO	Al₂O₃	B₂O₃	SiO₂
	oxides required									
	material supplies									
	oxides required									
	material supplies									
	oxides required									
	material supplies									
	oxides required									
	material supplies									
	oxides required									
	material supplies									
	oxides required									
	material supplies									

Formula to Recipe Proforma Example

Enter glaze molecular formula here:

	RO	R₂O₃	RO₂
	$0.4KNaO$ $0.3CaO$ $0.3MgO$	0.4	3.0

Flux total must equal 1.0

Material	MW × ME		= batch weight	% recipe
Potash feldspar	556.8	**0.4**	222.7	71
Dolomite	184.4	**0.3**	55.3	18
Flint	60.1	**0.6**	36.1	11
TOTAL			**314.1**	**100**

$$\frac{\text{batch item}}{\text{batch total}} \times 100 = \%$$

Glaze Oxides		RO Fluxes (monoxides)						R₂O₃ Sesquioxides		RO₂ Glass formers
Material		PbO	KNaO	CaO	MgO	BaO	ZnO	Al₂O₃	B₂O₃	SiO₂
	oxides required	–	0.4	0.3	0.3	–	–	0.4	–	3.0
Potash feldspar KNaO.Al₂O₃.6SiO₂	material supplies		**0.4**					0.4		2.4
	oxides required		✕	0.3	0.3			✕		0.6
Dolomite CaCO₃.MgCO₃	material supplies			**0.3**	0.3					
	oxides required			✕	✕					0.6
Flint SiO₂	material supplies									**0.6**
	oxides required									✕
_____	material supplies									
	oxides required									
_____	material supplies									
	oxides required									
_____	material supplies									

Raw Materials List

Variable, average or 'typical' formulas given*

Material	Formula	Molecular weight	Oxides entering fusion
Alumina hydrate	$Al_2(OH)_6$	156	Al_2O_3
Alumina	Al_2O_3	102	Al_2O_3
Barium carbonate	$BaCO_3$	197.3	BaO
Bentonite	$Al_2O_3.4SiO_2.9H_2O$	360.4	Al_2O_3-SiO_2
Bone ash	$Ca_3.(PO_4)_2$	310.3	CaO-P_2O_5
Borax	$Na_2B_4O_7.10H_2O$	381.2	Na_2O-B_2O_3
Boric acid	$B(OH)_3$	61.8	B_2O_3
Boric oxide	B_2O_3	69.6	B_2O_3
Calcium chloride	$CaCl_2$	111.1	CaO
Calcium carbonate (whiting)	$CaCO_3$	100.1	CaO

Clays*

Ball clay, low silica/ high iron	$0.08KNaO.Al_2O_3.2.5SiO_2$ $0.03MgO.0.06Fe_2O_3$ $2.0H_2O$	296	K_2O-Na_2O-MgO- Al_2O_3-Fe_2O_3-SiO_2
Ball clay, high silica/ low iron	$0.15KNaO.Al_2O_3.6.5SiO_2$ $0.05MgO.0.02Fe_2O_3.0.1TiO_2$ $2.0H_2O$	546	K_2O-Na_2O-MgO- Al_2O_3-Fe_2O_3-SiO_2-TiO_2
China clay	$Al_2O_3.2SiO_2.2H_2O$	258.2	Al_2O_3-SiO_2
Fireclay	$0.08KNaO.Al_2O_3.4.0SiO_2$ $0.08MgO.0.04Fe_2O_3$ $2.0H_2O$	394	K_2O-Na_2O-MgO- Al_2O_3-Fe_2O_3-SiO_2
Red clay	$0.16KnaO.Al_2O_3.4.5SiO_2$ $0.08CaO.0.3Fe_2O_3$ $0.07MgO$ $1.0H_2O$	441	K_2O-Na_2O-MgO-CaO Al_2O_3-Fe_2O_3-SiO_2

Chromium oxide	Cr_2O_3	152	Cr_2O_3
Cobalt carbonate	$CoCO_3$	119	CoO
Cobalt oxide	CoO	75	CoO
Colemanite	$2CaO.3B_2O_3.5H_2O$	411	CaO-B_2O_3
Copper carbonate	$CuCO_3$	124	CuO
Copper oxide	CuO	80	CuO
Cornish stone*	$K_2O.Al_2O_3.8.4SiO_2$ Na_2O CaO	695	K_2O-Na_2O-CaO-Al_2O_3-SiO_2
Cristobalite	SiO_2	60.1	SiO_2
Crocus martis (purple iron)	$FeSO_4$	152	Fe_2O_3
Cryolite	Na_3AlF_6	210	Na_2O-Al_2O_3
Dolomite	$CaCO_3.MgCO_3$	184.4	CaO-MgO
Feldspar calcium*	$CaO.Al_2O_3.2SiO_2$	278.3	CaO-Al_2O_3-SiO_2
Feldspar potash*	$K_2O.Al_2O_3.6SiO_2$	556.8	K_2O-Al_2O_3-SiO_2
Feldspar soda*	$Na_2O.Al_2O_3.6SiO_2$	524.6	Na_2O-Al_2O_3-SiO_2
Flint	SiO_2	60.1	SiO_2
Fluorspar	CaF_2	78.1	CaO

Raw Materials List continued

Material	Formula	Molecular weight	Oxides entering fusion
Frits			
Alkaline frits			
High alkaline frits			
Borax frits	} Various – *see* Chapter 9, The Raw Materials for Glazes		
Calcium borate frits			
Lead bisilicate			
Lead sesquisilicate			
Galena	PbS	239.3	PbO
Ilmenite	$FeTiO_3$	15	Fe_2O_3-TiO_2
Iron chromate	$FeCrO_3$	156	$Fe_2O_3.Cr_2O_3$
Iron oxide black	FeO	72	FeO
Iron oxide red	Fe_2O_3	160	Fe_2O_3
Iron oxide spangles	Fe_3O_4	231	Fe_2O_3
Lead oxide (litharge)	PbO	223.2	PbO
Lepidolite*	$Li_2F_2.Al_2O_3.3SiO_2$	334.1	Li_2O-Al_2O_3-SiO_2
Lithium carbonate	Li_2CO_3	73.8	Li_2O
Magnesium carbonate	$MgCO$	84.3	MgO
Magnesium sulphate	$MgSO_4$	120.4	MgO
Manganese carbonate	$MnCO_3$	115	MnO
Manganese dioxide	MnO_2	87	MnO
Nepheline syenite*	$K_2O.Al_2O_3.4.5SiO_2$ Na_2O	475	K_2O-Na_2O-Al_2O_3-SiO_2
Nickel oxide	NiO	75	NiO
Pearl ash (potassium carbonate)	K_2CO_3	138.2	K_2O
Petalite*	$Li_2O.Al_2O_3.8SiO_2$	612.6	Li_2O-Al_2O_3-SiO_2
Plaster of Paris	$2CaSO_4.H_2O$	290.4	N/A
Potassium dichromate	$K_2Cr_2O_7$	294	K_2O-Cr_2O_3
Quartz	SiO_2	60.1	SiO_2
Rutile	TiO_2	79.9	TiO_2 (+ small amount of FeO)
Silica	SiO_2	60.1	SiO_2
Silicon carbide	SiC	40	SiO_2
Soda ash	Na_2CO_3	106	Na_2O
Sodium silicate	Na_2SiO_3	122	Na_2O-SiO_2
Spodumene*	$Li_2O.Al_2O_3.4SiO_2$	372.2	Li_2O-Al_2O_3-SiO_2
Strontium carbonate	$SrCO_3$	147.6	SrO
Talc	$3MgO.4SiO_2.H_2O$	379.3	MgO-SiO_2
Tin oxide	SnO_2	150.7	SnO_2
Titanium dioxide	TiO_2	79.9	TiO_2
Vanadium pentoxide	V_2O_5	182	V_2O_5
Whiting (calcium carbonate)	$CaCO_3$	100.1	CaO
Wollastonite	$CaSiO_3$	116.2	CaO-SiO_2
Zinc oxide	ZnO	81.4	ZnO
Zirconium oxide	ZrO_2	123	ZrO_2
Zirconium silicate	$ZrSiO_4$	183.3	ZrO_2-SiO_2

Unity Based on Alumina

Molecular equivalent formulae for glazes are usually expressed with all the oxides divided through by the total of the fluxes so that the alumina and silica are compared to the 'unity' of the fluxes:

$$0.15 \text{ KNaO. } 0.25Al_2O_3.1.49SiO_2$$
$$0.45 \text{ BaO}$$
$$\underline{0.40 \text{ ZnO}}$$
$$1.00 \text{ (unity)}$$

As the clay formulae below indicate, the relationships of the oxides in clays are expressed with the alumina content to unity (note that the fluxes do not add up to one), that is, the oxide quantities divided through by the total amount of alumina, because it is deemed more important in a clay formula to be able to see the alumina to silica ratio clearly.

It is rare, but where a clay formula is expressed with the fluxes to unity it will have a much larger molecular weight, but it is perfectly alright to use it in glaze calculations so long as the correct formula weight is always applied. **The molecular weight of a flux unity formula must not be used for a clay which is unified on the alumina content and vice versa.**

Bending Temperatures for Orton Cones in °C
(Courtesy of Potclays Ltd)

ORTON CONE No.	60°C/hr	100°C/hr	150°C/hr
018	696	706	717
017	727	736	747
016	764	776	792
015	790	797	804
014	834	836	838
013	852	860	869
012	876	880	884
011	886	890	894
09	915	919	923
08	945	950	955
07	973	978	984
06	991	995	999
05	1031	1036	1046
04	1050	1055	1060
03	1086	1092	1101
02	1101	1110	1120
01	1117	1127	1137
1	1136	1145	1154
2	1142	1150	1162
3	1152	1160	1168
4	1168	1176	1186
5	1177	1186	1196
6	1201	1210	1222
7	1215	1227	1240
8	1236	1248	1263
9	1260	1270	1280
10	1285	1294	1305
11	1294	1304	1315

Note that the bending rate depends on the speed of firing.

Typical Clay Formulae for Use in Calculations

China clay		$Al_2O_3.$	$2SiO_2$	MW 258.2
Low silica/ high iron ball clay	0.08KNaO. 0.03MgO.	$Al_2O_3.$ $0.06Fe_2O_3$	$2.5SiO_2$	MW 296
High silica/ low iron ball clay	0.15KNaO. 0.05MgO.	$Al_2O_3.$ $0.02Fe_2O_3.$	$6.5SiO_2$ $0.1TiO_2$	MW 546
Fireclay	0.08KNaO. 0.08MgO.	$Al_2O_3.$ $0.04Fe_2O_3.$	$4.0SiO_2$	MW 394
Red clay	0.16KNaO. 0.08CaO.	$Al_2O_3.$ $0.3Fe_2O_3.$	$4.5SiO_2$ $0.07MgO$	MW 441

Dry Content of One Pint of Clay Slip at Various Pint Weights
(Courtesy of Potclays Ltd)

SLIP WEIGHT (oz/pt)	DRY CONTENT (oz)	SLIP WEIGHT (oz/pt)	DRY CONTENT (oz)
20	0.00	30	16.67
21	1.67	31	18.33
22	3.33	32	20.00
23	5.00	33	21.67
24	6.67	34	23.33
25	8.33	35	25.00
26	10.00	36	26.67
27	11.67	37	28.33
28	13.33	38	30.00
29	15.00	39	31.67

Conversion Tables (Courtesy of Potclays Ltd)

OUNCES		GRAMS	PINTS		LITRES	OUNCES PER PINT		GRAMS PER LITRE
1	=	28.4	0.5	=	0.3	10	=	498
2		56.7	1.0		0.6	20		996
3		85.0	1.5		0.9	26		1295
4		113	2.0		1.1	27		1345
5		141.7	2.5		1.4	28		1395
6		170.1	3.0		1.7	29		1445
7		198.4	4.0		2.3	30		1494
8		226.8	5.0		2.8	32		1594
9		255.1	6.0		3.4	33		1643
10		283.5	7.0		4.0	34		1693
11		311.8	8.0		4.6	35		1743
12		340.2	9.0		5.2	36		1793
16		453.6	10.0		5.7	37		1843

Casting Slip Recipes (Courtesy of Potclays Ltd)

Most clays can be made into casting slip as follows:

10kg plastic clay	or	10kg powdered clay
10–25g sodium silicate		12–30g sodium silicate 140°TW
10g soda ash		12g soda ash
850cc water		2,850cc water

Useful Addresses

Pottery Supplies

Acme Marls Ltd (Kiln Furniture Supplies)
Bournes Bank, Burslem
Stoke-on-Trent ST6 3DW (01782 577757)

W.G. Ball Limited
Longton Mill, Anchor Road, Longton
Stoke-on-Trent ST3 1JW
(01782 313956/312286)

Bath Potters Supplies
2 Dorset Close
Bath, BA2 3RF

Ceramatech Ltd
Units 16 and 17 Frontier Works
33 Queen Street
London, N17 8JA

Clayman
Morells Barn, Park Lane, Lagness, Chicester
West Sussex, PO20 6LTR

Cromartie Kilns Ltd
Park Hall Road, Longton
Stoke-on-Trent, ST3 5ATY

Fordham Thermal Systems Co. Ltd
Studlands Park Industrial Estate, Newmarket
Suffolk CB8 7EA
(01638 666020)

Gladstone Engineering Co. Ltd
Foxley Lane, Milton
Stoke-on-Trent ST2 7EH

Moira Pottery Company Ltd
Moira, Burton-on-Trent
Staffordshire DE12 6DF
(01283 221961)

Potclays Ltd
Brickkiln Lan, Etruria
Stoke-on-Trent, ST4 7BP
(01782 219816)

Potters Connection Ltd
Longton Mill, Anchor Road, Longton
Stoke-on-Trent, ST3 1JW

Potterycrafts Limited
Campbell Road
Stoke-on-Trent ST4 4ET
(01782 272444)

Valentine Clay Products
The Shiphouse, Birches Head Road, Hanley
Stoke-on-Trent ST1 6LH
(01782 271200)

General Information

Craftsmen Potters Association of Great Britain
William Blake House, Marshall Street
London W1V 1FD
(0171 437 7605)

Crafts Council
12 Waterloo Place
London SW1 4AU
(0171 930 4811)

Stoke Tourist Office:
01782 234567

Glaze Calculation Software

Victor Bryant
Terracotta Software, 18 Latchmere Road
Kingston-upon-Thames KT2 5TW

David Hewitt Pottery
7 Fairfield Road, Caerleon, Newport
South Wales NP6 1DQ

Hyperglaze, Richard Burkett
6354 Lorca Drive, San Diego
California 92115-5509, USA
http://members.aol.com/hyperglaze/index.html

Independent Micro Consulting (Insight)
134 Upland Drive, Medicine Hat
Alberta T1A 3N7, Canada

Further Reading

Hamer, F. & J., *The Potters Illustrated Dictionary of Materials and Techniques* (A&C Black)

Rhodes, D., *Clay & Glazes for the Potter* (A & C Black)

Parmelee, *Ceramic Glazes* Cahners

Green, D., *Understanding Pottery Glazes* (Faber &Faber)

Green, D., *A Handbook of Pottery Glazes* (Faber & Faber)

Fraser, H., *Glazes for the Craft Potter* (Pitman)

Fraser, H., *Ceramic Faults and their Remedies* (A&C Black)

Dinsdale, A., *Pottery Science* (Ellis Horwood)

Heath, A., *A Handbook of Ceramic Calculations* (Heath)

Maynard, D., *Ceramic Glazes* (Borax Holdings Ltd)

Ford, W. F., *The Effect of Heat on Ceramics* (Maclaren and Sons)

Leach, B., *A Potter's Book* (Faber)

Cooper & Royle, *Glazes for the Studio Potter* (Batsford)

Cooper, E., *A History of Pottery* (Longman)

Publications

American Ceramics, 15 West 44th Street, New York, NY 10036, USA

Ceramic Review, 21 Carnaby Street, London W1V 1PH

Ceramics Art & Perception International, 35 William St, Paddington, Sydney, NSW 2021 Australia

Crafts Magazine, Crafts Council, 44a Pentonville Road, Islington, London N1 9BY

Studio Pottery, 15 Magdalen Road, Exeter, EX2 4TA

Glossary

Acidic oxide The glass-forming oxides, of which silica is the most important. Titanium, tin and zirconium are also classed as acidic glass formers.

Actual formula Accurate formula of a material, as opposed to an ideal or typical formula.

Alkali The opposite of an acid, an oxide that will neutralize an acid and form a salt. In ceramic terms the glaze fluxes are defined as alkalis, the strongest of which are, soda, potash and lithium. Sometimes also referred to as basic oxides.

Amphoteric oxide Intermediate oxide between alkaline (flux) oxides and acidic (glass-forming oxides). Alumina is the most important amphoteric oxide in ceramic, acting as a stabilizer of the molten glaze.

Bag wall Wall separating ware from flames in fuel-burning kilns.

Basic oxide Alkaline oxide.

Bat wash Refractory protective coating for kilns and kiln furniture.

Batch recipe A clay or glaze recipe set out in the actual units of weight to be used in production, not necessarily expressed as percentages.

Biscuit Clay which has been once-fired for the purpose of achieving the desired porosity for glazing.

Bisque *See* Biscuit.

Blunger Machine for stirring and blending slips or glazes.

Bung A removable object used to plug observation/ventilation holes left in doors and walls of kilns.

Calcined A material which has been prefired for the purpose of removing chemically combined water.

Ceramic From the Greek *keramos'* meaning pottery vessel.

Ceramic change The point at which clay irreversibly becomes ceramic at about 600°C.

Coefficient of expansion/contraction A measure of the change in length or volume of a ceramic material in relationship to temperature.

Cones Temperature cones designed to bend or 'squat' at specific temperatures.

Crawling Movement of the glaze during firing that leaves the body exposed.

Crazing A network of cracks in the glaze caused by poor glaze/body fit.

Crystalline glaze A glaze in which crystals form on cooling. They can be cryptocrystalline (invisible to the naked eye, microcrystalline (small, but visible) and macrocrystalline (individually visible, and up to several inches across).

Decal American term for ceramic transfers.

Decomposition The process by which materials such as carbon become volatile during firing and are released as gases.

Deflocculate To disperse the clay particles in a slip, causing it to become more fluid without the addition of more water.

Devitrification The crystallization of a molten glaze as it cools.

Dunt A crack which occurs on heating or cooling, in particular at silica inversion points.

Earthenware Ware which is porous or semi-porous, not usually fired above 1200°C.

Element (1) A pure substance.

Element (2) An electricity conducting wire usually made of kanthal alloy that generates the heat in an electric kiln.

Faience Originally describing tin-glazed ware from Italy. In industry it is sometimes used to describe any glazed wares.

Filler Non-plastic material such as flint or quartz added to bodies. They reduce shrinkage and give density to the fired ware, and can improve the casting properties of bodies by allowing easier passage of water from the body into the plaster mould.

Firebox Area of the kiln in which fuels are consumed.

Flocculate To cause the suspended particles in a slip or glaze to become more densely compacted.

Flue Channel through which heat and fumes pass before entering the chimney.

Flux Those oxides which fuse other materials together.

Frit A blend of materials melted together, cooled and reground. In order to render soluble materials insoluble and poisonous substances safe.

Hardening-on Low temperature firing decorated ware to burn out media and lightly fuse the colours to the ware before glazing.

Heat work The relationship between the temperature inside the kiln and the time taken for it to penetrate the ware.

Hydrated A material with chemically combined water, for example clay – $Al_2O_3.2SiO_2.2H_2O$.

Impermeable Not penetrable by liquids, for example non-porous vitreous clays.

Kanthal An alloy consisting of approximately 22 per cent chromium, 6 per cent aluminium and 72 per cent iron with a coating of aluminium oxide. Used for the element wire in electric kilns.

Kaolinite 'Pure' clay. From the Chinese *kao* (high) *ling* (hill), denoting the origins of primary clay from granite rock.

Kiln furniture Shelves and props for stacking ware inside a kiln.

KNaO The symbol used to combine potassia (K_2O) with soda (Na_2O) for general calculation purposes.

Lawn Sieve

Leather hard Clay which is part dried, that is, has lost the water of plasticity.

Loss On Ignition (LOI) The loss of weight of a clay or other ceramic material on firing due to decomposition.

Low solubility A lead glaze which passes the safety test for lead release.

Mature A clay or glaze which attained its optimum temperature.

Metakaolin Fired clay.

Opener A grog or similar refractory material added to clay to give structural strength and reduce shrinkage.

Peeling Flaking off of a fired glaze under extreme compression.

Percentage recipe Recipe in which the ingredients are expressed as parts of a total of 100.

Plasticity The ability of a material to combine fluidity with structural strength.

Porosity The ability to absorb liquid through tiny pores in the clay body.

Pyrometer Temperature-indicating instrument that translates the reading from a thermocouple probe inside the kiln into °C or °F.

Pyroplastic Softened by heat.

Readsorption The taking up of atmospheric moisture by dry clay.

Refractory A material capable of withstanding high temperatures without melting, for example alumina.

Saggar A container usually made from fireclay to protect wares from contamination by kiln gases. Now sometimes used for exactly the reverse, to contain the fumes from combustible/volatile material packed around the ware so as to prevent it contaminating other ware in the kiln.

Scumming Surface deposits on ware caused by the evaporation of soluble salts present in the clay.

Sedimentation The settling of particles from a liquid suspension, sometimes used to separate out fine particles which can be removed after the heavier coarse particles have settled first.

Sesquioxide An oxide in which the atoms of one element combine with oxygen in the ratio of 2:3, or example alumina sesquioxide – Al_2O_3.

Short clay Clay with low plasticity.

Sintering The first stages of fusion and densification leading to vitrification.

Slake To add dry materials to settle in water and allow the full penetration of the liquid into the microscopic pores of its particles.

Slip Fluid suspension of a clay in water.

Slop Fluid suspension of glaze materials in water.

Slurry A rough, uneven, wet mix of clay and water.

Soak To maintain a specific temperature in a kiln for a period of time.

Spare Part of a mould which acts as a reservoir for casting slip to avoid the need to top up during the casting process.

Spit-out Blisters created in the glaze during enamel firing of porous wares.

Stabilizer An amphoteric oxide that allows a glaze to become molten while restricting its fluidity. Alumina is the most important oxide used for this purpose.

Stoneware Vitreous or semi-vitreous ware usually fired above 1200°C.

Stringing Description of the pattern created in low silica, typically wood ash glazes, of long 'runs' of thicker glaze around thinner areas.

Terracotta From the Roman meaning baked earth. A term often applied to unglazed red earthenware. In the pottery industry it is used to denote any unglazed wares.

Theoretical formula A simplified formula for a material which is variable in its actual composition.

Thermocouple A probe consisting of a refractory ceramic sheath containing two metal wires of different conductivity, for example platinum and rhodium. The effect of heat on the wires creates an electrical difference which is measured on a pyrometer.

Thixotropy The property of a liquid to become more viscous when static. An important characteristic in casting slips.

Tired clay Clay which has lost plasticity through poor preparation.

Vitrification point The highest temperature a clay can be fired to without deformation. A fully vitrified (vitreous) clay would be dense and glassy with no porosity.

Volatile Any element or material which will vaporize during firing. Carbon and water are two of the commonest examples.

Ware Any type of pottery object.

Index